KT-498-918

Scottish Artists 1750–1900

FROM CALEDONIA TO THE CONTINENT

DEBORAH CLARKE AND VANESSA REMINGTON

Royal Collection Trust

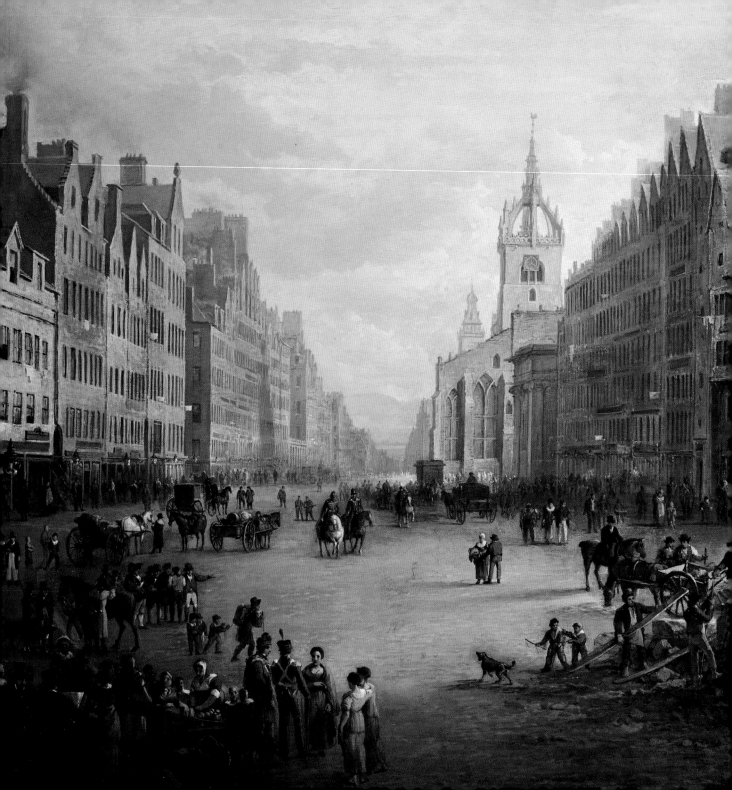

Contents

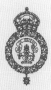

This exhibition is a celebration of Scottish artistic identity and reflects the long-standing association between Scottish artists and the Monarchy. Drawing on a distinguished group of works from the Royal Collection, it charts the development of the uniquely Scottish school of art, with its roots in the Edinburgh Enlightenment. Whether artists drew their inspiration from Scottish life, landscape and culture or from adventurous travels abroad, their work reveals a distinctly Scottish vision, characterised by its naturalness, truth to life and detailed observation.

From King George III to Queen Victoria, the Royal Family has had a formative role to play in the emergence and development of a Scottish school of art. Allan Ramsay was the first Scottish artist of European significance who enjoyed royal support and became a favourite at the court of King George III. Sir David Wilkie's success was assured by the continued endorsement of King George IV at a decisive moment in his career. Queen Victoria's favourite Scottish artist was John Phillip and she was delighted by his vibrant and colourful Spanish scenes. She also favoured the landscapes of James Giles, who recorded the views around Balmoral Castle, her new Highland home. The practice of the Royal Family commissioning and acquiring work from Scottish artists continues today, with the active patronage of painters whose art evolves from this tradition and whose inspiration comes from the architecture and landscape of Scotland and abroad.

The importance of drawing as part of a thorough artistic training is evident in much of the work included in this exhibition. This emphasis is continued today at the Royal Drawing School, which I founded and where several Scottish artists maintain this tradition, particularly in the teaching of anatomy and perspective.

I can only hope that this catalogue, the first devoted to Scottish art collected by the British Monarchy, will surprise and delight readers and encourage more people to enjoy the Royal Collection.

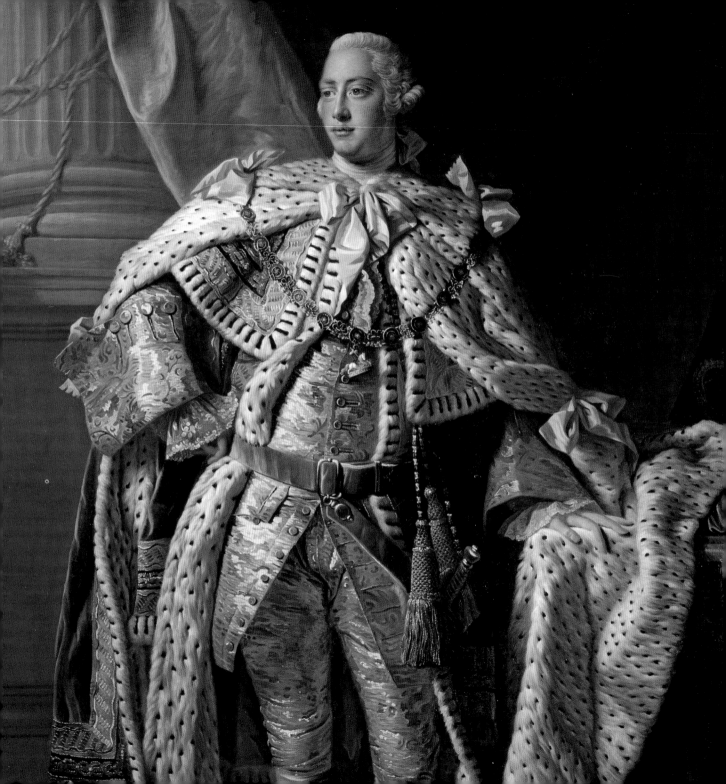

Royal Patrons and the Taste for Scottish Art

From romantic landscapes of Caledonia to colourful and exotic scenes from the Continent, family portraits and records of contemporary events, the wide-ranging subject matter and diverse styles of Scottish art acquired by the royal family between 1750 and 1900 reflect the individual and distinctive tastes of the principal patrons, George III, George IV, Queen Victoria and Prince Albert. All were discerning collectors who made many important and significant additions to the Royal Collection. Although works by Scottish artists, acquired either by commission, purchase or gift, were comparatively small in number over this period, they form a distinctive group at a time when Scottish art was coming into its own and taking its place on the wider stage of European art.

The first artist with strong Scottish connections to work at court was John Michael Wright (1617–94), who styled himself as 'king's painter'. His powerful portrait of Charles II (fig. 2) shows the King wearing sumptuous robes and St Edward's Crown, and holding the orb and sceptre made for the coronation in 1661. Wright has captured the triumph of the restored monarchy and, although it is not known who commissioned the portrait or where it was meant to hang, it was obviously intended to impress. Wright, whose parents were probably Scottish and who trained in Edinburgh under

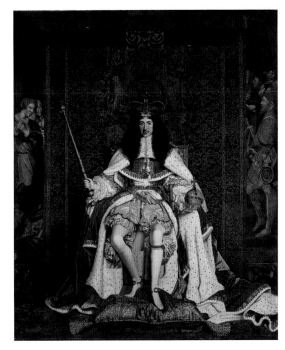

FIG. 2. John Michael Wright, *Charles II, c.*1676. Oil on canvas. RCIN 404951

the artist George Jamesone (1587–1644), went on to paint a number of works for Charles II. [1]

A century after Wright's portrait, the Scottish artist Allan Ramsay (1713–84) painted George III in

OPPOSITE: FIG. 1. Allan Ramsay, *George III*, 1761–62 (detail). Oil on canvas. RCIN 405307

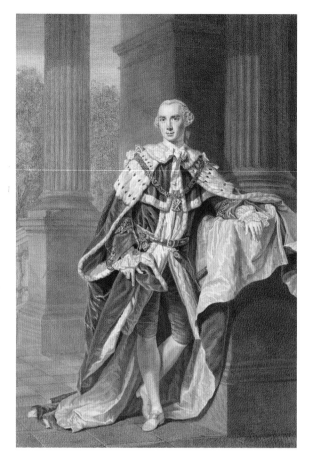

FIG. 3. William Wynne Ryland after Allan Ramsay, *John, Earl of Bute, First Lord of the Treasury*, 1763. Engraving with etching. RCIN 662399

coronation robes (fig. 1). The young King, described by Horace Walpole (1717–97) as 'tall and full of dignity; his countenance florid and good natured', is depicted wearing the magnificent robes with a natural grace and elegance.[2] This portrait, the most popular and frequently copied royal portrait of all time, was the definitive image of the King. Ramsay, the first Scottish artist of European significance, was the son of the poet Allan Ramsay (1684–1758), author of *The Gentle Shepherd* (1725). He

was brought up in Edinburgh, the city that emerged as the Scottish centre of the Enlightenment, the intellectual movement that flourished in Europe in the eighteenth century. Early training in Edinburgh and London was followed by formative visits to Italy, which contributed to his emergence as a portrait painter of European stature. In 1738, unchallenged by other serious rivals, he set up a successful studio in London and continued to maintain a clientele and contacts in Edinburgh. Ramsay played a leading role in the intellectual life of the time: in Edinburgh in 1754 he founded the Select Society, an elite debating club, with his friend the philosopher David Hume (1711–66) and the economist Adam Smith (1723–90). An extended stay in Italy between 1754 and 1757 further refined his artistic style. After an absence of four years, during which time the young English artist Joshua Reynolds (1723–92) had set himself up as a competitor in the field of portraiture, Ramsay re-established his flourishing practice in London.

Ramsay's success was assured by the royal patronage that followed his return from Italy in 1757 and his appointment as court artist to George III in 1760. Ramsay was introduced to the Prince of Wales (later George III) by fellow Scot John Stuart, 3rd Earl of Bute (1713–92), tutor, adviser and 'dearest friend' to the young Prince and a close acquaintance of the Prince's father, Frederick, Prince of Wales (1707–51)[3]. Bute commissioned from Ramsay a portrait of his pupil (Private Collection) and Ramsay was invited to Kew Palace for a sitting in October 1757. The Prince in return commissioned a portrait of Bute from Ramsay, in which the elegant and well-dressed Earl reveals his celebrated shapely legs (NTS; fig. 3). Bute, with his wide-ranging intellectual interests, undoubtedly played an influential role in the formation of George III's tastes and choice of artists and architects. It was he who stage-managed the

two greatest acquisitions of George III's reign in 1762: the Albani collection of drawings, secured by the Scottish architect James Adam (1732–94), brother of the King's architect, Robert Adam (1728–92); and, through Bute's younger brother, James Stuart Mackenzie (1719–1800), the collection of Joseph Smith (*c*.1682–1770), the British Consul in Venice, which included a large number of works by Canaletto (1697–1768) and what was later recognised as a masterpiece by Johannes Vermeer (1632–75), *A Lady at the Virginal with a Gentleman, 'The Music Lesson'* (RCIN 405346).

On the accession of George III in 1760 the success of Ramsay's earlier portrait, together with the continued influence of Lord Bute, led directly to his selection as the painter of the state portrait, the work authorised as the official likeness of the new King. Ramsay later described the range of images he had been required to provide of both the King and Queen Charlotte:

> I painted, from the life, a whole length picture of him for Hanover, a profile for the coinage, and another whole length which after the Coronation, I, by his Majesties orders dressed in Coronation robes. Soon after her Majesty's arrival, she likewise did me the honour to sit to me; and these two pictures in coronation robes are the originals from which all the copies ordered by the Lord Chamberlain are painted.[4] (figs 1 and 4)

It was therefore generally assumed that Ramsay was George III's choice of artist to become Principal Painter in Ordinary to His Majesty. This distinguished position, first held by Sir Anthony van Dyck (1599–1641) in 1632, was the highest honour to which a British artist could aspire, and it was customary for a new appointment to be made at the start of a reign. Ramsay felt it unneces-

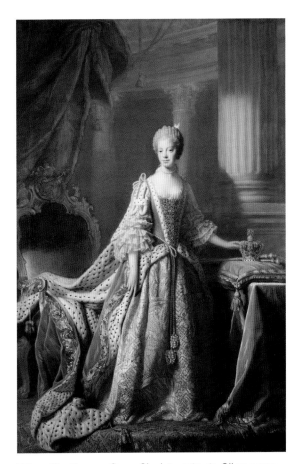

FIG. 4. Allan Ramsay, *Queen Charlotte*, 1760–61. Oil on canvas. RCIN 405308

sary to make a formal application for the post but the Lord Chamberlain, without consulting the King, renewed the appointment of the previous incumbent, John Shackleton (d. 1767). A difficulty arose as the official state portraits and their numerous copies were normally the responsibility of the Principal Painter in Ordinary, but the King had already sat to Ramsay and afterwards indicated that all copies should be entrusted to the Scottish artist. To give Ramsay official status at Court, in December 1761 he was appointed as 'one of

FIG. 5. Allan Ramsay, *The Artist's Wife: Margaret Lindsay of Evelick*, 1758–60. Oil on canvas. Scottish National Gallery NG 430

take your dinner"'. A gifted conversationalist, Ramsay often 'spoke freely and without disguise to the King concerning European affairs, with which he was well acquainted.'[5] He enjoyed a good relationship with Queen Charlotte; a natural linguist, he was proficient in five languages and one of the few people at Court to whom the young Queen could enjoy talking in her native German. Ramsay's affinity with the Queen resulted in some of his most distinguished and elegant works; his portrait *Queen Charlotte with her Two Eldest Sons* of 1764 (no. 2) combines the grandeur of a royal portrait with the intimacy of a domestic scene. The delicate colouring and natural elegance revealed Ramsay's close affinities with French artists of the period, such as Maurice-Quentin de La Tour (1704–88) and Jean-Marc Nattier (1685–1766). Ramsay had already shown his talent as an incomparable painter of women in exquisite portraits such as those of his second wife, Margaret Lindsay, of 1758–60 (fig. 5), and Elizabeth Montagu of 1762 (Private Collection). This natural ability was confirmed by Horace Walpole, who wrote: 'Mr Reynolds seldom succeeds in women: Mr Ramsay is formed to paint them.'[6]

At the same time Ramsay experienced the strong anti-Scottish feeling focused on Lord Bute, styled 'the Thane' after his appointment as Prime Minister in 1762. Bute was the victim of a ceaseless stream of abuse in the press and was accused, among other things, of elevating fellow Scots to prominent positions. Ramsay suffered from allegations that his promotion to painter to the King, particularly in preference to Reynolds, was because of his Scottish birth. The strength of Ramsay's position as George III's favourite painter was confirmed by the King who, when requested by his minister Lord Eglinton to sit to Reynolds for a portrait, refused with the words: 'Mr Ramsay is my painter, my Lord.'[7] Reynolds was later appointed by the King as the first President of

His Majesty's Principal Painters in Ordinary', although it was stipulated that the salary that went with the office of Principal Painter would be reserved for Shackleton. On Shackleton's death in 1767, Ramsay finally succeeded him as Principal Painter in Ordinary, the first Scot to be appointed to this important role.

Ramsay became a great favourite at Court and, when working at Buckingham House (later Palace), he was often asked by the King 'to convey his easel and canvass to the dining room, that he might observe his progress, and have the pleasure of his conversation'. On occasion, when the King had dined on 'his usual allowance of boiled mutton and turnips, he would rise and say, "Now, Ramsay, sit down in my place, and

the Royal Academy on its foundation in 1768 and succeeded Ramsay as Principal Painter in Ordinary.

Ramsay was responsible for the production of the large number of copies of the state portraits that ambassadors and governors of provinces were entitled to receive as gifts from the King, and which others could purchase by application to the Lord Chamberlain's department. These copies were to occupy Ramsay for the rest of his life and, at 80 guineas each, to provide a considerable income.[8] Ramsay's studio in Soho Square was described by Joseph Moser (1748–1819), who knew and admired the artist: 'I have seen his show-room crowded with portraits of His Majesty in every stage of their operation'.[9] In 1767 he moved his studio to more spacious premises in Harley Street in order to accommodate the large numbers of royal portraits being worked on at any one time.

Ramsay employed a number of assistants, although for several years he insisted on painting 'the head with his own hand'.[10] His first principal assistant was his Scottish pupil David Martin (1737–97), who later set up his own studio in Edinburgh and was made the Prince of Wales's Painter to Scotland. Martin was succeeded by another of Ramsay's pupils, Philip Reinagle (1749–1833), the son of a Hungarian musician living in Edinburgh.

While working on the copies of the state portraits, Ramsay continued to receive other royal commissions until the end of his career as an artist. He painted several members of the royal family and Queen Charlotte's family, including, in 1767, a portrait of Prince William, the future William IV (no. 3). But in these later years royal patronage was shared with others, such as the German painter Johann Zoffany (1733–1810), and Queen Charlotte commissioned portraits of her own family from both these artists. The portraits of the Queen's mother (no. 5) and one of her brothers (no. 4), together

with the painting of George III's mother, Augusta, Princess Dowager of Wales (Private Collection), ordered by the Princess for the Brunswick court, represent Ramsay's last royal commissions. In 1773 an accident to his arm effectively ended his career as a painter.

Like Ramsay, the architect Robert Adam owed his introduction to George III to Lord Bute. Adam knew Ramsay in Edinburgh and met him again in Italy in 1756, when Adam accompanied Ramsay on tours of Rome, sketching ancient monuments. It was through Bute that Adam was appointed to the royal post of Architect to the Board of Works, together with William Chambers (1723–96). Adam was responsible for designing temporary structures to be erected in the garden of Buckingham House in June 1763, as part of the celebrations to mark both the King's birthday and the royal occupation of the house (nos 6 and 7). Although Adam contributed to the design of new interiors at Buckingham House, the ornate style of his decoration did not entirely please the King, who had commented on his work for Syon House: 'two [sic] much gilding, which puts me in mind of ginger-bread. Mere simplicity will always bear the preference.'[11] It was Chambers who continued to work for the royal family and Adam who had greater success working for private rather than royal patrons.

Sir David Wilkie (1785–1841) experienced even greater recognition than Allan Ramsay and was celebrated within his own lifetime in England, Scotland and on the Continent, largely due to royal patronage and the popular success he enjoyed at the annual Royal Academy exhibitions. Wilkie, the talented son of the minister of Cults, Fife, attended the Trustees' Academy in Edinburgh, an important training school for many painters who went on to leave their mark on the development of Scottish art. He moved permanently to London in 1805 to seek the greater opportunities offered

both in terms of training and professional reputation. He achieved almost immediate fame with *The Village Politicians* (Scone Palace, Perth), one of his first realistic portrayals of rural life, which drew huge crowds when it was shown at the Royal Academy in 1806. Wilkie continued to enjoy critical and popular success with his vivid small-scale scenes of everyday life, exhibited regularly at the Royal Academy, which showed an affinity with the work of Flemish seventeenth-century genre painters such as David Teniers the Younger (1610–90) and Adriaen van Ostade (1610–85).

Wilkie's reputation was sealed by two high-profile royal commissions from the Prince Regent, the future George IV, who had a taste for genre painting and was acquiring seventeenth-century Dutch and Flemish paintings for his own collection.[12] Wilkie received his first royal commission through the President of the Royal Academy, Benjamin West (1728–1820), who confirmed: 'I had the honour of personally receiving the Regent's command for Mr Wilkie to paint that Picture, for His Royal Highness.'[13] This was *Blind-Man's-Buff* (fig. 6), exhibited at the Royal Academy in 1813. Wilkie, who was on the hanging committee that year, ensured that his painting was placed prominently: 'my picture of Blindman's Buff was accordingly placed in the principal centre in the great room', where 'everybody seems to like it, and many think it is the best I have painted'.[14] The painting found great favour with the Prince and was hung in Carlton House, the Prince's London residence, with works by van Ostade, Jan Steen (1626–79) and others. Wilkie reported that 'he was so delighted with the picture that I had painted for him, and wished me to paint, at my leisure, a companion picture of the same size'.[15] The *Penny Wedding*, or *'Scotch Wedding'* as it was originally called (no. 13), which depicts 'the manners and customs and characters of old Scotland',

was completed in 1818, following Wilkie's tour of Scotland in 1817.[16]

A major opportunity for royal patronage came on the occasion of the historic visit of George IV to Scotland in 1822. It was the first visit to Scotland by a British reigning monarch since Charles I in 1641, and the accompanying two-week-long extravaganza centred on Edinburgh was masterminded by the writer Sir Walter Scott (1771–1832; fig. 7), who devised the King's programme and accompanying pageantry. The main ceremonies were designed to confirm George IV as legitimate king, the latest in a long line of Scottish monarchs, of a country with a distinctive, unified Highland identity, as emphasised by Scott: 'We are THE CLAN and our king is THE CHIEF.' The programme included major spectacles such as the arrival of the King at Leith, the entrance of the King to

FIG. 6. Sir David Wilkie, *Blind-Man's-Buff*, 1812-13 (detail). Oil on panel. RCIN 405537

his Scottish royal residence, a drawing room for ladies, a *levée* for gentlemen, a procession from the Palace of Holyroodhouse to Edinburgh Castle, a banquet at Parliament House and a Highland ball. Scott's instructions, in a pamphlet published anonymously in advance of the visit, provided details of etiquette and appropriate dress, including the wearing of tartan, for each occasion. For the ball it was advised that 'no Gentleman is to be allowed to appear in any thing but the ancient Highland costume, with the exception of those in uniform'.[17] The visit was witnessed by one seventh of the Scottish population and only a very few thought the whole event 'burlesque[d] the national character or dress of real Highlanders'.[18] The King was delighted by Scott's presentation of Scotland as an ancient and traditional clan society, designed to heal any lingering rift between the Hanoverian monarch and his northern kingdom.

The 'King's Jaunt,' as the visit became known, proved a major attraction for artists.[19] They were given prime access to all events, and hoped to find the perfect subject for a modern history painting that would be popular to buyers including, possibly, the King himself. Wilkie travelled from London for the occasion, as did J.M.W. Turner (1775–1851), who hoped to secure the King's patronage for a series of nineteen commemorative paintings of the royal visit.[20] A number of Scottish artists were also on the spot to record the various occasions: they included the landscape artist Alexander Nasmyth (1758–1840), who depicted the preparations required for the procession to the Castle in *The Lawn Market* (no. 27); and Alexander Carse (*c.*1770–1843), Wilkie's contemporary at the Trustees' Academy, who recorded the King's landing at Leith (CAC 1978/30).

Having witnessed many of the events of the week, Wilkie found it difficult to settle on a subject and wrote that he had 'made multitudes of sketches, with the King

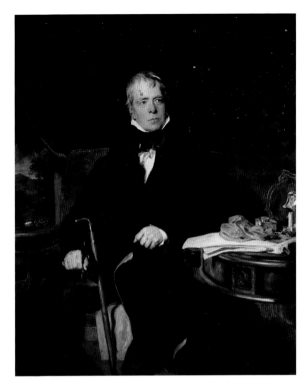

FIG. 7. Sir Thomas Lawrence, *Sir Walter Scott*, 1820–26. Oil on canvas. RCIN 400644

and without the King, but as yet without hitting upon anything to satisfy me. It presented in reality scenes of the greatest excitement but to redress these upon canvas seems the difficulty, and I have not been able to accomplish it.'[21] Wilkie consulted the King, who 'fixed upon his admission to the palace of his ancestors, with all the chiefs of the north to his right and left'.[22] Wilkie had been present at the King's arrival at the Palace and his painting *The Entrance of George IV to Holyroodhouse* (see no. 21) shows the moment when the Duke of Hamilton (1767–1852), the premier peer of Scotland, presented the keys to the King in front of his ancient Scottish royal residence. The King, acknowledged as the legitimate holder of the keys, was thus the rightful King of Scotland.

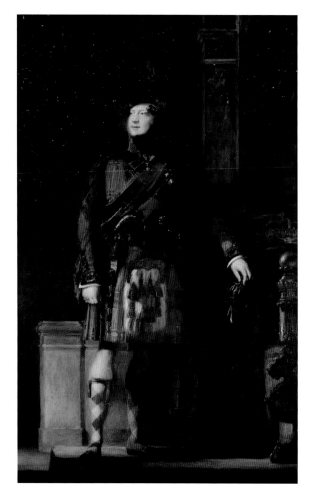

FIG. 8. Sir David Wilkie, *George IV*, 1829. Oil on canvas. RCIN 401206

Wilkie obtained an invitation through Scott to the *levée* at Holyroodhouse, during which 1,200 gentlemen were presented to the King. All were encouraged to wear Highland dress and the King himself was resplendent in his kilt, 'the same brilliant *Steuart Tartans,* so called, in which certainly no Steuart, except Prince Charles, had ever before presented himself in the saloons of Holyrood'. Wilkie himself commented:

'He looked exceedingly well in tartan. He had on the kilt and the hose, with a kind of flesh-coloured pantaloons underneath.'[23] Wilkie went on to depict the King as a Highland chieftain, in the Royal Stewart tartan worn on this occasion, in a portrait completed in 1830 (fig. 8).

For the duration of the *levée* at Holyroodhouse, paintings by Scottish artists were put on display in the rooms adjoining the King's Closet, to 'enable His Majesty to judge the State of the Art in this Country'. Artists represented were the foremost portrait painter in Edinburgh, Henry Raeburn (1756–1823); Wilkie's friend William Allan (1782–1850); Andrew Geddes (1783–1844), a portrait painter who often depicted his subjects in exotic costume; and Ramsay's former assistant, Alexander Nasmyth.[24]

Raeburn had spent most of his career in Edinburgh, although he considered a move to London and exhibited regularly at the Royal Academy. In Scotland, he was celebrated as the first Scottish portrait painter of eminence who chose to stay in his own country and was in constant demand as a painter to the wealthy and famous, recording Scottish society in the later years of the Enlightenment. His clientele were not royal but the landed, mercantile and professional classes, and no paintings by Raeburn were acquired by either George III or George IV. Raeburn finally received royal approval when his significant role in the artistic life of Scotland was recognised by George IV on the last day of the King's visit. He was knighted at Hopetoun House, one of two Scots to be honoured by his sovereign in his native country since the union of 1707; the other was Captain Adam Ferguson, the friend of Scott and Keeper of the Regalia of Scotland. Wilkie dined with Raeburn the next day and described the party as 'a complete jollification'.[25] The following year Raeburn was appointed by the King to the post of His Majesty's

Painter and Limner in Scotland, 'out of respect for your character and professional merits'.[26] The office of Royal Limner had been created in the reign of Queen Anne in 1703 but had, in effect, become a sinecure, and Raeburn was the first professional painter to be appointed for over a hundred years. In this role Raeburn would have been expected to paint a portrait of the King, but he died a few months after his appointment.

On Raeburn's death in 1823, Wilkie succeeded to the post of Royal Limner and it fell to him to paint the portrait of the King. Wilkie wrote, as he was working on his portrait of the King in Highland dress: 'This was to have been done by Sir Henry Raeburn and I now do it in virtue of holding the same office of Limner for Scotland'.[27] Wilkie also seems to have been encouraged by his appointment to continue with his painting of George IV entering Holyroodhouse. In August 1823 he was summoned to Windsor, where 'The King approved completely of the plan and intention of the sketch and expressed his pleasure that I should proceed with the Picture … and that he would sit to me for the figure'.[28] Wilkie returned to Edinburgh in 1824 to make further sketches of the Palace and additional portraits of the key figures but continued to have difficulties with the picture. It was not completed before he suffered a nervous breakdown, brought on by financial problems, overwork, and a series of family tragedies, which left him unable to paint. The following year he set off on a prolonged visit to the Continent, visiting Germany, Italy and Spain. He used the opportunity to look at as much art as possible: 'My great pursuit is pictures; and there is scarce one of any note … that I have not seen'.[29] He spent time in Rome, where he studied the work of Renaissance artists such as Michelangelo and Titian. He was one of the first professional artists to visit Spain, recently opened up to travellers after the Spanish War of Independence (1808–14), and he saw much potential in this relatively little-known country, which he described as 'the wild, unpoached game-preserve of Europe'.[30] In Madrid he spent time studying the paintings of Spanish artists Velázquez and Murillo. His travels proved to be a turning point in his art. Gradually he started to paint again and his art was transformed, both in style and subject matter, as he took inspiration from contemporary Spanish events such as the guerrilla uprising against the French, employing a broader style with a fresh use of colour (fig. 9).

On his return in 1828 Wilkie was summoned by the King to Windsor to show him the work he had done abroad. The King purchased two Italian pictures, *A Roman Princess Washing the Feet of Pilgrims* (no. 14) and *I Pifferari* (no. 15), and three Spanish ones, *The Defence of Saragossa* (no. 18), *The Spanish Posada* (no. 16)

FIG. 9. Sir David Wilkie. *The Spanish Posada: A Guerilla Council of War*, 1828 (detail). Oil on canvas. RCIN 405094

and *The Guerilla's Departure* (no. 19). He commissioned a fourth, *The Guerilla's Return* (no. 20), to complete the set. Wilkie reported to Sir William Knighton (1776–1836), Royal Physician and the King's Private Secretary, as well as one of the artist's most important supporters and patrons, 'the approval has been to my satisfaction. The *Posada* is preferred, as best of all, and the fourth picture commanded to be got on with.'[31] The five completed pictures were all exhibited at the Royal Academy in 1829 and the King was delighted. His generous support came at a decisive moment in the artist's career. Wilkie had been away from London for three years and his paintings had changed from small, highly finished scenes of everyday life to larger, contemporary subjects in a broader style; crucially, the King's continued patronage confirmed Wilkie's reputation in the eyes of the British public. The success of his Spanish paintings, together with a growing interest in Spanish culture in Britain, encouraged other artists to visit and delight in the novelty of the country, including Scots David Roberts (1796–1864) in the 1830s and John Phillip (1817–67) in the 1850s.

Wilkie completed the *Entrance of George IV to Holyroodhouse* and the portrait of the King in Highland dress; both were shown at the Royal Academy in 1830. In the same year the King, a few months before his death, recognised Wilkie's pre-eminence as an artist and appointed him to the important post of Principal Painter in Ordinary, in succession to Sir Thomas Lawrence (1769–1830). In reality this meant that Wilkie took on the role of official portraitist and also found himself in demand beyond royal circles. On his accession in 1830 William IV reappointed Wilkie to the post instead of making a new appointment, as was customary at the beginning of a reign. In 1836, in celebration of his artistic achievements, the King awarded him a knighthood. He

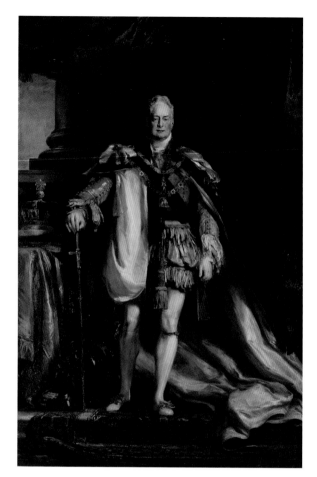

FIG. 10. Sir David Wilkie, *William IV*, 1832. Oil on canvas. RCIN 404931

commissioned Wilkie to paint a full-length portrait of himself, wearing the robes of the Order of the Garter, for the Waterloo Chamber at Windsor Castle; for this he gave several sittings in Brighton (fig. 10). Sir William Knighton subsequently wrote to Wilkie: 'your portrait of His Majesty was much, very much, approved of; in point of likeness and execution, the story of the court is, that it surpasses all the attempts, of the other artists, who have exercised their pencils in regard to his present Majesty.'[32]

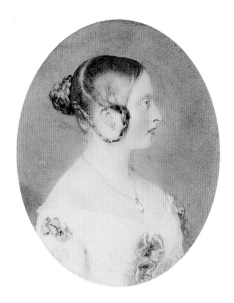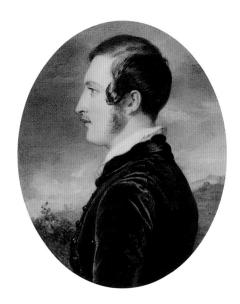

FIG. 11. Sir William Ross, *Queen Victoria*, 1841. *Prince Albert*, 1837. Watercolour on ivory laid on card. RCINs 421462 and 422422

On the accession of Queen Victoria in 1837 Wilkie again continued as both Principal Painter in Ordinary and Royal Limner to the Queen, but he did not experience the same remarkable degree of success and appreciation as he had enjoyed under George IV and William IV. The Queen asked him to paint *The First Council of Queen Victoria* (RCIN 404710) to record her address to the Accession Council at Kensington Palace on 20 June 1837. Initially it seemed that she admired the painting but she came to dislike it intensely and wrote in her Journal in 1847 that she thought it 'one of the worst pictures I have ever seen, both as to painting & likenesses'.[33] Perhaps this reaction is unsurprising given the official nature of this first commission. Similarly, the Queen did not like the state portrait Wilkie painted of her in 1840 (LLAG, LL3598) and gave him no more commissions. She did purchase one further picture by

Wilkie, after his death, of the Sultan of Turkey, which the artist had painted in Constantinople in 1840 and intended as a gift for the Queen (RCIN 407268).

Wilkie was succeeded in the post of Royal Limner by Sir William Allan in 1841. Although his painting *The Orphan* (no. 28) had been acquired by either William IV or Queen Adelaide in 1834, Allan's chosen speciality at the time of history painting, particularly scenes from Scottish history, seemed to have limited appeal to Queen Victoria. Despite early promise, by the time of his appointment as Royal Limner Allan's style and subject matter probably seemed old-fashioned and no further paintings by him were acquired.

Nevertheless, both Queen Victoria and Prince Albert (fig. 11) were enthusiastic and discerning patrons of art and a considerable number of works they commissioned and collected throughout their marriage were by

Scottish artists. Victoria and Albert had a great love of Scotland and acquired their own estate in the Highlands, Balmoral, in 1848. Undoubtedly they felt a strong attraction to work by artists from Scotland. They admired romantic Highland views by James Giles (1801–70; nos 45–48); depictions of poignant contemporary events, such as that by Sir Joseph Noël Paton (1821–1901; no. 35); and colourful and exotic scenes of Spain, Egypt and the Holy Land by David Roberts and John Phillip (nos 36–39, 41–44). The royal couple were well informed and visited art exhibitions regularly, including those at the Royal Academy, where many Scots exhibited. Several Scottish artists were recommended to the Queen by close friends and relatives or by other artists. Sir Edwin Landseer (1802–73), for example, praised the paintings of Phillip to the Queen, while Paton endorsed the work of Kenneth MacLeay (1802–78). Several pictures by Scots were among the birthday and Christmas presents given regularly by Victoria and Albert to each other, with great ceremony, throughout their married life, including works by Paton, Roberts, Giles, Phillip and James Drummond (1816–77). The Queen and Prince Albert each took a great interest in the work they commissioned, and could be attentive and, on occasion, demanding patrons. Both were keen and proficient amateur artists, interested in the creative process of art as well as the finished product. In addition, both viewed their roles as patrons of the arts as part of the public duty of the monarchy and took this role seriously.[34]

Before her marriage Queen Victoria was advised by Lord Melbourne (1779–1848), Prime Minister for the first two years of her reign, and they often discussed artistic matters. It was almost certainly through Melbourne that the Scottish artist Sir Francis Grant (1803–78) was introduced to the Queen. Grant, the younger son of a Perthshire laird, had no formal training as an artist

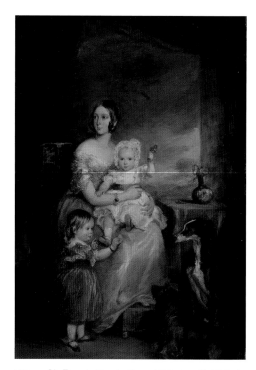

FIG. 12. Sir Francis Grant, *Queen Victoria with Victoria, Princess Royal, and Albert Edward, Prince of Wales*, 1842. Oil on canvas. RCIN 406944

but achieved success as a painter of sporting scenes and fashionable portraits. The Queen commissioned him to paint *Queen Victoria Riding Out* (no. 29), which documents the 'ridings out' she enjoyed in the company of Melbourne and other members of her court. She recorded at length in her Journal the sittings, which took place at Buckingham Palace between April and October 1839: 'sat to Mr Grant on horseback till 4'; 'saw Lord Conyngham sitting to Grant upon a wooden horse'.[35] The Queen was happy with the picture and its success led to further royal commissions. In late 1842 Grant painted *Queen Victoria with the Princess Royal and Albert Edward, Prince of Wales* (fig. 12), a composition reminiscent of Allan Ramsay's portrait of *Queen Charlotte and her Two Eldest Children* (no. 2); Victoria

gave the picture to Prince Albert for Christmas that year. In 1845 she sat for a large equestrian portrait for Christ's Hospital, Horsham, to commemorate her visit to the school (no. 30); Grant also painted Prince Albert as a pendant (no. 31). Grant went on to become the first Scottish President of the Royal Academy in 1866.

In 1841 Prince Albert was appointed President of the Royal Commission on the Fine Arts and became involved in the scheme to decorate the interior of the new Palace of Westminster with a series of historical murals. It is probable that it was in connection with this project that Albert first came into contact with William Dyce (1806–64), an artist whose advice he came to value highly. Of all the Scottish artists whose work was collected by the royal couple, it was Dyce who was most in tune with Prince Albert's tastes. Dyce was from Aberdeen and had worked for a number of years as a portrait painter in Edinburgh; he had also studied in Rome, where he had come into contact with the German Nazarene painters. Like the Nazarenes, Dyce was inspired by early Italian art and his work owed a debt to the clean lines and clear colour of the painters of the Quattrocento. In 1845 Prince Albert, also an admirer of Italian art of this period, purchased Dyce's *Madonna and Child* (no. 32), in which the influence of Raphael is clearly evident. This was recognised by Queen Victoria when she 'saw in Albert's room downstairs a most beautiful picture of the Madonna and Child by Dyce, quite like an Old Master, & in the style of Raphael, – so chaste, & exquisitely painted'.[36] The Prince was delighted and in 1846 commissioned a companion picture of St Joseph (no. 33), which he considered to be even finer. It was at this time that he was also beginning to purchase early Italian paintings; he was one of a small group of collectors in Britain to appreciate such work.[37]

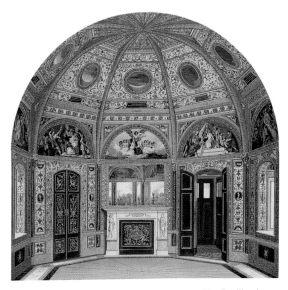

FIG. 13. Ludwig Gruner, 'Comus Room', from *The Pavilion in Buckingham Palace Gardens*, 1845. Chromolithograph with hand-colouring. RCIN 708005

Both Prince Albert and Dyce were interested in fresco painting, the suggested medium for the Palace of Westminster murals. Dyce's fascination with fresco dated from his visits to Rome and his contact with the Nazarenes, who were interested in the technique. The Prince was also attracted to fresco as an art form, probably due to the recent revival of the technique in his native Germany. Dyce received commissions from the Prince for frescoes, including one in the 'Comus Room', part of the new Garden Pavilion in the grounds of Buckingham Palace, and *Neptune Resigning the Empire of the Seas to Britannia* (figs 13 and 14) for the upper wall of the stairwell of Osborne House, the royal couple's new residence on the Isle of Wight. As he noted, the Queen and Prince Albert differed in their opinion when he showed them a sketch for the work: the 'Prince thought it rather nude; the Queen, however, said not at all'.[38] Prince Albert watched Dyce regularly as he worked on the fresco at Osborne between 3 August and 7 October 1847, leading Dyce to comment to his fellow

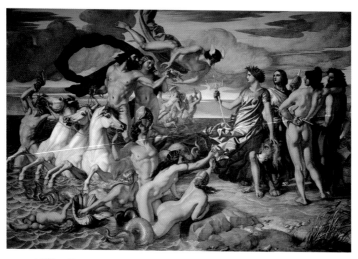

FIG. 14. William Dyce, *Neptune Resigning the Empire of the Seas to Britannia*, 1847. Fresco. RCIN 408424

artist, C.W. Cope, who was about to embark on a fresco in the Palace of Westminster: 'Only, when you are about to paint a sky seventeen feet long by some four or five broad, I don't advise you to have a Prince looking in upon you every ten minutes or so.'[39] Victoria and Albert were happy with the finished result, describing it as 'a magnificent painting, so well drawn, conceived and executed'.[40]

Prince Albert and William Dyce shared a concern for the public role of art in society and while at Osborne they enjoyed conversations on artistic matters. It was during one of these discussions that the idea of a cycle of frescoes based on Thomas Malory's *Morte d'Arthur* was first suggested. In 1847 Dyce was commissioned to paint the Queen's Robing Room in the Palace of Westminster with frescoes on this subject, a project that was to occupy him for much of the rest of his life. He continued to work occasionally for the royal family, completing drawings of the four royal children early in 1848, for example, for which he had a number of sittings. The Queen commented: 'Dyce has sent the finished drawings of the Children, framed, & they are really beautiful, even though not very individual likenesses.'[41] It seems that she did not keep the drawings, but purchased two others much later, after Dyce's death (no. 34).

Queen Victoria's visits to the annual exhibition at the Royal Academy often resulted in a purchase or a commission. When Sir Joseph Noël Paton's *'Home': the Return from the Crimea* was exhibited in 1856, the Queen described it as 'beautiful in sentiment & execution'.[42] The painting, which depicts a Scottish soldier's reunion with his family upon his return from service in the Crimean War (1854–6), was widely praised for its blend of emotional realism, patriotism and topical subject-matter. Queen Victoria commissioned Paton to paint a slightly smaller version (no. 35), which she presented to Prince Albert for Christmas in 1859. In 1863, two years after Prince Albert's death, the Queen asked 'Mr Noël Paton, the Scotch painter' to do a 'small "In Memoriam" of me with Alice & the 3 youngest Children'.[43] Although the Queen and some of the children sat for Paton, the painting was never completed, probably due to the artist's ill health. Paton spent much

of his working life in Scotland, only visiting the Continent briefly in 1863. He was appointed Royal Limner in 1864 and was knighted in 1867, as the Queen noted: 'After luncheon I knighted … good Mr Noël Paton (as my Limner in Scotland).'[44]

Paton had succeeded Sir John Watson Gordon (1788–1864) as Royal Limner. Watson Gordon, appointed in 1850 in succession to Sir William Allan and knighted in the same year, had established himself, after Raeburn's death, as the leading portrait painter in Edinburgh and exhibited regularly in London. Queen Victoria had seen some 'men's portraits by Watson Gordon' at the Royal Academy and had arranged for him to paint the Prince of Wales.[45] However, his work did not gain royal approval, as is evident in the letter the Prince wrote to his mother: 'I am sorry to hear that you find Sir J. Watson Gordon's pictures … of me so bad, but I cannot say I feel surprised at it, so I thought that you would not like them.'[46] No works by Watson Gordon were acquired by Queen Victoria.

The Queen first saw the work of David Roberts, the landscape and theatrical scenery painter from Edinburgh, at the Royal Academy in 1840. Roberts had travelled widely overseas, to Spain in 1832 (like Wilkie) and to Egypt and the Holy Land in 1838–9, the first independent professional artist to travel extensively in this area. His paintings of the Middle East, such as *A View in Cairo* (no. 36), purchased by Queen Victoria, evoke a romanticised atmosphere, often with theatrical lighting and dramatic viewpoints, aligned to a topographical accuracy. The following year the Queen commissioned two Spanish pictures from Roberts as gifts for Prince Albert, *A View of Toledo and the River Tagus* (no. 39) and *The Fountain on the Prado, Madrid* (no. 38). Roberts had much success at the Royal Academy and was able to charge high prices for his

paintings. However, he achieved greatest recognition for his views of the Middle East, *The Holy Land, Syria, Idumea, Arabia, Egypt and Nubia* (no. 37), published in three volumes with lithographs executed by Louis Haghe (1806–85) (fig. 15). These presented a comprehensive view of the monuments, landscape and people of the region and were dedicated to Queen Victoria and published by subscription between 1842 and 1849; three further volumes were added in 1846. Roberts was thus able to reach a wide audience, his accurate illustra-

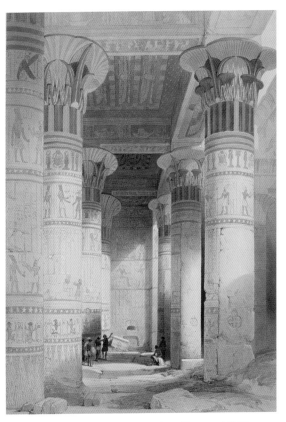

FIG. 15. After David Roberts. 'Philae' from *Egypt and Nubia*, v. I, 1846. Lithograph. RCIN 1075157

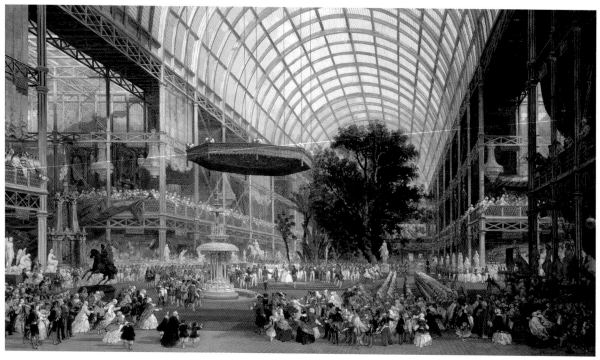

FIG. 16. David Roberts, *The Inauguration of the Great Exhibition: 1 May 1851*, 1854. Oil on canvas. RCIN 407143

tions influencing other artists and architects, such as Alexander 'Greek' Thomson (1817–75) from Glasgow.

It was in connection with a painting of the Great Exhibition that Roberts came into direct contact with Prince Albert and subsequently experienced the interference and strong opinions of his royal patron. Having recorded the opening of the Great Exhibition in 1851 in a small oil painting (RCIN 405570), which was purchased by the Queen as a present for Prince Albert, he was then asked to paint a larger and more detailed record of the occasion. After discussion with the Queen and Prince Albert, Roberts found the subject unsatisfactory and progressed with difficulty. He had at least three further interviews with his patrons, for which he was summoned to Osborne, Buckingham Palace and Windsor, and during which alterations were suggested.

Prince Albert, in particular, requested changes to dress, decorations and uniforms, as well as the size of the figures. The painting was finally completed in 1854 (fig. 16) and Roberts commented, after disagreeing with the Prince about a proposed alteration, 'I must decline His suggestion I was not a true Courtier, and I have no doubt so thought he for I have not been asked again to paint for the Court'.[47]

Queen Victoria's favourite Scottish painter was undoubtedly John Phillip, the artist from Aberdeen, whose vivid and colourful scenes of Spanish life and passion for Spanish culture led to him being known as 'Phillip of Spain'. Scottish interest in Spain and Spanish art had been awakened by Wilkie in 1827, followed by the publication of travel books and, in 1848, the first critical account of Spanish art in English, *Annals of the*

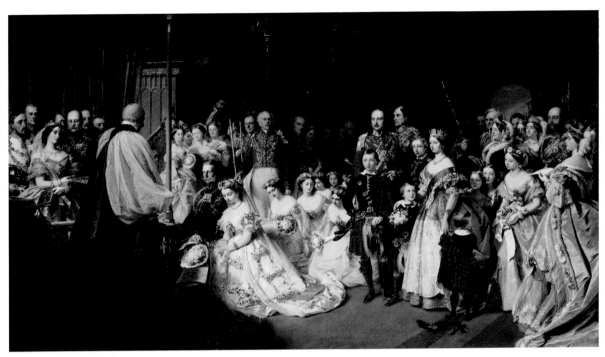

FIG. 17. John Phillip, *The Marriage of Victoria, Princess Royal, 25 January 1858*, 1860. Oil on canvas. RCIN 406819

Artists in Spain, written by the Scot, William Stirling-Maxwell (1818–78). Recovering from illness and inspired by Wilkie and his subject matter, Phillip followed in his footsteps to Spain in 1851. The landscape of Andalucia and first-hand experience of Spanish paintings by Velázquez and Murillo had a major impact on his painting; on his return, his vibrant Spanish street scenes immediately made a mark at the Royal Academy. Their successful reception led to a series of royal commissions, which unquestionably helped Phillip's career greatly. Landseer first brought his paintings to the attention of Queen Victoria, who was delighted by the 'very clever & talented sketches & studies, of Spanish gipsies ... by an artist of the name of Philip'.[48] The Queen and Prince Albert were to acquire four pictures of Spanish subjects by Phillip, all given to each other as Christmas presents.

Victoria commissioned *A Spanish Gypsy Mother* (no. 41) and purchased *'El Paseo'* (no. 42) for Albert in 1852 and 1854 respectively, and he gave the Queen *The Letter Writer of Seville* (no. 43) for Christmas in 1853. After a visit to the Royal Academy in 1858 the Queen acquired *The Dying Contrabandista* (no. 44) as a gift for the Prince for Christmas 1858.

As a mark of royal favour, Phillip received a prestigious commission from the Queen to record the marriage of the Princess Royal to Prince Frederick William of Prussia on 25 January 1858. Phillip must have felt that such an important commission, to include nearly fifty portraits, including those of all the royal family, would enhance his reputation as a successful artist. Phillip's finished painting, which was shown at the Royal Academy in 1860, captures the joy and

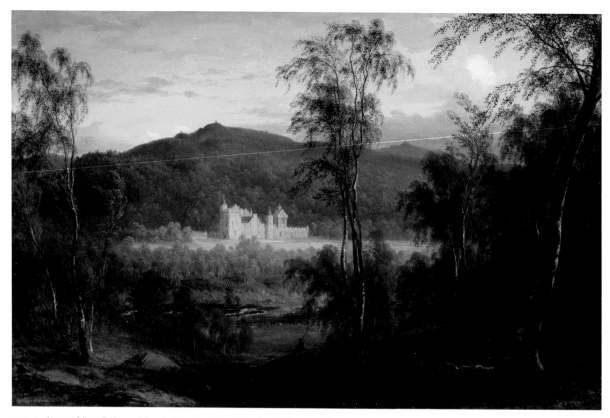

FIG. 18. James Giles, *Balmoral Castle from the River Dee*, 1835. Oil on panel. RCIN 403052

excitement of the happy occasion, which took place at the Chapel Royal (fig. 17). Queen Victoria, her faith in the artist confirmed, commented, 'Philip's Marriage is out & out the best & quite resplendent'.[49] On his death in 1867 the *Scotsman* described Phillip as 'the most illustrious painter which Scotland has produced since Wilkie'; the Queen mourned 'the death of our greatest painter'.[50]

Victoria and Albert had a deep and heartfelt love of Scotland and commissioned work from many artists to commemorate the scenery they cherished. Their interest in the country was stimulated by the novels of Sir Walter Scott; on their first visit in 1842, they viewed Scotland through Scott's eyes and his romantic descriptions of the land and its inhabitants shaped their own views of the country. The Queen described the Highlands, on seeing them for the first time, as 'inexpressibly beautiful; such high Mountains, sometimes richly wooded, & at other times wild & barren'.[51] Further visits in 1844 and 1847 convinced the Queen and Prince Albert of the desirability of acquiring their own 'Highland Home', and in 1848 the Prince took on the lease of the Balmoral estate on Deeside (fig. 18). This had become available on the death of Sir Robert Gordon, the previous leaseholder, and Sir Robert's elder brother, George Hamilton-Gordon, the 4th Earl of Aberdeen, recom-

mended the property to the Prince. The Aberdeen artist James Giles had worked for both Sir Robert and Lord Aberdeen, and it was his views of the old castle of Balmoral that were shown to the royal couple and persuaded them to take on the lease without inspecting it. On first viewing the estate in 1848, the Queen and Prince Albert were delighted, prompting Victoria to write: 'The Scenery all round is the finest almost I have seen anywhere. It is very wild & solitary & yet cheerful and beautifully wooded.'[52] Following a walk on their first day at Balmoral, the Queen commented that 'It was so calm & solitary as one gazed around, that it did one good & seemed to breathe freedom & peace, making one forget the world & its sad turmoil'.[53]

Giles was probably introduced to the Queen during the royal couple's visit of 1848, as she commissioned him to paint two oil paintings, of Balmoral and Lochnagar (nos 45, 46) as Christmas presents for Prince Albert, together with five watercolours. The following year Giles encountered difficulties with his royal patron when the Queen asked him to paint three more views of the surrounding area, as records of happy expeditions she had made to these places. She was very specific about the viewpoints for the three landscapes, which Giles did not always think most suitable and which were not easy to work from, but he wryly observed: 'Royal orders must be obeyed'.[54]

Away from the private pleasures of Balmoral, Prince Albert engaged with the art establishment in

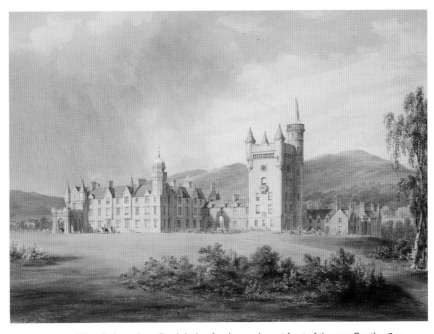

FIG. 19. James Giles, *Balmoral: realized design for the south-east front of the new Castle*, 1853. Watercolour and bodycolour. RCIN 452813

Edinburgh when he laid the foundation stone for the new National Gallery in 1850. The designer was William Henry Playfair (1790–1857), Scotland's leading architect, and the site for the building lay in the heart of the city, to the south of Playfair's existing elegant, classical-style Royal Institution.[55] In his address at the ceremony, the Prince described the prospective building as 'a temple to be erected to the Fine Arts' and expressed his hope that 'the impulse given to their culture in this country … will not only tend to refine and elevate national taste but will also lead to the production of works which will give the after generations an adequate idea of our advanced state of civilization.'[56] Queen Victoria, who was not present at the occasion but remained with her young children at Holyroodhouse, wrote in her Journal: 'everything having gone off beautifully, thousands of people there, 70 000 tickets having been sold'.[57] Opened in 1859, Playfair's new building, which was to house both the National Gallery and the Royal Scottish Academy, complemented the adjacent Royal Institution; both were set against the dramatic backdrop of Edinburgh Castle.[58]

In November 1851 Prince Albert purchased the Balmoral estate outright and made plans to demolish the old house and build a new, larger castle nearer the river Dee, with a better outlook. The Aberdeen architect William Smith (1817–91) drew up designs in close collaboration with the Prince. He asked James Giles, who had already painted views of the exterior of the old house, to make drawings of the proposed elevations of the new castle in order to give the royal couple an impression of its finished appearance (fig. 19). The royal family took up residence in the new castle in the summer of 1855 and visited regularly throughout the rest of Queen Victoria's reign.

Whilst at Balmoral the Queen and Prince Albert enthusiastically immersed themselves in their interpretation of Highland culture. The kilt was obligatory for all male retainers; the royal couple designed their own Balmoral tartan, worn by the royal family when in residence. Tartan was used extensively throughout the castle for carpets, curtains and upholstery (fig. 20). Paintings by the English artist Landseer, such as *The Highlander* of 1850 (fig. 21), reflected the royal view of the Highlands as a wild and romantic place, populated by kilted clansmen, and confirmed an image of Scotland that was presented to the rest of Britain. The royal family considered Balmoral a place for outdoor pursuits, free from the social constraints of other royal residences, as depicted by the Bavarian artist Carl Haag (1820–1915) in *Evening at Balmoral Castle: the stags brought home* (RCIN 451255).

James Giles's last commission was to record the interiors of the old castle before its demolition in 1855 (RCINs 919470–3). However, the Queen was dissatisfied with the size of his finished watercolours and Giles's

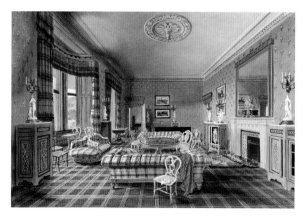

FIG. 20. James Roberts, *Balmoral: the Drawing Room*, 1857. Pencil, watercolour and bodycolour. RCIN 919477

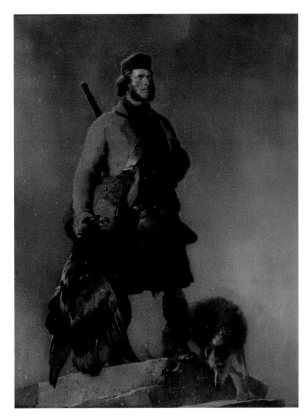

FIG. 21. Sir Edwin Landseer, *The Highlander*, 1850. Oil on canvas. RCIN 401515

exasperation with the Queen's demands led him to charge a high price which he knew would be viewed as unacceptable. He was not invited to work for the royal family again. Giles's reaction to his royal commissions was one of bitter disappointment, as he noted in his diary: 'I would much rather not work to Royalty. I never made anything but a loss by it.'[59]

The Glaswegian William Leighton Leitch (1804–83) was Queen Victoria's drawing master from 1846, one of a number of artists who taught her drawing through-out her life. Leitch first came to the notice of the Queen through one of her ladies-in-waiting, Charlotte,

Viscountess Canning (1817–61), and he continued to teach the Queen and her children until 1865. He also produced a number of watercolours of Scotland for the Queen, including a series commemorating places she visited on her first trip to the country in 1842 (no. 50). Many of Leitch's watercolours were mounted in the Queen's Souvenir Albums as records of places visited. Leitch often accompanied the royal family to both Balmoral and Osborne, and at his retirement at the age of 61 he was given a pension by the Queen. On hearing of his death, the Queen described him as 'dear old Mr Leitch, my kind drawing master, such an excellent artist'.[60]

There were fewer additions to the Royal Collection of Scottish art after Prince Albert's death in 1861. However, one of Queen Victoria's most important acts of patronage after this date was to commission the watercolour artist and miniature painter Kenneth MacLeay to paint a set of watercolours of her favourite Scottish retainers. MacLeay, from Oban, had been recommended to Queen Victoria by Sir Joseph Noël Paton, a fellow Scot; he had also come to the notice of Prince Alfred, Duke of Edinburgh, who had been impressed by MacLeay's work in an exhibition of Scottish art in honour of the Social Science Congress in Edinburgh in 1863. The Queen first commissioned from MacLeay portraits of Prince Alfred and Prince Leopold together with Prince Arthur, and then a series of large watercolour portraits of her Scottish retainers. These included her personal servant John Brown (fig. 22), the Head Keeper John Grant, underkeepers, ghillies, foresters and other servants (nos 57, 58). The project, which took several years, evolved into an extensive and detailed pictorial survey of Scottish clansmen. The watercolours were exhibited in London in 1869 and published the following year in two volumes of chromo-lithographs entitled *The Highlanders of Scotland*.[61]

FIG. 22. Kenneth MacLeay, *John Brown*, 1866. Watercolour. RCIN 920711

Several Scots were given official recognition through appointments at Court. There was often stiff competition for the most prominent post of Royal Painter and Limner in Scotland. Kenneth MacLeay had applied unsuccessfully for this in 1864, when the Queen decided in favour of Paton. Sir William Ross (1794–1860), who had strong Scottish connections, was appointed Miniature Painter to the Queen in 1837 and over the next twenty years went on to paint 140 miniatures and watercolours of Queen Victoria and her extended family (see nos 68–72). Edinburgh-born John Christian Schetky (1778–1874), who had been Marine Painter in Ordinary to both George IV and William IV,

continued in this post under Queen Victoria. Gourlay Steell (1819–94), also from Edinburgh, was appointed Animal Painter to the Queen in Scotland in 1874, in succession to Landseer (no. 54). His elder brother, Sir John Steell (1804–91), was Sculptor to the Queen in Scotland and designed the bronze equestrian memorial statue of Prince Albert in Edinburgh's Charlotte Square.

Although royal patronage of Scottish artists after Prince Albert's death was limited, some notable Scottish works entered the Royal Collection in 1888, on the occasion of the opening of the Glasgow International Exhibition of Science, Art and Industry. This exhibition, held in Kelvingrove Park, was one of a series of international exhibitions and world fairs that dominated the cultural scene in the second half of the nineteenth century and was the largest to be held in Scotland. The exhibition was opened by the Prince of Wales, as honorary President, on 8 May 1888; the Lord Provost presented the Prince and Princess of Wales with 'two elegant albums of paintings by members of the Glasgow Art Club', and in doing so expressed the hope that they would form a suitable memento of the day's proceedings, containing as they did specimens of the drawings of about thirty members of the club'.[62] The main exhibition building, over a quarter of a mile in length and occupying around 14 acres, was in the form of a Moorish palace and its appearance was commemorated in one of the watercolours in the Glasgow Art Club gift (fig. 23). The albums also included work by Sir James Guthrie (1859–1930; no. 62), E.A. Walton (1860–1922; no. 63), Robert Macaulay Stevenson (1860–1952; no. 64) and William Kennedy (1860–1918; fig. 24).[63] All were members of the Glasgow Art Club, founded in 1867, and part of the group known as the Glasgow Boys, who had studied in Scotland and spent time on the Continent and were committed to painting in the open air.

FIG. 23. James Sellars, *Grand Entrance, International Exhibition, Glasgow 1888*, 1888. Watercolour. RCIN 922845

FIG. 24. William Kennedy, *Afternoon camp in Stirling*, 1888. Watercolour. RCIN 922822

At the very end of the nineteenth century the Edinburgh artist Sir William Quiller Orchardson (1832–1910) was commissioned by the Royal Agricultural Society to paint a large canvas entitled *Four Generations: Queen Victoria and her Descendants*, depicting Queen Victoria; her son, the Prince of Wales (later King Edward VII); her grandson, the Duke of York (later King George V); and her great-grandson, Prince Edward of York (later King Edward VIII) (Government Art Collection, London, 0/632).[64] Orchardson had a number of sittings and prepared several studies for the painting, five of which were probably acquired at the time by the Prince of Wales or Duke of York (no. 65).[65] This final image of the royal family of the nineteenth century, by a Scottish artist, looks to both the past and the future.

The Royal Family's interest in Scottish art has continued during the twentieth and twenty-first centuries. Queen Elizabeth The Queen Mother was presented with a magnificent clock by John Smith of Pittenweem (1770–1816) on the occasion of her marriage in 1923 (no. 79), and she acquired some notable oil sketches by Wilkie (nos 22, 24) and a painting by the Perthshire artist David Farquharson (1839–1907; no. 56). The Queen also purchased a sketch by Wilkie in 1990 (no. 26). Prince Philip, Duke of Edinburgh, a keen amateur artist, is an Honorary Member of the Royal Scottish Academy and, since 1958, has been a regular visitor to the RSA's Annual Exhibition. He has over the years acquired an extensive collection of pictures by modern Scottish artists to hang at the Palace of Holyroodhouse, including works by Dame Elizabeth Blackadder, the current Royal Limner (b. 1931), James Morrison (b. 1932) and Victoria Crowe (b. 1945). His Royal Highness's comment that 'Scotland seems to have been particularly favoured with artists of talent and temperament' helps to explain why the work of Scottish artists has proved so popular with several generations of the royal family.[66]

1 See Anderson 2014–15, pp. 7–13; Edinburgh 1989, pp. 18–20; Edinburgh 1982, p. 14.

2 Letter to Sir Horace Mann, 1 November 1760; Walpole 1937–83, XXI, p. 449.

3 For further details of Ramsay and Lord Bute see Edinburgh 1989, pp. 123–138.

4 Portland MSS, University of Nottingham, PWF 8031; quoted in Smart and Ingamells 1999, p. 111.

5 Cunningham 1829–33, V, p. 39.

6 Walpole 1937–83, XV, p. 47

7 Quoted in Smart 1992, p. 182.

8 For a full list see Smart and Ingamells 1999, pp. 112–22.

9 Quoted Edinburgh and London 1992–3, p. 134.

10 Cunningham 1829–33, V, p. 39.

11 Aspinall 1962–70, I, no. 674.

12 George IV acquired a group of 86 Dutch and Flemish paintings from Sir Thomas Baring (1772–1848), most of which were collected by Sir Thomas's father, Sir Francis Baring (1740–1810); they arrived at Carlton House on 6 May 1814.

13 Benjamin West to Lt Gen Turner, 27 July 1813; NLS, MS 9835 f.71.

14 Cunningham 1843, I, p. 378.

15 Wilkie to his sister, 17 May 1813; Cunningham 1843, I, p. 379.

16 Cunningham 1843, II, p. 9.

17 [Scott] 1822, pp. 7, 17

18 Edinburgh 1961, p. 4.

19 The term was coined by Scott; see Prebble 2000, p. 49.

20 Two sketchbooks, 'The King in Edinburgh' and 'The King's Visit to Scotland', and two oil studies are in Tate (CC, CC1, NO 2857, NO 2858); see London 1981.

21 Wilkie to Perry Nursey, 20 November 1822; quoted in Edinburgh 1975, p. 15

22 Cunningham 1843, II, p. 89.

23 Lockhart 1837, V, p. 203. The King's Highland Dress was supplied by George Hunter & Co. of Princes Street, Edinburgh, for a total of £1,354 18s; see Norman 1996–7; Cunningham 1843, II, p. 86

24 Letter from William Adam to T.C. Mash, 19 August 1822 (NRS RH4/446.4). See also [Scott] 1822, p. 8.

25 Cunningham 1843, II, p. 89

26 Letter from Sir Robert Peel, quoted in Edinburgh 1997, p. 212.

27 Letter to Robert Liston, 29 April 1829; NLS, MS 5679 f.39.

28 Letter to Sir Willoughby Gordon 28 August 1823; NLS, Acc. 7901.

29 Cunningham 1843, II, p. 423.

30 Cunningham 1843, II, p. 524.

31 Cunningham 1843, III, p. 10.

32 Letter from Sir William Knighton, 11 December 1831; NLS, Acc. 7972.

33 Journal, 12 November 1847. Queen Victoria's Journal survives in the Royal Archives in an edited manuscript copy by Princess Beatrice. It contains many references to artists and sittings. The text of the Journal can now be found online at http://www.queenvictoriasjournals.org/home.do.

34 For a full discussion of Queen Victoria and Prince Albert as patrons of the arts see London 2010.

35 Journal, 23 and 25 April 1839.

36 Journal, 9 August 1845.

37 By 1847 there were 24 early Italian paintings hanging at Osborne. See London 2010, p. 24.

38 Quoted in Pointon 1979, p. 94; for a discussion see pp. 93–5

39 Dyce to Sir Charles Eastlake, Dyce Papers XXII; quoted in Pointon 1979, p. 103.

40 Journal, 29 September 1847

41 Journal, 3 February 1848.

42 Journal, 1 May 1856.

43 Journal, 25 February 1863.

44 Journal, 26 March 1867.

45 Journal, 10 May 1859.

46 RA VIC/ADDA3/72.

47 Quoted in Guiterman 1990, p. 48; for correspondence relating to this commission see pp. 45–50.

48 Journal, 31 October 1852.

49 Journal, 3 May 1860.

50 Scotsman, 1 March 1967. Fulford 1971, p. 125.

51 22 September 1858; RA Z.7/11

52 13 September 1848; RA Y93/48/

53 Journal, 8 September 1848.

54 James Giles diary, 3 January 1849; Mr. T.A.S. MacPherson, great-grandson of James Giles, kindly allowed access to Giles's diary.

55 The Institution for the Encouragement of Fine Arts in Scotland was founded in 1819 to promote artistic enlightenment through loan exhibitions. The building, designed by Playfair, opened in 1826. In 1835 the Scottish Academy (granted its 'royal' charter in 1838) was given permission to lease some of the galleries in the Institution building. See Gordon 1976, pp. 12–16, 59–60, 174.

56 Scotsman, 31 August 1850.

57 Journal, 30 August 1850.

58 The Royal Scottish Academy moved to the Institution building in 1910. The Institution was thereafter known as the Royal Scottish Academy.

59 James Giles diary, 8 December 1855

60 Journal, 28 April 1883.

61 See Smailes 1992, pp. 14–17.

62 Scotsman, 9 May 1888, p. 10.

63 See Millar 1995, p. 29, where it is suggested that the albums may have been bound in one volume at a later date.

64 Exhibited at the Royal Academy of Arts in 1900, as Windsor Castle 1899: Portraits (no. 143).

65 See Millar 1995, p. 668.

66 HRH Duke of Edinburgh, 'Foreword', in Gordon 1976.

CATALOGUE

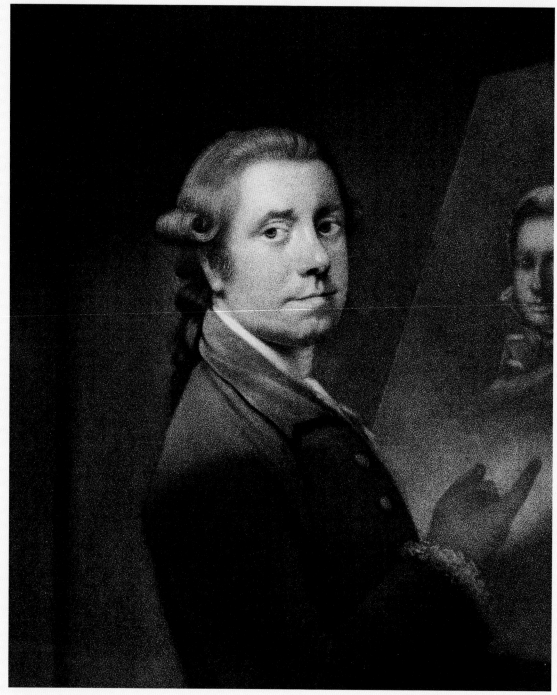

FIG. 25. Abraham Wivell after Allan Ramsay, *Allan Ramsay, Esq.* (detail), 1820. Mezzotint. RCIN 660610

Allan Ramsay (1713–1784)

'Elegant, accomplished man of the world'
—Alan Cunningham, *The Lives of the Most Eminent British Painters,* 1829–33

It was during the lifetime of Allan Ramsay that Scottish artists began to enter the European mainstream and Ramsay was foremost among them. A Scottish artist of European importance, he established himself as the leading portrait painter of his day, his excellence recognised by his appointment as painter to the King. He was also a pre-eminent figure in the Enlightenment, the intellectual climate that flourished all over Europe, including Scotland, in the eighteenth century. Scotland's distinctive society produced an extraordinary number of enquiring minds and Edinburgh, Ramsay's place of birth, emerged as the centre of the Scottish Enlightenment. His remarkable portraits of intellectual and aristocratic society, together with those of the royal family, can be seen as embodying some of the central preoccupations of the Enlightenment: an intense study of material reality allied to a sympathetic response to the individuality of the sitter. While Ramsay was very much a product of his Edinburgh upbringing he, more than any other artist of the period, also drew inspiration from the wider European cultural scene, fusing Italian and French influences into his distinctive and graceful art.

Ramsay was the son of poet and bookseller Allan Ramsay, who encouraged his artistic talent from an early age. He undertook some training from 1729 at Edinburgh's Academy of St Luke, which his father had helped set up, and then studied further in London in 1732. On his return to Scotland he established his own practice in Edinburgh as a portrait painter. In 1736 he travelled to Italy via Paris for the first of his continental tours, where he studied with the painters Francesco Imperiali (1679–1740) in Rome and Francesco Solimena (1657–1747) in Naples. He returned in 1738 to establish himself as a portrait painter in London and within a year his practice in Covent Garden was flourishing. He was frequently employed to portray the Scottish nobility: sitters included the Duke of Buccleuch, the Duke of Argyll and the Duchess of Montrose. He continued to maintain a studio in Edinburgh and to retain important connections in Scotland, many of which would remain significant throughout his career.

He played a leading role in the intellectual life of the time, both in London and Edinburgh. Prior to a second visit to Italy in 1754 he spent some months in Edinburgh, where he founded a debating society, the Select Society. This was to become 'the most important circle of intellectuals in Scotland' and can be seen as significant in the wider European Enlightenment.[1] Ramsay executed around forty portraits in his Edinburgh studio at this time, including those of a number of the leading figures of intellectual and artistic society, such as David Hume (fig. 26), the architect James Adam (also a member of the Select Society) and his mother, Mary (widow of leading Scottish architect William Adam and mother also of Robert and John). These portraits combine powerful characterisation with elegance reminiscent of French painting. At the same time Ramsay was writing *A Dialogue on Taste*, published in 1755, in which he identified 'naturalness' as a desirable

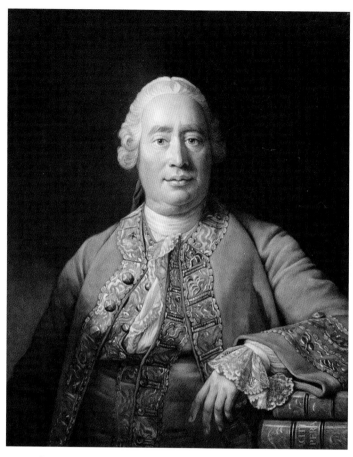

FIG. 26. David Martin after Allan Ramsay, *David Hume, Esq.* (detail), 1767. Mezzotint. RCIN 656741

quality in art, commending the naturalism of the French painter and pastellist Maurice-Quentin de La Tour.

Late in 1754 Ramsay departed once again for Italy, where he remained for two and a half years. Here he studied painting and enrolled at the French Academy in Rome. He was joined by Robert Adam, who observed that Ramsay was 'pretty generally known and regarded'.[2]

On his return to London in 1757 Ramsay purchased a house in Soho Square, where he set up a studio. Despite the fact that, during his absence, the young Joshua Reynolds had established himself as a competitor in the field of portraiture, Ramsay re-established the successful practice he had left over four years before. It was shortly after his return from Italy that he attracted the

attention of fellow Scot Lord Bute, who commissioned him to paint the Prince of Wales, the future George III, in 1757. Following the accession of George III in 1760, Ramsay went on to produce some of his most distinguished and elegant work for the royal family (see pp. 10–13 and nos 1–5). While he was working on royal commissions, Ramsay was at the same time earning a reputation for more direct and intimate portraits, particularly of women, such as of Mrs Anna Bruce of Arnot of 1765 (SNG, NG 946). His soft, delicate palette and close affinities with French painting can also be seen in his portrait of *Queen Charlotte with her Two Eldest Sons* (no. 2).

Ramsay continued to maintain a studio in Edinburgh and made regular visits to the city throughout his life, spending much time and energy on the upkeep of his properties on Castle Hill. Always proud of his Scottish birth, he insisted that his children, although brought up in England, should consider themselves Scots. He continued to be a notable figure in intellectual circles of London and Edinburgh and maintained his philosophical interests and friendship with David Hume. This culminated in the portrait of Hume (SNPG, PG 1057) and of the French philosopher of the Enlightenment Jean-Jacques Rousseau (1712–78), which he painted for Hume in 1766 (SNG, NG 820).[3] He continued to receive commissions from the royal family, most particularly from Queen Charlotte (nos 4, 5), but his career as a painter essentially came to an end in 1773, when he severely injured his right arm in an accident.

Some of Ramsay's pupils were to have significant influence on Scottish painting in later years. His first assistant, David Martin, entered his studio as a boy in 1752 and joined him in Rome in 1755. Martin spent much time making copies of the state portraits and later set up his own practice in Edinburgh. Here he did much to preserve the 'natural' tradition established by Ramsay and became Edinburgh's leading portrait painter until he was superseded by Raeburn in the 1790s. The most celebrated of Ramsay's pupils was Alexander Nasmyth (1758–1840), who attained distinction particularly as a landscape painter (see no. 27). Nasmyth's early training was at the recently founded Trustees' Academy in Edinburgh; in 1774 he commenced his apprenticeship under Ramsay, who had retired from painting, and (in the words of Nasmyth's son James) was 'exceedingly kind to his young pupil'.[4]

1. Emerson 1973, p. 291; the first meeting, on 22 May 1754, had 15 attendees. By February 1755 the number of members had increased to 83.
2. Fleming 1962, p. 174.
3. For a discussion of these paintings see Glasgow 2013–14, pp. 36–41
4. Nasmyth 1885, p. 24.

1 Allan Ramsay
George III (1738–1820), 1761–2

Oil on canvas
249.5 x 163.2 cm
RCIN 405307

PROVENANCE
Commissioned by George III.

REFERENCES
Millar 1969, no. 996; Smart 1992, pp. 152, 161–6, 173, 214–15; Simon 1994, pp. 451–5; Smart and Ingamells 1999, p. 9, no. 192; London 2004, no. 3.

George III succeeded to the throne on 25 October 1760, on the death of his grandfather George II (r. 1727-60); his coronation took place at Westminster Abbey on 22 September 1761. Ramsay has depicted the young King in sumptuous coronation robes worn over a coat and breeches of cloth of gold.[1] Ramsay had already painted a full-length portrait of him in 1757, as Prince of Wales, for Lord Bute. The success of that portrait led to this major commission, despite the fact that due to an oversight Ramsay was not appointed Principal Painter in Ordinary on the King's accession and John Shackleton was reappointed to the post (see pp. 11–12). Ramsay wrote in 1766: 'I painted, from the life, a whole length picture of him for Hanover, a profile for the coinage, and another whole length which after the Coronation, I, by his Majesties orders dressed in Coronation robes.'[2] Horace Walpole recorded seeing the painting in March 1762, 'painted exactly from the very robes which the king wore at his coronation'.[3]

This painting of the King is the prime version of the state portrait in coronation robes, painted for St James's Palace.[4] Shortly afterwards, Ramsay painted the companion portrait of Queen Charlotte (fig. 4). Ramsay was responsible for producing the numerous copies of the state portraits: the demand was immense, from members of the royal family, sovereigns, heads of state, colonial governors, ambassadors, corporations, institutions and courtiers. Orders for 150 pairs, 26 of the King alone and 9 of the Queen alone, are listed.[5] Ramsay resolved to 'give the last painting to all of them with my own hand' but employed several assistants, of whom the best were the Scottish artists David Martin and Philip Reinagle.

1. George III's coronation robes were supplied by Ede and Ravenscroft. See Campbell 1989, p. 35.
2. Portland MSS, University of Nottingham, PWF 8031; quoted in Smart and Ingamells 1999, p. 111.
3. Walpole 1937, V, p. 56.
4. Millar 1969, p. 93; Simon 1994, p. 451; Smart and Ingamells 1999, p. 112. See Smart and Ingamells 1999, p. 89 for discussion.
5. A full list is given in Smart and Ingamells 1999, pp. 112–21.

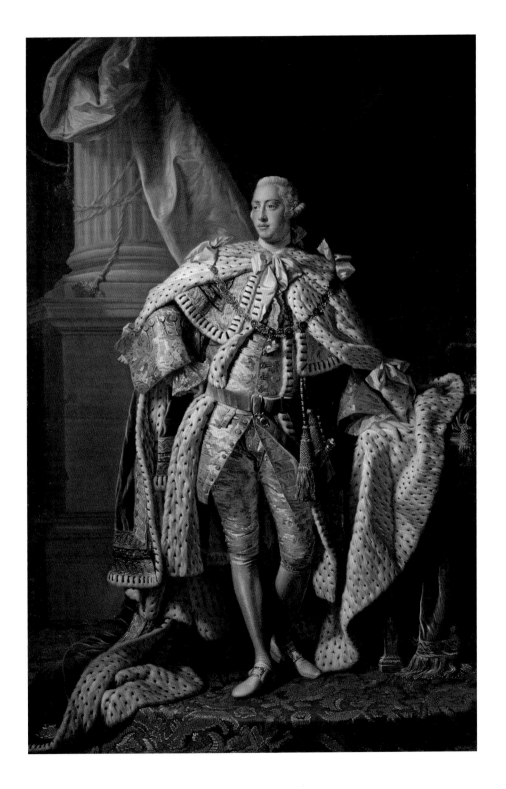

2 Allan Ramsay
Queen Charlotte with her Two Eldest Sons, c.1764-9

Oil on canvas
247.8 x 165.0 cm
RCIN 404922

PROVENANCE
Probably painted for George III or Queen Charlotte.

REFERENCES
Millar 1969, no. 998; Smart 1992, p. 184; Edinburgh and London 1992–3, no. 86; Simon 1994, p. 451; London 1998, no. 13; Smart and Ingamells 1999, p. 9, no. 87; Tite 2001, pp. 1, 5, 7; Retford 2006, pp. 104, 191; Hanover 2014, no. 218.

Queen Charlotte is shown seated with Prince Frederick (b. 1763), later Duke of York, on her lap and Prince George (b. 1762), the future George IV, at her side, in a grand palace interior. The splendour of the architecture contrasts dramatically with the intimate family group surrounded by domestic objects, such as a work basket and children's toys. The portrait displays a debt to the paintings of Sir Anthony Van Dyck, in particular his *Charles I and Henrietta Maria with their Two Eldest Children* of 1631 (RCIN 405353), which combines the dignity required of a royal portrait with the naturalness of a family group. In fact, on completion, Ramsay's portrait was placed in the King's Gallery, Kensington Palace, where Van Dyck's painting was hanging.[1] The elegance, subtlety and exquisite colouring of the painting also reveal his interest in contemporary French portraiture, and the imposing architectural setting recalls the state portraiture of Carle Vanloo (1705–65), First Painter to King Louis XV, and his nephew Louis-Michel (1707–71). The two French artists met Ramsay on a visit to London in 1764.

The Queen is seated beside a spinet, on which lies a copy of John Locke's *Some Thoughts Concerning Education* (1693). The book, which was widely read for its advice to parents on raising children, is a reminder that the King and Queen were taking note of Locke's belief that education was the crucial formative influence, not only for the individual but also for the nation. The toys, such as the bow and arrow held by Prince George and the toy drum, demonstrate that the royal couple enjoyed the company of their children and watching them at play.[2]

The sitters are painted on three separate pieces of canvas that have been joined together. This was part of Ramsay's normal procedure when painting the royal family, as etiquette demanded that sittings take place in one of the royal residences. This allowed him to take the initial likeness from life before completing the painting in his studio. There are many preparatory studies for this painting, including one showing that Ramsay planned the final composition from the start (SNG, D 2149). The ages of the two princes indicate that the portrait was begun in 1764, although Ramsay appears not to have been paid until 1769, when a payment from the Privy Purse records 'Paid Mr Ramsay Painter for a picture of the Queen with [the] Prince of Wales & Prince Frederick'.[3] It is possible that there was some delay in completing the picture; early accounts relate, rather improbably, that the young Prince George grew and changed so quickly during the course of the commission that he is represented as both the baby and the young boy.[4]

1. See Tite 2001, p. 5.
2. See Millar 1969, p. xiv.
3. RA GEO/MAIN/17216.
4. Croly 1891, p. 252; Pyne 1819, I, p. 100, cited in Edinburgh and London 1992–3, p. 140.

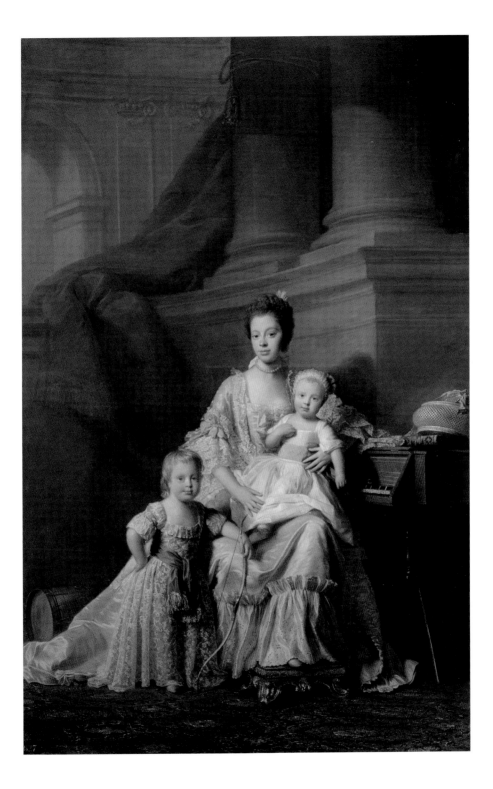

3 Allan Ramsay
Prince William, later Duke of Clarence (1765–1837), c.1767

Oil on canvas
128.3 x 97.8 cm, including an addition on the right of about 3.8 cm
RCIN 404924

PROVENANCE
Presumably painted for George III or Queen Charlotte.

REFERENCES
Millar 1969, no. 999; Smart 1992, p. 230; Edinburgh and London 1992–3, no. 95; Smart and Ingamells 1999, no. 539.

Prince William, Duke of Clarence, was the third son of George III and Queen Charlotte and succeeded to the throne as William IV in 1830 on the death of his brother, George IV. This portrait was probably painted in 1767, when the Prince was about two years old; he is shown as a lively baby, beating a drum decorated with the royal cipher, in an otherwise quiet and elegant setting. On the table behind him are two Worcester porcelain tea bowls and saucers and a cream jug together with an English silver-gilt tea urn.[1] The meticulous painting of these items is particularly subtle and in harmony with the soft half-light of the scene as a whole. It shows the artist's continual interest in French portraiture, particularly the work of Maurice-Quentin de La Tour and Jean-Marc Nattier, in whose paintings such domestic details are often to be found.

The young prince is shown wearing 'coats', the type of long dress worn by young boys at this time. The picture has been described as 'one of the most charming of eighteenth-century depictions of children'.[2] The portrait was formerly attributed to Johann Zoffany, until it was identified as the 'Portrait of his Royal Highness the Duke of Clarence, when a child, painted by Ramsay', which formerly hung at Frogmore House.[3] As with other portraits by Ramsay, the head was painted on a separate canvas and set into the larger canvas. Payment for this portrait may have been included in the sum of £152 5s, which Ramsay was paid on 3 February 1769 'for other portraits'.[4]

1. The Worcester porcelain, *c.*1765, was identified by Errol Manners. The tea urn was probably made in London, *c.*1767, by Thomas Whipham and Charles Wright (identified by Kathryn Jones and Timothy Schroder); there are similar examples in the Philadelphia Museum of Art and the Huntington Library, Art Collections and Botanical Gardens. Information kindly supplied by Jeannie Chapel.
2. Smart 1992, p. 230.
3. Identified by Oliver Millar, see Millar 1952, p. 268; Pyne 1819, I, p.19
4. RA GEO/MAIN/17216.

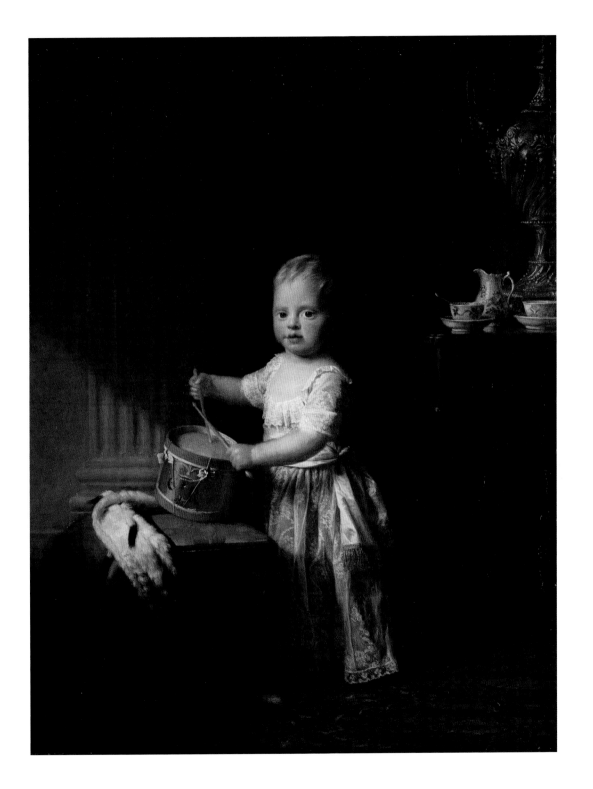

4 Allan Ramsay
Prince George Augustus of Mecklenburg-Strelitz (1748–1785), 1768–9

Oil on canvas
127.3 x 101.6 cm
RCIN 406963

PROVENANCE
Presumably painted for Queen Charlotte.

REFERENCES
Millar 1969, no. 1000; Simon 1987, p. 142; London 1991a,
no. 60; Smart 1992, p. 230; Smart and Ingamells 1999, no. 190.

Prince George Augustus was the son of Prince Karl I,
Duke of Mecklenburg-Strelitz, and Princess Elizabeth
Albertina (no. 5), and the younger brother of Queen
Charlotte. He visited London between November 1768
and August 1769 and it was probably during this time
that his portrait was painted by Ramsay. The Prince is
depicted standing in woodland and resting the tricorn hat
in his right hand on a rocky ledge. He wears the uniform
of an officer of the Cuirassiers of the 4th Regiment of
Austrian-Salzburg Dragoons, or 'Serbellonis', of which
he was later Colonel from 1778 to 1786. He attained the
rank of Major General in the Austrian Army.

The head and shoulders have been painted on to a
separate piece of canvas that has been set into a larger
piece. This practice, much favoured by Ramsay, is also
evident in *Queen Charlotte with her Two Eldest Sons*
(no. 2) and *Prince William* (no. 3). A preparatory chalk
drawing, in the Scottish National Gallery (D.2043),
indicates that Ramsay always planned this portrait as a
three-quarter length. On 3 February 1769 he was paid
145 guineas 'for other Portraits', which probably
included this one.[1]

1. RA GEO/MAIN/17216.

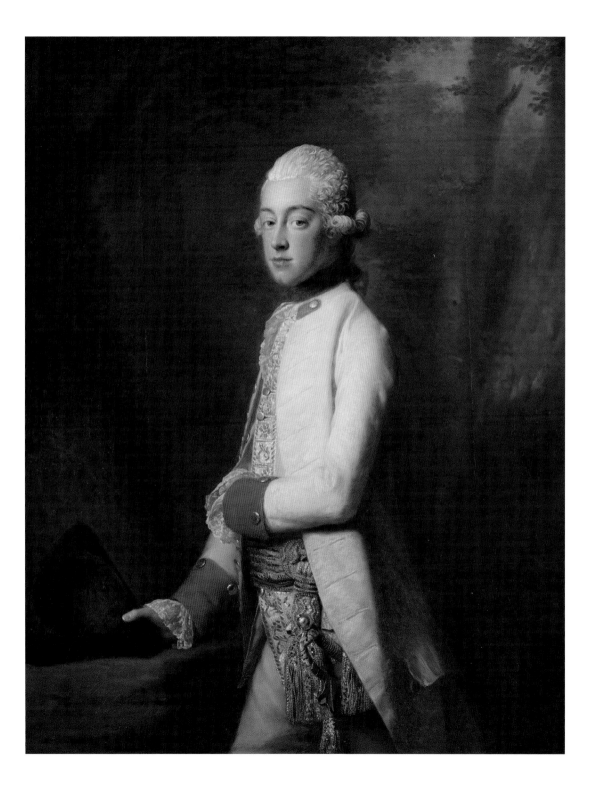

5 Allan Ramsay
Princess Elizabeth Albertina, Duchess of Mecklenburg-Strelitz (1713–1761), c.1769

Oil on canvas
127.3 x 101.6 cm
RCIN 403553

PROVENANCE
Probably painted for Queen Charlotte.

REFERENCES
Millar 1969, no. 1001; Smart 1992, pp. 230, 232; Edinburgh and London 1992–3, no. 99; Smart and Ingamells 1999, no. 153.

Princess Elizabeth Albertina, Queen Charlotte's mother, was the daughter of Ernest Frederick, Duke of Saxe-Hildburghausen and wife of Prince Karl I of Mecklenburg-Strelitz. This is a posthumous portrait, as Princess Elizabeth Albertina died in 1761, before her daughter Charlotte left for England to marry George III. Queen Charlotte probably commissioned Ramsay to paint this portrait of her mother to hang with other portraits of her family, including those of her brothers, Prince George of Mecklenburg-Strelitz, also by Ramsay (no. 4), and Prince Ernest Gottlob Albert of Mecklenburg-Strelitz by Johann Zoffany (RCIN 406813).

The Princess is shown holding a fan in her hands, her left elbow resting on a marble-topped table. She wears a blue dress decorated with lace, a black stole around her head and diamonds in her hair. Some of the features in this portrait, such as the face and hairstyle, were probably based on a painting of the 1740s by the German artist Daniel Woge (1717–97) in the Royal Collection (RCIN 402454).

Painted around 1769, this portrait is a good example of Ramsay's late style, in which the rich colouring shows his attraction to the work of contemporary French artists such as Nattier. A beautiful chalk drawing of the arms and the fan (fig. 27) suggests that Ramsay worked hard on the elegance and liveliness of the posture to make up for the absence of a living model for the face.

FIG. 27. Allan Ramsay, *A Lady's Right and Left Hand with a Fan*. Study for *Elizabeth Albertina, Princess of Mecklenburg-Strelitz (1713–1761)*, c.1769. Red chalk, heightened with white on buff paper. Scottish National Gallery D 2076 A

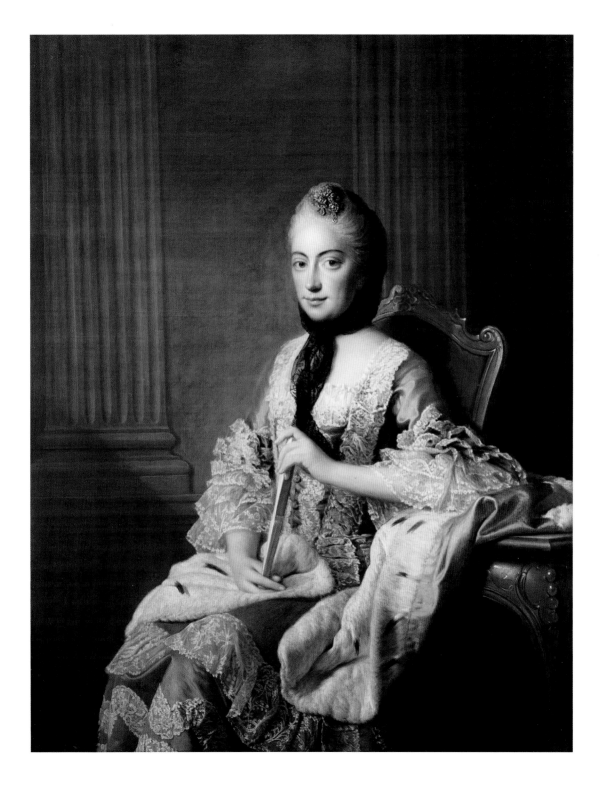

Robert Adam (1728–1792)

6　*General Design of a Transparent Illumination, proposed to have been Executed in the Queen's Garden in Honour of His Majesty's Birth Day. The 4th June 1763*, 1763

Pencil, pen and ink and watercolour
48.0 x 125.0 cm
Signed: *Robt. Adam Architect*
RCIN 917643.a

PROVENANCE
Made for Queen Charlotte.

REFERENCES
Oppé 1950, no. 18; London 2004, no. 95.

7　*Design of a Bridge Illuminated in Honour of His Majesty's Birth Day, The 4th June 1763. By Order of Her Majesty*, 1763

Pencil, pen and ink and watercolour
48.0 x 63.5 cm
Signed: *Robt. Adam Architect*
RCIN 917643.c

PROVENANCE
Made for Queen Charlotte.

REFERENCE
Oppé 1950, no. 20.

Son of the prominent Scottish architect William Adam, Robert Adam was educated in Edinburgh's enlightened intellectual circles. He joined his father's practice in 1746 and, on William's death, ran it with his two brothers, John and James. Like his friend Allan Ramsay, he travelled to Italy to continue his studies and, also like Ramsay, he owed his introduction to the King to fellow Scot Lord Bute. Adam became one of the most successful and fashionable architects of the time, his designs combining classical inspiration with delicate decorative features. In 1761 he was appointed, with William Chambers, joint Architect to the Board of Works by George III.

These two designs are from a set of four by Adam for fireworks and illuminations for George III's 25th birthday on 4 June 1763. The larger design is a proposal for a temporary structure to be erected in the grounds of Buckingham House, purchased the previous year, which also marked the start of royal occupation of the house. In the event, Adam's design for a simpler structure was used. The illuminations were planned by Queen Charlotte as a surprise for the King: four thousand lamps were lit for the party at night.

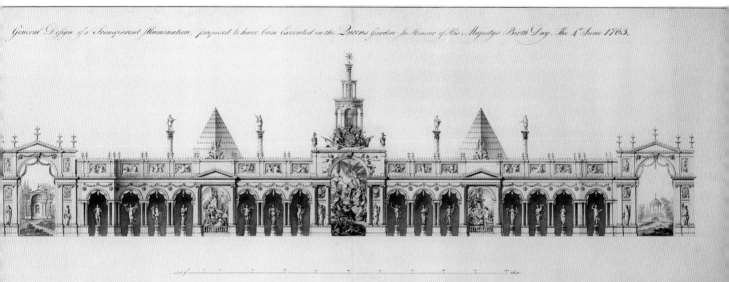

General Design of a Transparent Illumination, proposed to have been Executed in the Queens Garden in Honour of His Majestys Birth Day, The 4th June 1763.

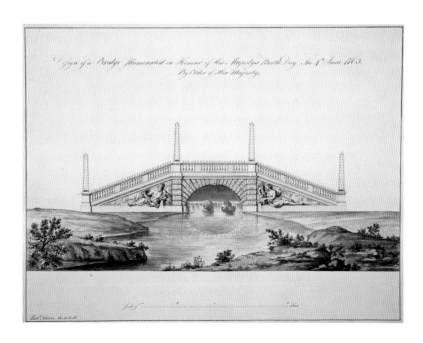

Design of a Bridge Illuminated in Honour of His Majestys Birth Day, The 4th June 1763.
By Order of Her Majesty.

8 David Allan (1744–1796)
The Romans Polite to Strangers, Palazzo Ruspoli al Corso Rome, c.1775

Pencil, pen and brown wash
38.5 x 53.8 cm
Signed: *D. Allan del.*
RCIN 913358

PROVENANCE
Acquired by George IV when Prince Regent on 23 March, 1812.

REFERENCES
Oppé 1950, no. 22; Edinburgh and London 1986–7, no. 78.

David Allan was born in Alloa and attended the Foulis Academy in Glasgow for seven years. In 1767 he moved to Rome, where he stayed for ten years and studied with Gavin Hamilton (1723–98), painting ambitious historical pictures, portraits, caricatures and genre scenes. On returning to London in 1777 he spent two years trying to establish himself before finally settling in Edinburgh. Allan specialised in painting family groups; he also produced book illustrations and was appointed Master of the Trustees' Academy in Edinburgh in 1786.

This drawing is one of a group of ten in the Royal Collection by Allan showing scenes from the Carnival in Rome (see RCINs 913351–6 and no. 9). In all of the drawings, the architecture is reversed, implying that Allan executed them as designs for engravings. In 1780 Allan informed Sir William Hamilton that drawings of the Carnival which he had made in 1775 had been purchased by Paul Sandby, who 'executed them charmingly in aquatinta prints'.[1] Only four aquatints by Sandby are known, however, which were published with an accompanying introduction in 1780–81 (BM, 1904,0819.759); this drawing was the subject of the second of the four prints. It is unclear whether Allan made these designs expressly to be engraved by Sandby. The Carnival drawings, still in Sandby's studio at the time of his death, were acquired by Colnaghi from the Sandby sale and purchased by the Prince Regent for 30 guineas in 1812.

1. Quoted in Crouther Gordon 1951, p. 32

The ROMANS Polite to STRANGERS
Palazzo Rufpoli al Corfo Rome

9 David Allan
Piazza Navona, Rome, c.1775

Pencil, pen and brown wash with touches of white bodycolour
37.0 x 52.5 cm
Signed: *D. Allan inv.t*
RCIN 913355

PROVENANCE
Acquired by George IV when Prince Regent on 23 March, 1812.

REFERENCE
Oppé 1950, no. 27.

This drawing of the Piazza Navona in Rome, with the *Fountain of the Four Rivers* (1648–51) by Bernini prominent in the middle distance and groups of figures in the foreground, is one of a group of ten by Allan of the Roman Carnival (RCINs 913351–60). They reveal his skill at portraying a variety of social classes and facial features in a lively manner. He exhibited five of the Carnival drawings at the Royal Academy in 1779. Allan finally settled in Edinburgh in 1779 and specialised in painting family groups.

PIAZZA NAVONA Rome.

FIG. 28. Sir David Wilkie, *Self-Portrait*, *c*.1804–5. Oil on canvas. Scottish National Portrait Gallery PG 573

Sir David Wilkie (1785–1841)

'Mr. Wilkie's pictures, generally speaking, derive almost their whole value from their reality, or the truth of the representation … his pictures may be considered as diaries, or minutes of what is passing constantly about us.'
—William Hazlitt, *Lectures on the English Comic Writers,* 1819

David Wilkie, born in Cults, Fife, and trained in Edinburgh, enjoyed even greater success in London than Allan Ramsay had done over half a century earlier (fig. 28). All the conventional rewards of a successful artistic career fell to Wilkie as he was appointed in succession a member of the Royal Academy (1811), His Majesty's Painter and Limner in Scotland on the death of Raeburn (1823), Principal Painter in Ordinary to the King on the death of Lawrence (1830), and knighted in 1836. Yet it was not until long after Wilkie's death that his principal legacy began to be seen in terms of the creation of an explicitly Scottish iconography in art, to match Sir Walter Scott's creation of a Scottish literary genre in the same era. His credentials as the founder of the 'fine old Scotch school', established by early twentieth-century commentators and art historians, would not have been recognised by Wilkie himself.[1] He cherished no concept of a Scottish school; from 1805 he lived and worked in London and, if anything, he regarded himself as belonging to 'the English school of the south'.[2] His paintings that depend entirely on Scottish literary or cultural influences, such as *The Penny Wedding* (no. 13), completed after his tour of Scotland in 1817, form only a part of Wilkie's overall output, which took on an increasingly international flavour from 1827 onwards.

Yet it was undoubtedly as the 'Scottish Teniers' that Wilkie gained his international reputation, with his scenes of everyday life reviving the tradition of genre painting in Europe.[3] The wide distribution of his work in print form spread his name both at home and abroad. Sir William Knighton, visiting the Munich printseller Artaria & Fontana in 1833, reported: 'I found many of the prints from Wilkie's works hung round his shop. There never was a modern artist held in such estimation as our Wilkie is on the Continent.'[4]

Prints after seventeenth-century Dutch masters, particularly those after Adriaen van Ostade, first served as a guide to the young Wilkie training at the Trustees' Academy in Edinburgh.[5] Once in London, however, he was exposed at first hand to the genre paintings of David Teniers the Younger; his handling and colouring altered significantly as a result. The artist James Northcote (1746–1831) commented that *The Village Politicians* (Scone Palace, Perth; exhibited Royal Academy 1806) must have been painted 'in a room filled with the pictures of Teniers'.[6] Private Old Master collections, such as the Stafford and Grosvenor collections, were on view for the first time to a select public in London in the early years of the nineteenth century; Wilkie also benefited from the Old Master Loan exhibitions at the British Institution from 1813. His 'first manner, when his style was founded on the Flemish and Dutch schools' chimed with the artistic preferences of his early patrons, collectors such as Sir George Beaumont (1753–1827), Henry Phipps, 1st Earl Mulgrave (1755–1831) and, later, Sir Robert Peel (1788–1850).[7] It also brought him to the attention of the Prince Regent,

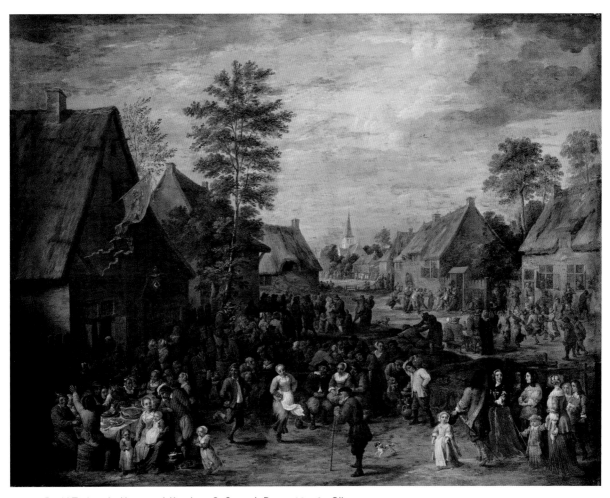

FIG. 29. David Teniers the Younger, *A Kermis on St George's Day, c.*1664–67. Oil on canvas. RCIN 405207

whose predilection was for Dutch and Flemish pictures, just at the period when the Prince was embarking on his keenest period of acquisitions (fig. 29).[8]

High-profile commissions from the Prince Regent for *Blind-Man's-Buff* (no. 10) and *The Penny Wedding* (no. 13) sealed the artist's reputation, but his next royal commission almost proved his undoing. *The Entrance of George IV at Holyroodhouse* (no. 21) was undertaken in 1824, two years after the events it recorded. It coincided with a period of family tragedy and financial problems for Wilkie, and the difficulties he experienced in its execution may have contributed towards a nervous breakdown in 1825 which left him unable to work, and drove him abroad to recover.

Wilkie had travelled to the Continent twice before, to Paris in 1814 and the Low Countries in 1816. But this extended continental tour was to prove a turning point in his art. From July 1825 until late 1827 he was in Italy, where he saw the work of Correggio in Parma and, in Rome, immersed himself in the work of the masters of the High Renaissance, particularly Raphael, Michelangelo and Titian. He broke his return journey with a six-month spell in Madrid, where the works of Velázquez and Murillo had a profound impact on him. When, in 1826, he had recovered sufficiently to start painting again, his art was transformed, both in terms of style and subject matter. The comic elements and high finish which had been the mainstay of his scenes of everyday life had disappeared for good; instead, Wilkie explored the dramatic and the heroic on a new large scale and with a broader style to match.

Wilkie was only the first of a succession of Scottish artists to look for fresh subjects abroad. William Allan, John Phillip and David Roberts also made extended foreign tours in pursuit of new material, although none of them underwent such a transformation of their art as Wilkie. George IV's intervention was to prove critical in shaping the public response to this new style and in re-establishing Wilkie's artistic career after an absence of three years. The King's decision to buy two of his Italian pictures (nos 14, 15) and four of his Spanish ones (nos 16, 18–20) did not quieten all the artist's critics, but did go some way towards mitigating public criticism of his new style. One of George IV's last acts before his death was to appoint Wilkie to be his Principal Painter in Ordinary (1830). Wilkie was confirmed in the office by William IV and later by Queen Victoria, although Queen Victoria disliked both her state portrait of 1837 (LLAG, LL 3598) and Wilkie's *First Council of Queen Victoria* of 1838 (RCIN 404710).

In August 1840 Wilkie set out for the Holy Land, intending to gather material for biblical subjects. However, he did not survive the return journey from Jerusalem and died at sea on 1 June 1841. Wilkie's friend J. M. W. Turner recorded the artist's burial off Gibralter in his painting *Peace—Burial at Sea* (Tate, London; N00528).

1. Sickert 2003, p. 231.

2. Draft of a letter from Wilkie to the Duchess of Sutherland, Brighton, November 1831 (NLS 9836,45), quoted in Tromans 2007, p. 247.

3. Oxford 1985, p. 10; Raleigh 1987, p. 214.

4. Knighton, 1838, II, p. 363, 13 October 1833.

5. John Burnet, engraver to Wilkie, maintained that 'The pictures by the Flemish and Dutch masters, he had little opportunity of seeing in Scotland, and his knowledge of composition was picked up from the etchings of Ostade and Rembrandt, either in private collections, or occasionally seen at sales', Burnet 1848, p. 108; see also Raleigh 1987, p. 4.

6. Quoted in Edinburgh 1992, p. 49.

7. Burnet 1848, p. 109.

8. The Prince Regent acquired 86 Dutch and Flemish paintings from the collection of Sir Thomas Baring (1772–1848) in 1814.

10 Sir David Wilkie
Blind-Man's-Buff, 1812–13

Oil on panel
63.2 x 91.8 cm
Signed and dated: *David Wilkie. 1812*
RCIN 405537

PROVENANCE
Painted for George IV, when Prince Regent, in 1812–13.

REFERENCES
Cunningham 1843, I, pp. 339, 347, 350–53, 378–82; III,
pp. 525; Millar 1969, no. 1175; Pointon 1984, pp. 15–25; Oxford
1985, no. 2; London 1991b, no. 154; London 2002b, no. 9;
Tromans 2007, pp. 89, 90, 126–7, 138, 264, fig. 2.7.

Blind-Man's-Buff was David Wilkie's first royal commission and sealed his triumphant debut and rise to fame on the London art scene. The painting was displayed to the public twice in its early history: once, still unfinished, at the artist's solo exhibition in 1812, and again at the Royal Academy the following year. Wilkie recorded that it

FIG. 30. Pietro Longhi, *Blind-Man's-Buff*, 1744. Oil on panel.
RCIN 403030

attracted much attention at the Royal Academy and was 'fully as much liked as any I ever painted'.[1] It became even more widely known through Abraham Raimbach's engraving, published in London in 1822, and others published in Paris from 1823 onwards.[2] The Prince Regent was delighted with the painting and Sir Thomas Lawrence informed Wilkie in 1818 that it hung in 'one of His Royal Highness's private Rooms upstairs' at Carlton House.[3] The Carlton House inventory of 1819 reveals that *Blind-Man's-Buff* hung in the Upper Ante Room, at Carlton House, alongside Dutch and Flemish paintings including three by, or after, Isaac and Adriaen van Ostade.[4]

The Prince Regent commissioned the painting in 1810, to serve as a companion piece to *The Country Choristers* (RCIN 405540) by Edward Bird (1772–1819), and he stipulated that Wilkie should have a free choice of subject.

Numerous preparatory sketches survive, including a pen and ink sketch (no. 11). These reveal that the artist's plans for the composition had become fixed by an early stage, and certainly by November 1811.[5] The clarity of his intentions from the outset may indicate that he was already contemplating a painting on this theme when he undertook the commission. The long gestation of the painting, which Wilkie only completed in April 1813, was due in part to a bout of ill health, the first of several that he suffered periodically throughout his life.

The game of 'Blind-Man's-Buff' was already popular in French art; the Prince Regent owned a painting on the subject by the Venetian artist Pietro Longhi (1702–85) which was probably based on an engraved French source (fig. 30). Wilkie's interpretation of the subject took the entertainment out of the drawing room and set it instead in a homely, everyday interior peopled with humbler participants. His muted, golden tones and careful structuring of the figural groups reveal the influence of

Dutch genre 'merrymaking' scenes by such painters as Jan Steen and Adriaen van Ostade. But the boorishness and dirt associated with seventeenth-century Dutch tavern scenes have been replaced here by a gentler vision: this is 'life with mirth and good temper', closely observed with minute attention to naturalistic detail.[6] In Wilkie's hands, this depiction of a traditional national pastime becomes a snapshot of a section of society at large: youthful, ebullient, and with a hint of amorous 'fun and glee' beyond the confines of the game.[7]

1. Cunningham 1843, I, p. 380.
2. Pointon 1984, p. xx.pp. 16–23
3. Cunningham, 1843, I, p. 379; Layard 1906, pp. 130–31.
4. Catalogue of His Magesty's Pictures in Carlton House, 1819, no. 155 (RCIN 112591)
5. See the dated sketch in oil on panel (Tate N00921)
6. Millar, 1969, no. 1175
7. Cunningham 1843, I, p. 381

11 Sir David Wilkie
*A Study for Blind-Man's-Buff, c.*1810–11

Pen and ink
8.1 x 10.3 cm
RCIN 933857

PROVENANCE
Purchased by HM The Queen in 2003.

This is a small but lively preparatory sketch for *Blind-Man's-Buff* (no. 10). It is a rapidly drawn but closely observed work, typical of Wilkie's style as a draughtsman at this early stage of his career. The artist often produced sketches on small sheets of paper that were to hand, as well as creating larger-scale planned preparatory sketches. Later in his career he used chalk, and also watercolour, more frequently in the preparatory process leading to a finished oil painting.

Only the right side of the composition is shown here, but the essential figures, and the relationship between the groups, are already established. The central blindfolded figure lurching forward with bent knees and outstretched arms, and the young man clinging to the wall on the right, appear almost unchanged in the finished oil. The kneeling figures on the floor to the right also relate closely to the group presented in the finished oil. Wilkie omitted the line of players trailing the blindfolded figure, allowing a longer view into the deep space of the room in which the game is set.

12 Sir David Wilkie
A Study of a Seated Girl, c.1813–18

Black and red chalk on buff-coloured paper
18.8 x 10.6 cm
RCIN 917563

PROVENANCE
Collection of Julian Lousada; Christie's, London, 7 March
1947, lot 56; purchased by King George VI.

REFERENCE
Oppé 1950, no. 661.

This is a study for the figure of the seated girl on the
extreme left of *The Penny Wedding* (no. 13). Wilkie's
working process usually involved the creation of detailed
figural studies as he finalised poses and connections
between figures. In the painting he adjusted the pose of
this seated guest, raising her arm to tie up the skirts
of the young girl beside her who is about to step out to
dance. By adding this gesture, Wilkie enlivens her pose
so that it becomes as animated as her expression. This
supports the contention of Wilkie's engraver, John
Burnet, that he 'soon became aware that, in telling a
story, the action of the hands was as necessary as the
action and expression of the features'.[1]

1. Burnet 1848, p. 104.

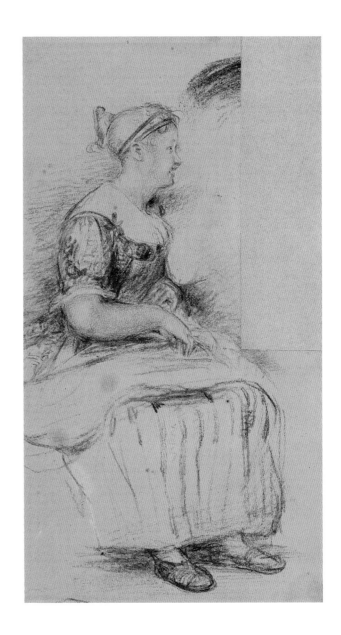

13 Sir David Wilkie
The Penny Wedding, 1818

Oil on panel
64.4 x 95.6 cm
Signed and dated: *DAVID WILKIE 1818*
RCIN 405536

PROVENANCE
Painted for George IV, when Prince Regent, in 1818–19.

REFERENCES
Cunningham 1843, II, pp. 9–11, 19; III, p. 526; Millar 1969, no. 1176; Edinburgh 1985, pp. 18–19; Edinburgh and London 1986–7, no. 183; Raleigh 1987, no. 18; London 1991b, no. 152; Nottingham and Penzance 1998–9, no. 48; Macmillan 2000, pp. 172–4, pl. 139; Macmillan 2001, pp. 30, 33, pl. 4; London 2002b, no. 16; Tromans 2007, pp. 90, 169, 222–4, 238, 244, 245, pl. 4.

The instructions for Wilkie's second royal commission were relayed to him at 'a very grand dinner' in 1813.[1] Here he was invited by the Prince Regent to paint a companion piece for *Blind-Man's-Buff* (no. 10). As with the earlier painting, the idea for *The Penny Wedding* had been in Wilkie's mind long before he received the commission; it had, in fact, been suggested to him as a possible subject as early as 1807.[2] Unlike *Blind-Man's-Buff*, however, the design for *The Penny Wedding* evolved significantly over time; one early sketch shows the bridal couple on the far right of the composition (BM 1860, 0714.59). Wilkie did not begin to paint the picture until 1818; it was eventually delivered to the Prince Regent at Carlton House on 26 January 1819.

The scene portrayed here is more distinctively Scottish than the subjects of any of Wilkie's paintings produced since he left Fife in 1805. The notable figure of Niel Gow (1727–1807), the famous fiddler portrayed by Raeburn (SNPG, 160), presides over a Scottish

'penny wedding,' at which guests contributed a penny towards the cost of the festivities; any surplus went towards the costs of the newly married couple setting up home together. This uniquely Scottish custom was sufficiently unfamiliar to a London audience for Wilkie to include an explanation in the Royal Academy catalogue in 1819. He would probably have attended a penny wedding but the custom was dying out by the second decade of the nineteenth century; indeed, the costumes suggest that the event celebrated here is set about fifty years earlier. Wilkie's nostalgic depiction of 'the manners and customs and character of old Scotland' evoked a reassuring vision of continuity and decency to present to the Prince Regent in the post-Napoleonic years of economic hardship at home and political instability abroad.[3]

Unfortunately, *The Penny Wedding* was not well received by Wilkie's royal patron. The artist had drawn less on the long-standing Flemish 'kermis' (wedding dance) scene exemplified by David Teniers the Younger in *A Kermis on St George's Day*, acquired by George IV in 1811 (fig. 29), and more on contemporary and eighteenth-century Scottish sources. He had followed artists such as David Allan and Alexander Carse in erasing the signs of drink and debauchery for which such wedding celebrations had become notorious, to the Prince Regent's chagrin: it was alleged that he disliked the absence of any unseemly elements in the painting 'for he loved a joke which touched on the delicate line of decorum'.[4]

1. Cunningham 1843, I, p. 379.
2. Macmillan 2000, p. 172.
3. Cunningham 1843, II, p. 9.
4. Cunningham 1843, II, p. 9.

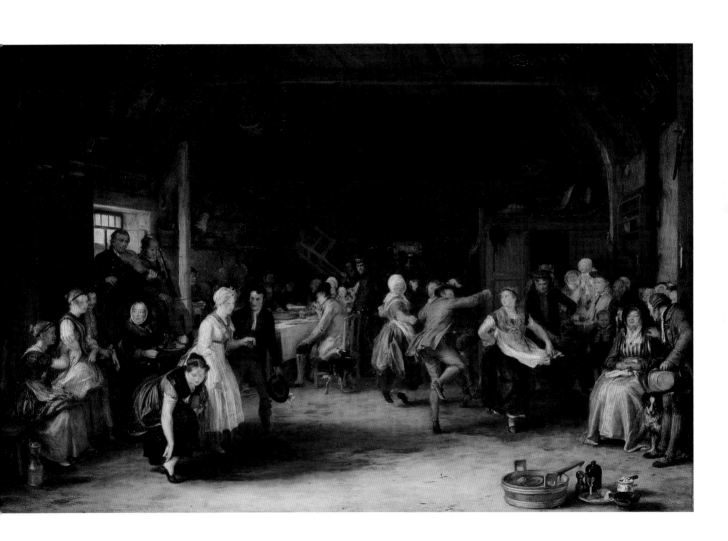

14 Sir David Wilkie
A Roman Princess Washing the Feet of Pilgrims, 1827

Oil on panel
50.2 x 42.2 cm
Signed and dated: *David Wilkie Geneva 1827*
RCIN 405096

PROVENANCE
Purchased by George IV in 1828.

REFERENCES
Cunningham 1843, II, pp. 446, 452–5; III, pp. 3, 4, 15–16, 527; Millar 1969, no. 1178; Edinburgh 1985, pp. 79–82; London 1998, no. 27; Tromans 2007, p. 154.

Completed by Wilkie in Geneva in 1827, this painting was inspired by the scenes of faith and devotion he had seen during his recent stay in Rome. In a letter addressed to his brother Thomas, he described the subject as 'a handsome young lady, humbling herself, even to the washing of the feet of a poor pilgrim'.[1] The subject was inspired by an event that Wilkie had witnessed in the Convent of Santa Trinità dei Pellegrini in December 1825, when 'a sisterhood composed of the first ladies of rank, the princesses of the place' washed the feet of female pilgrims.[2] Wilkie delights in the scene of self-abasement, taking particular pleasure in the varied costumes of the princess, her attendant and the pilgrims in their traditional garb and headgear. A model was chosen for the central figure because of her resemblance to Princess Doria Pamphilj (1788–1829), an aristocrat from Rome renowned for her charitable works. Wilkie returned to the subject again in a painting of *Cardinals, Priests and Roman Citizens Washing the Pilgrims' Feet* of 1827 (GM, 1717).

A Roman Princess Washing the Feet of Pilgrims was one of the first in Wilkie's radically different, broader and darker new style inspired by his three-year continental tour.[3] Exposure to the work of Titian and Correggio in particular brought a new richness and depth to his colouring, while the fluid and more painterly style that he adopted suited his increasingly elevated subject matter. The only trace of his former style, characterised by meticulous brushwork and painstaking attention to detail in the manner of Teniers, is the delicate handling of the silver ewer and basin at the foot of the steps.

George IV's purchase of *A Roman Princess Washing the Feet of Pilgrims*, together with no. 15 and four of the Spanish paintings (nos 16, 18–20), gave Wilkie's altered style a significant endorsement and was an important boost to its critical reception in London.

1. Cunningham 1843, II, p. 454.
2. Cunningham 1843, II, p. 211.
3. *The Parish Beadle* (1820–23; Tate, N00241) anticipated this new style and was met with a critical reception when it was exhibited at the Royal Academy in 1823.

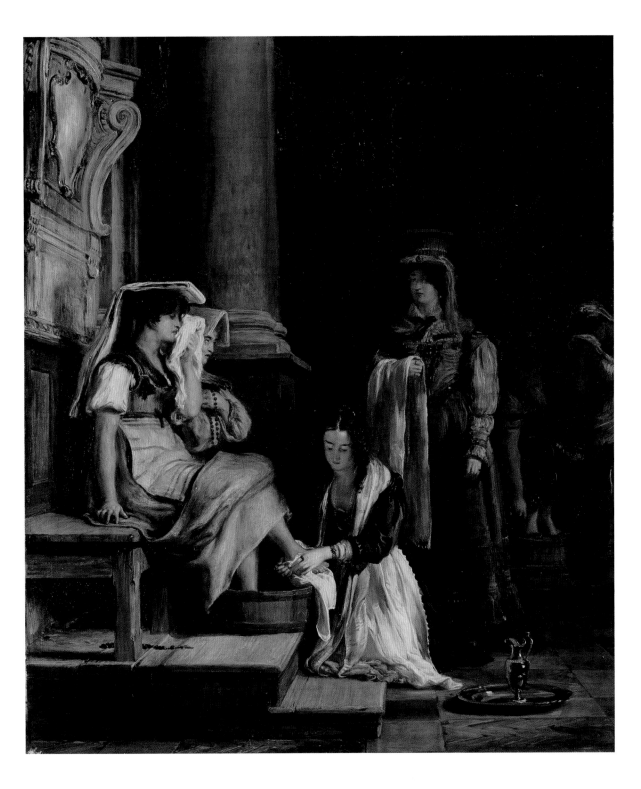

15 Sir David Wilkie
I Pifferari, 1827

Oil on canvas
46 x 36.2 cm
Signed and dated: *D Wilkie Roma / 1827*
RCIN 405861

PROVENANCE
Purchased by George IV in 1828.

REFERENCES
Cunningham 1843, II, pp. 414, 454; III, pp. 3, 4, 15–16, 527; Millar 1969, no. 1177; Edinburgh 1985, pp. 79–82; Raleigh 1987, no. 27; London 1998, no. 26; London 2002b, no. 23; Tromans 2007, pp. 153–4.

When Wilkie arrived in Rome in November 1825 it was with the main purpose of improving his health, for he was barely well enough to paint. But the sights he encountered in the Holy City thrilled him: his arrival coincided with the culmination of the 'Holy Year' celebrations and the city was thronged with pilgrims and preachers participating in church rituals. By the time he returned to London he had completed four paintings based on pilgrim subjects; two of these (the present painting and no. 14) were purchased by George IV in August 1828 for £420.[1]

In Fife and London Wilkie had articulated national identity through the depiction of costume and custom. In the same way he distilled the essence of the Holy City with his paintings of the flamboyant costume and elaborate Catholic rituals of the priests and pilgrims he observed. The subject of *I Pifferari* ('The Pipers') is a group of pilgrims worshipping at a wayside shrine accompanied by a band of pipers. In a letter to his brother in November 1825, Wilkie recorded:

Multitudes of pilgrims from all parts of Italy are assembled in the streets, in costumes remarkably fine and poetical … Each party of pilgrims is accompanied by one whose duty is to give music to the rest. This is a piper, or pifferaro, provided with an immense bagpipe, of a deep rich tone … while another man plays [the melody] on a smaller reed … In parading the streets they stop before the image of the Virgin, whom they serenade, as shepherds of old, who announced the birth of the Messiah.[2]

The haunting music of the *pifferari* inspired other artists and composers of Wilkie's generation. Hector Berlioz (1803–69) encountered them in Italy in 1831–2 and described them in terms which suggest that he may have been familiar with a print based on Wilkie's painting:

These are wandering musicians who towards Christmas come down from the mountains four or five at a time, with bagpipes and *pifferi* (a sort of oboe), on which they perform sacred music before the images of the Madonna. They generally wear large brown cloth cloaks and pointed brigand hats and there is a strange wild air about them which is quite unique.[3]

Turner, too, was inspired to paint *Modern Italy: The Pifferari* (GM, TW0285) on the basis of similar scenes which he witnessed in Italy. While some artists, such as Thomas Uwins (1782–1857), remained unmoved by these demonstrations of faith, Wilkie found such scenes inspirational.[4] The son of a Presbyterian minister, he found himself forced to reflect on the nature of the relationship between art and the Church. He hints at this here by the inclusion of Raphael's *Madonna della Sedia* on the left, and by adopting a compositional form

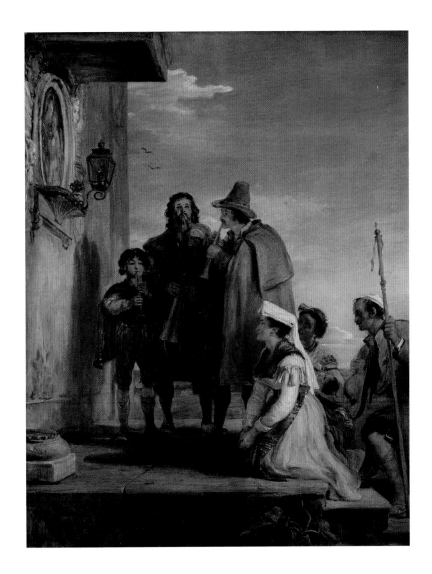

familiar in High Renaissance depictions of the Adoration of the Shepherds.

Wilkie was not the first Scottish artist to exploit the artistic possibilities of pilgrim scenes in Rome: David Allan, visiting the city fifty years previously, had produced a series of etchings of pilgrims, including *pifferari*, with which Wilkie was no doubt familiar.[5]

1. The other two are *The Pilgrims in the Confessional* (SNG, NG 2315); *Cardinals, Priests and Roman Citizens Washing the Pilgrims Feet* (GM, inv. 1717).

2. Cunningham 1843, II, p. 194.

3. Berlioz 1969, p. 159.

4. Edinburgh 1985, p. 81.

5. This series of six etchings of Italian subjects included *The Calabrian Shepherds playing the pastorale to the Infant Jesus on Christmas at Rome* (B M, 1865, 0610.930-935), to which the design of Wilkie's painting is related.

16 Sir David Wilkie
The Spanish Posada: A Guerilla Council of War, 1828

Oil on canvas
74.9 x 91.4 cm
Signed and dated: *David Wilkie. Madrid 1828*
RCIN 405094

PROVENANCE
Purchased by George IV in 1829.

REFERENCES
Cunningham 1843, II, pp. 506–7, 509; III, pp. 2, 4, 5, 9–11, 13, 14–16, 505, 527; Millar 1969, no. 1179; London 2002b, p. 36, pl. 2; Tromans 2007, p. 181.

The Spanish War of Independence (1808–14), one of the Napoleonic Wars, was provoked by the deposing of the King of Spain in favour of Napoleon's brother, Joseph Bonaparte. Regular and guerilla Spanish forces combined to fight a long and bitter war of resistance against the French, who were eventually driven out in 1814. Many accounts of the valiant Spanish resistance circulated both at the time of the conflict and later, seizing the imagination of the British public. *Childe Harold's Pilgrimage* (1812) by Lord Byron (1788–1824) had already cast the revolt in a romantic light by the time Wilkie drew on this episode of Spanish history for a series of four paintings. *The Spanish Posada: A Guerilla Council of War* was the first of three painted in Spain in 1827–8; these also included *The Defence of Saragossa* and *The Guerilla's Departure* (nos 18, 19). A fourth painting, *The Guerilla's Return* (no. 20), was commissioned by George IV in 1829 after Wilkie's return to London. *The Spanish Posada* was admired by the artists and connoisseurs with whom he mixed in Madrid, and when he sold the series to George IV on his return to London, it proved to be the King's favourite.

The painting depicts a council of war taking place in a remote mountain inn (*posada*). The protagonists are three seated churchmen (a Dominican, a monk from the Escorial and a Jesuit) and two guerillas. One of the latter, in Valencian costume, leans forward conspiratorially; the other stands guard with his rifle, on the right. Local flavour is provided by the *contrabandista* who rides in on his donkey; the dwarf playing his guitar, intended as a reference to the art of Velázquez; and the young girl and goatherd in the foreground. On the left, a residual comic element typical of the kind that had formerly dominated Wilkie's work appears in the form of the loafing student whispering endearments to his landlady as she serves chocolate.

This painting, and the other three in the series, are unusual in British art in that each shows a Catholic priest in a positive role. Renewed interest in the beauty and colour of the Catholic faith perhaps reflects the notion that traditional Catholicism and its continental devotees represented the antithesis of radical, secular, revolutionary France.

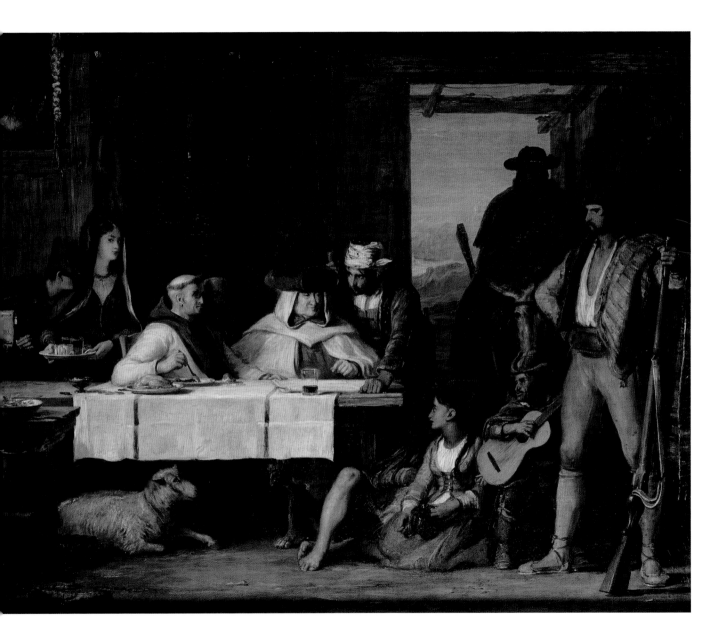

17 Sir David Wilkie
The Spanish Posada: A Guerilla Council of War, 1827

Pencil, black chalk and watercolour
17.5 x 21.9 cm
Inscribed in ink: *Madrid Octb.r 24ᵗʰ 1827*; signed: *D Wilkie*
RCIN 922931

PROVENANCE
Purchased by HM The Queen in 1980.

REFERENCE
London 2002b, no. 53.

This pencil and watercolour study is a preparatory
sketch for *The Spanish Posada: A Guerilla Council of War*
(no. 16). Wilkie had developed the composition in Spain
in early October 1827 in connection with an entirely
different idea for a painting of an incident from the life
of Christopher Columbus (fig. 31). Wilkie's friend, the
American writer Washington Irving (1783–1859), had
been living and working in Madrid since 1826, writing a
biography of Columbus, and presumably stirred the
artist's interest in the explorer and his life but, by
24 October 1827, Wilkie had revised his initial intentions
entirely, and reworked the composition to show a
meeting of guerillas in a remote Spanish inn. The
finished painting follows the sketch closely, although
the figures have been reduced slightly in scale and set
further back in the picture space in order to achieve a
greater sense of depth.

FIG. 31. Sir David Wilkie, *Christopher Columbus in the Convent of
La Rábida*, 1827. Chalks and watercolour. Leicester Museum and
Art Gallery LMC 1449322

Wilkie's practice in London had been to make
multiple preparatory sketches for each finished painting,
starting with small sketches in pen and ink for indepen-
dent figures, more finished figure studies on a larger
scale, sometimes in chalk, larger-scale compositional
drawings, and finally oil sketches of the whole design.
In Spain, however, he appears to have abandoned this
lengthy process in favour of working directly on to
canvas from fluent watercolour sketches like this one of
the entire composition.

Madrid Sett 24th 1827 D Wilkie

18 Sir David Wilkie
The Defence of Saragossa, 1828

Oil on canvas
94 x 141 cm
Signed and dated: *David Wilkie. Madrid 1828*
RCIN 405091

PROVENANCE
Purchased by George IV in 1829.

REFERENCES
Cunningham 1843, II, pp. 506–7, 509, 510–11; III, pp. 2, 5, 9–11, 13, 14–16, 505, 527; Millar 1969, no. 1180; Raleigh 1987, no. 30; London 1988–9, no. 68; London 1991a, no. 68; London 2002a, no. 29; London 2002b, p. 37; Tromans 2007, pp. 181–2; Edinburgh 2009, pl. 21.

The Defence of Saragossa was unlike any painting previously attempted by Wilkie. The third of his Spanish pictures, it recreates on a grand scale an historical event of the utmost drama and heroism. The episode shown had taken place in 1808, during the Spanish War of Independence, when Spanish civilians defended Saragossa against the invading Napoleonic forces. In the face of a French assault, Agostina Zaragosa (the 'Maid of Saragossa') has stepped over the body of her dead husband to light the fuse in the cannon directed towards the French forces by the resistance leader, Don José de Palafox y Melci, Duke of Saragossa (1780–1847). Agostina's decisive action was a turning point in the attack and led to the withdrawal of the French forces. Wilkie's interpretation of this episode was informed by Lord Byron's description in *Childe Harold's Pilgrimage* (1812) of the moment when the French forces experience defeat: 'Foil'd by a woman's hand, before a batter'd wall'.[1]

The artist's six-month sojourn in Madrid over the winter of 1827–8 brought him into contact with Palafox, who sat for him in March 1828. A preparatory sketch dated 29 November 1827 (BMAG, inv. 579) shows that the composition was already fully developed some months earlier, but the painting was not completed until January 1829, after Wilkie had returned to London.

During his time in Spain Wilkie added the influence of Velázquez and Murillo to that of Rubens and the Italian Old Masters Titian and Correggio, who superseded his former Netherlandish models. Contemporaries were quick to see Velázquez as his primary influence in *The Defence of Saragossa*, but Wilkie himself claimed that he had 'tried without reserve the deep contrast we used to admire in Titian – the deep blue sky and draperies against the brown shadows and sun-burnt flesh of a warm climate. The Bacchanal of Titian in the Museo del Prado we so often admired was my chief model'.[2]

1. *Childe Harold's Pilgrimage*, canto 1, stanza 56.
2. David Wilkie to Prince Dolgoruki, London, 27 September 1828 (MS Yale University, Beinicke Library, New Haven, Za Irving: 29), quoted in Raleigh 1987, p. 216.

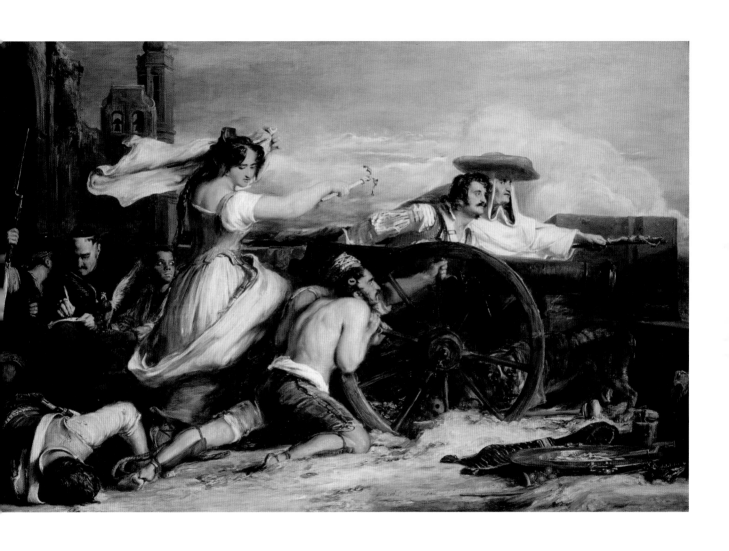

19 Sir David Wilkie
The Guerilla's Departure, 1828

Oil on canvas
92.7 x 81.9 cm
Signed and dated: *David Wilkie. Madrid. 1828*
RCIN 405092

PROVENANCE
Purchased by George IV in 1829.

REFERENCES
Cunningham 1843, II, pp. 506–7, 509; III, pp. 2, 4, 5, 9–11, 13, 15, 505, 521, Edinburgh and London 1951, nos 31, 44; Millar 1969, no. 1181; London 2002b, pp. 37, 40; Tromans 2007, pp. 181–2; Edinburgh 2009, pl. 19.

The Guerilla's Departure was the second of three pictures of the Spanish resistance to the French occupation completed by Wilkie in Madrid between October 1827 and May 1828. All three (including nos 16 and 18) were purchased by George IV for 2,000 guineas in March 1829, after Wilkie's arrival home. The King also commissioned a fourth painting (no. 20) to hang as a companion piece to this picture.

A conspiratorial moment is suggested by the smallest of gestures, as a Carmelite monk offers a resistance fighter a light for his cigar. The fighter's departure is imminent, for his rifle is loaded on his donkey's saddle pack; the viewer is left uncertain as to whether the lighting of the cigar disguises whispered final exchanges concerning the forthcoming campaign or a last-minute confessional. Wilkie retained the capacity to transform an everyday incident into one with broader meaning: here the tension and anticipation of the dangerous events ahead is expressed in the characters' close concentration on their small task.

Wilkie's sojourn in Madrid was the last stage of his three-year continental tour. By this time he had experimented with new designs and a bolder, broader style. The complex, crowded compositions of his London years have here given way to a simpler, pyramidal structure with the large-scale heroic figures set forward in the picture space. The small boy on the left is a tribute to Murillo, whose work became a major influence on Wilkie at this period: 'Murillo is here in great force and variety', he wrote to landscape painter and picture dealer Andrew Wilson (1780–1848) from Madrid on 6 May 1828; 'for female and infantine beauty, scarce any has surpassed him'.[1] The child relates to the figure of a beggar in *Two Peasant Boys* by Murillo (DPG 224).

1. Cunningham 1843, II, p. 521.

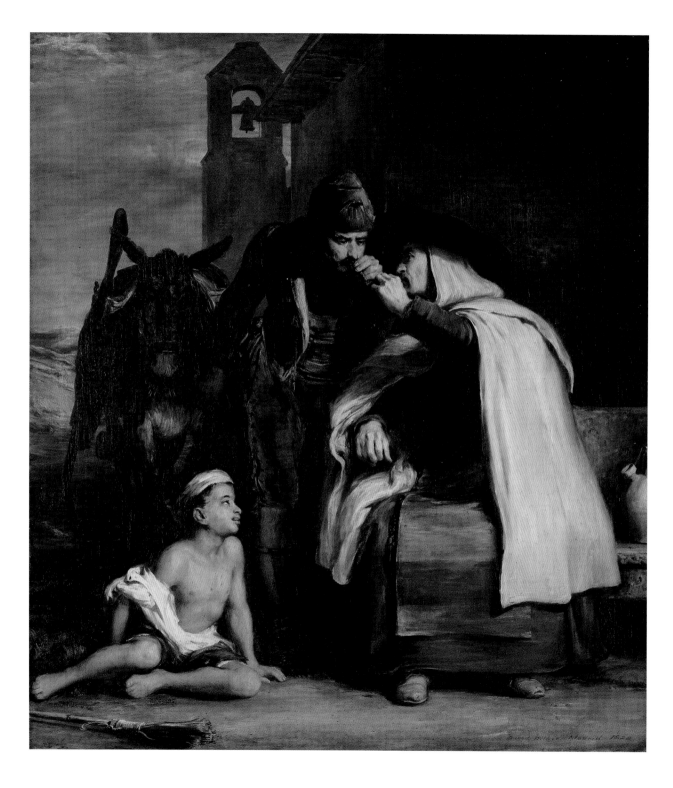

20 Sir David Wilkie
The Guerilla's Return, 1830

Oil on canvas
92.7 x 81.9 cm
Signed and dated: *David Wilkie London 1830*
RCIN 405093

PROVENANCE
Commissioned by George IV in 1829; presented by the artist
to the King for 400 guineas in 1830.

REFERENCES
Cunningham 1843, III, pp. 5, 10, 527; London 1951, no. 37;
Millar 1969, no. 1182; Tromans 2007, p. 81; Edinburgh 2009,
pl. 20.

George IV commissioned Wilkie to paint *The Guerilla's Return* as a companion piece to *The Guerilla's Departure* (no. 19) and to complete the set of four Spanish subjects he had purchased from Wilkie in March 1829 (also including nos 16 and 18).

Wilkie's subject here is the return of the wounded guerilla to his family and supporters. Weary and injured, he is tended by his anxious wife and another woman in the foreground, who prepares to bathe and dress his wounds. The confessor who was present at his departure emerges from the shadows in the background to help him dismount, and perhaps to conceal him.

The four paintings in the set extol the heroic role of ordinary peasants and priests in the Spanish War of Independence. In this instance, the sacrifice of the Spanish peasant-turned-freedom-fighter is emphasised by creating a visual parallel with images of Christ entering Jerusalem on a donkey (Matthew 21: 1–11).

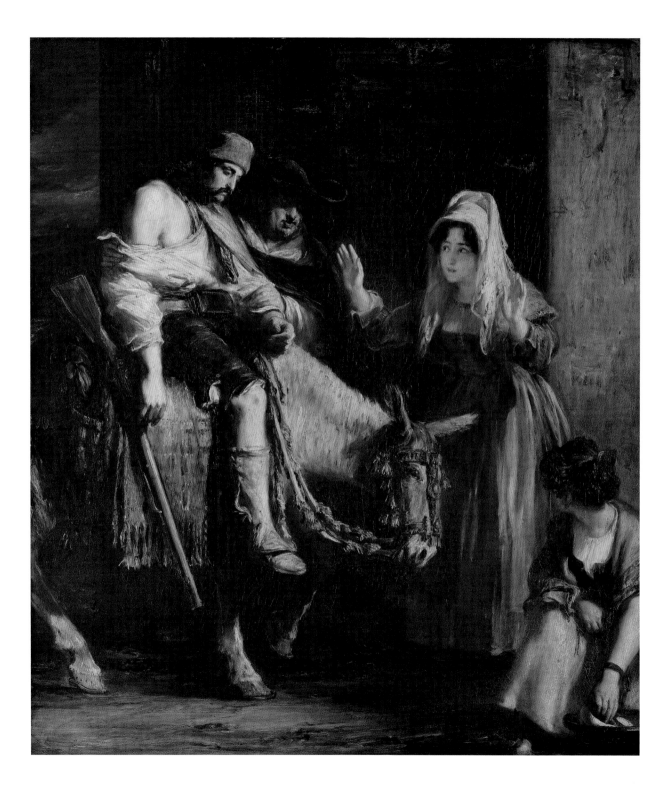

21 Sir David Wilkie
The Entrance of George IV to Holyroodhouse, 1822–30

Oil on panel
126.0 x 198.1 cm
Signed: *David Wilkie*
RCIN 401187

PROVENANCE
Commissioned by George IV.

REFERENCES
Cunningham 1843, II, pp. 82, 84–5, 86, 89–91, 96, 103, 104–6, 111, 116, 118, 119–20, 122; III, pp. 9, 10, 25, 28, 30, 37, 42, 43, 44–5, 527; Millar 1969, no. 1184; Edinburgh 1975, pp. 15–20; London 1981, p. 43; Raleigh 1987, p. 221; Russell 1987, no. 230; Errington 1988, p. 12; London 2002b, pp. 23–4; Morrison 2003, pp. 52–4, pl. 3.2; Tromans 2007, pp. 100, 226, 227.

George IV was the first British reigning monarch to visit Scotland for nearly two hundred years. The visit was encouraged by Sir Walter Scott, who devised the King's programme and the accompanying pageantry. Wilkie travelled to Edinburgh for the occasion and wrote that he was so 'completely on the watch for the important arrival that I cannot leave town'.[1] This painting depicts the moment when George IV arrived at the Palace of Holyroodhouse on 15 August 1822. Wilkie witnessed the event: 'I saw the King alight; he had not much colour, but upon the whole was looking well. He was dressed in the field marshal's uniform, with a green ribbon of the Order of the Thistle. He was received by the Dukes of Hamilton and Montrose, and a variety of others.'[2]

Wilkie made many sketches of different events he had witnessed in Edinburgh but found it difficult to settle on a subject for an official commemoration of the King's visit. It seems that the final choice was made by the King, who 'fixed upon his admission to the palace of his ancestors, with all the chiefs of the north on his right and left'.[3] Wilkie showed a sketch to the King in late August 1823 and wrote to Sir Robert Peel in October: 'I am now beginning a picture, six feet long, of the King entering Holyrood House'.[4] A drawing (no. 23) indicates that Wilkie had established the layout early, but the final painting shows George IV in a more upright posture.

The following year Wilkie had three sittings with the King, but the picture continued to cause him difficulties and this, together with a series of family tragedies, may have contributed to the ill health that prompted him to travel abroad to recover. He can have done little towards the picture while on the Continent, although the Duke of Hamilton wrote to the artist when both were in Rome in 1827 to confirm arrangements, 'that you maybe enabled to take the likeness you require for the King's picture'.[5] Following his return home in 1828, Wilkie started work on the picture once more.

The most obvious source of inspiration for the picture was *The Coronation of Marie de' Medici* by Peter Paul Rubens (1577–1640), which Wilkie had seen in Paris in 1814; this probably influenced his final composition of the complex ceremony.[6] On 11 February 1830 he told Sir William Knighton that the picture was ready to be submitted for the King's inspection and late in 1829 he had written that 'It is all painted in, and waits only for the toning'.[7] The finished painting was exhibited at the Royal Academy in 1830.[8]

Alexander, 10th Duke of Hamilton, the hereditary Keeper of the Palace, is shown kneeling, presenting the keys of the Palace to the King. To the left of the King the figure of the Lord Chamberlain, James Graham, 3rd

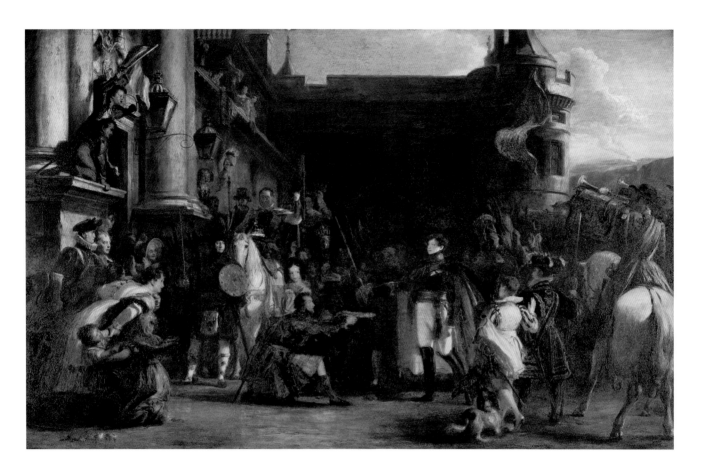

Duke of Montrose (1755–1836), points towards the entrance of the Palace. George Campbell, 6th Duke of Argyll (1768–1839), in Highland dress, stands in front of the Palace. Behind him, the Honours of Scotland are borne on horseback: the Crown is held by Sir Alexander Keith (1780–1832), Knight Marischal of Scotland; the Sceptre by Lord Francis Leveson-Gower (1800–57); and the Sword of State by George Douglas, 17th Earl of Morton (1761–1827). On the left, near the entrance,

stands John Hope, 4th Earl of Hopetoun (1765–1823), in his uniform as Captain-General of the Royal Company of Archers, the King's Bodyguard for Scotland, formed for this occasion. Sir Walter Scott can be seen to the left of the main entrance. To the right of the King are trumpeters, a page and the Exon, the junior officer acting for the Yeoman of the Guard. Crowds of enthusiastic spectators clamber over every part of the Palace to catch a view of the King.

The painting has suffered from an excessive use of mastic resin mixed with oil paint (megilp), which Wilkie used to achieve the rich depth of tone he had seen in the work of Rembrandt and other Dutch masters.[9] Unfortunately, his technique has caused large areas of disfiguring craquelure. Wilkie also favoured the use of the bituminous material asphaltum on many of his paintings, which was recommended for glazing and deep transparent shadows, but this has also resulted in irreversible damage.

1. David Wilkie to Sir Robert Liston, 12 August 1822, NLS, MS 5668, f. 30.
2. Cunningham 1843, II, pp. 84–5.
3. Cunningham 1843, II, p. 89.
4. Cunningham 1843, II, p. 116.
5. Duke of Hamilton to David Wilkie, 18 April 1827, NLS, Acc. 7972.
6. Wilkie had admired the Medici cycle of pictures by Rubens on his visit to the Luxembourg in Paris in 1814; they are now in the Louvre. See Irwin 1975, p. 177.
7. Wilkie's receipt for 1,600 guineas for the picture is dated 2 March 1830 (RA GEO/MAIN/26760); Cunningham 1843, IIII, p. 28.
8. As *George IV Received by the Nobles and People of Scotland* (Royal Academy catalogue, 1830, no. 125).
9. For a description of Wilkie's technique see Burnet 1848, pp. 109–10.

OPPOSITE: Sir David Wilkie (1785–1841), *The Entrance of George IV to Holyroodhouse*, 1822–30 (detail). RCIN 401187

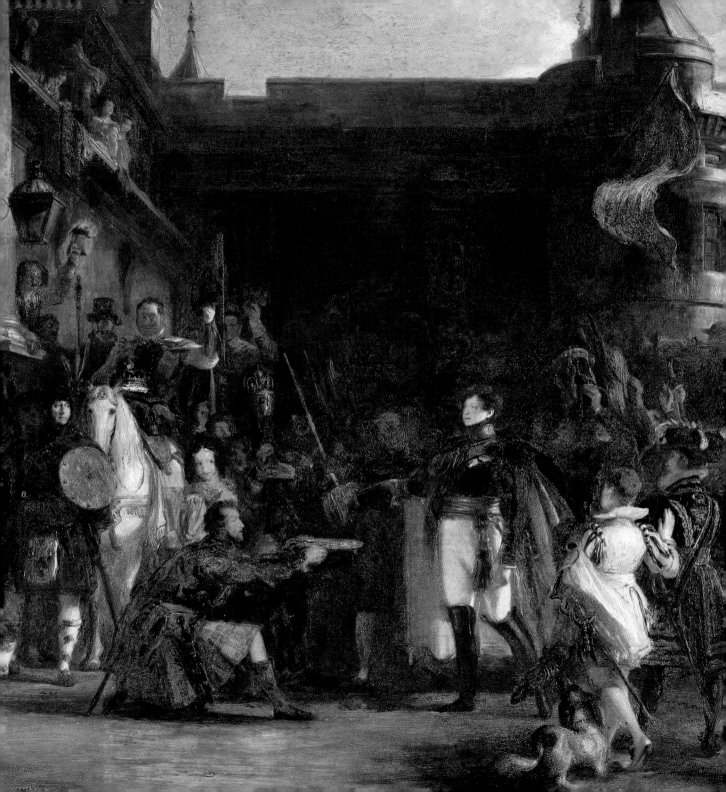

22 **Sir David Wilkie**
The Entrance of George IV to Holyroodhouse, 1822–30

Oil on paper laid on panel
44.6 x 27.8 cm
RCIN 409055

PROVENANCE
Purchased by Queen Elizabeth The Queen Mother in 1948.

REFERENCE
Millar 1969, p. 142.

This is an oil sketch for part of Wilkie's painting to commemorate George IV's entry into the Palace of Holyroodhouse on his visit to Scotland in 1822 (no. 21).

It shows the King, dressed in Field Marshal's uniform, with a page and lively dog to the right. To the left of the King, the figure of the Lord Chamberlain, the Duke of Montrose, is visible as he points towards the entrance of the Palace. The Duke of Hamilton's hand and the cushion on which are the keys he is presenting to the King can just be seen to the far left. The arrangement of the King's stance was changed in the final picture.

The freedom and fluid handling of paint indicates that this oil sketch may have been made after Wilkie's stay on the Continent during 1825–8, when his style changed in response to paintings he had seen on his travels. On his return he began work on the picture again and made an oil sketch of the whole composition (SNPG 1040).

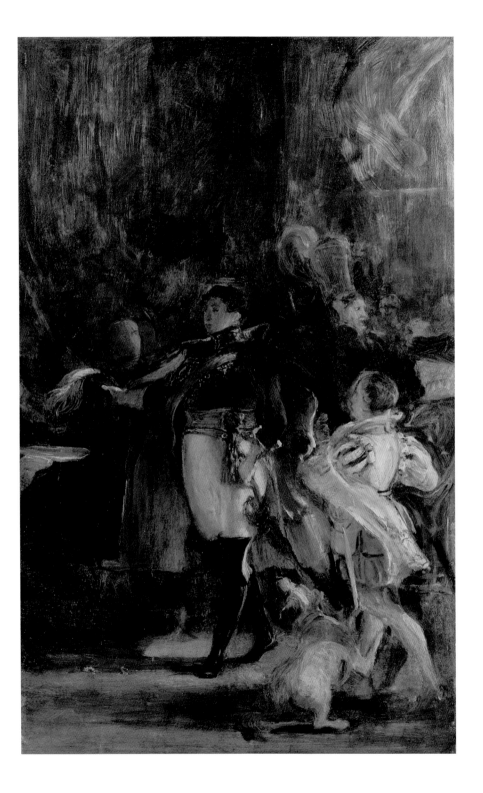

23 Sir David Wilkie
George IV's Entry into Holyroodhouse, 1822

Pencil, pen and ink on pale buff paper
31.4 x 52.0 cm
RCIN 913593

PROVENANCE
Royal Collection by 1947.

REFERENCES
Oppé 1950, no. 663; Millar 1969 p. 142;
Edinburgh and Wellington 2004–5, no. 60.

This is an early study for the large painting of the
same subject (no. 21). Wilkie witnessed the arrival of
George IV at the Palace; before the event he had
'arranged with the chamberlain's officers that I and
another artist, Mr [Samuel] Joseph, the sculptor, should
be allowed to put on our court dresses in an attic room
of the palace, court dresses being indispensable for
admission into the presence. I accordingly put mine on,
which, with hair-powder and all the et-ceteras, looked
really splendid.'[1]

FIG. 33. Sir David Wilkie, *A man in Highland costume (George
Campbell, 6th Duke of Argyll)*, c.1824. Black chalk on buff
paper. RCIN 914769

FIG. 32. Sir David Wilkie, *The Palace of Holyroodhouse*,
c.1824. Pencil and white and black chalk. RCIN 917626

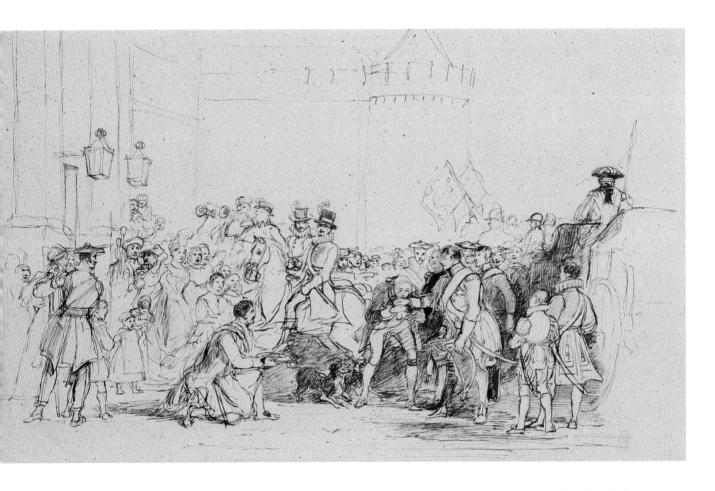

The King is shown to the right, having just alighted from his carriage. The Duke of Montrose kisses his hand and the Duke of Hamilton kneels before him, presenting the keys to the Palace. The drawing indicates that the basic layout of the composition had been established but Wilkie still had much to do to refine the details. When the first sketch of the picture was shown to the King, he was asked how he stood when presented with the keys. The King replied: '"Stood! Not as I stand there but thus:" and he set his foot forward, threw his body back, put on

"a martial and swashing outside" and said "There!"' [2] Wilkie heeded the King's comments: the final painting shows him in a more upright posture than this study.

Wilkie returned to Edinburgh in 1824 to make further sketches of the palace (fig. 32) and portraits of the main figures (fig. 33) but did not finish the painting until 1830.

1. Letter to Miss Wilkie, 16 August 1822; Cunningham 1843, II, p. 84.
2. Cunningham 1843, II, p. 90.

24 Sir David Wilkie
Queen Adelaide with Princess Victoria and Members of Her Family, c.1831–2

Oil on canvas
127 x 102.2 cm
RCIN 409157

PROVENANCE
Wilkie's sale, Christie's, London, 25–30 April 1842 (lot 219), bt Tiffen, presumably for John Thornton Leslie-Melville, 9th Earl of Leven and Melville (1786–1876); by descent; acquired from the Leven and Melville family by Captain Michael John Wemyss of Wemyss (1888–1982) and presented to Queen Elizabeth The Queen Mother in 1948.

REFERENCES
Edinburgh 1958, no. 90, Millar 1969, no. 1187; Tromans 2007, p. 101.

The event shown here is the presentation of the 11-year-old Princess, later Queen, Victoria at a 'Drawing Room' (or formal reception) at St James's Palace on 24 February 1831. The Drawing Room was held to celebrate the birthday of Princess Victoria's aunt, Queen Adelaide, consort of William IV, who stands immediately behind her at the top of the stairs. The Princess's appearance accords with a contemporary record of the event, according to which she wore 'an elegant dress of Nottingham blonde lace over rich white satin'.[1]

This was Princess Victoria's first court appearance, and it is the young guest rather than the new Queen who is the central focus of the painting, surrounded by her immediate family and associates. The presence of this small figure at the head of a flight of steps is perhaps intended to echo the form of composition conventionally used to depict the Presentation of the Virgin in the Temple. On this momentous occasion, the absence of Princess Victoria's late father, Edward, Duke of Kent, is acknowledged by his presence in the form of a bust on a pedestal on the left. The young man immediately behind Princess Victoria's right shoulder is her half-brother, Charles, Prince of Leiningen (1804–56); beside him (and unfinished) is the presumed figure of her half-sister, Feodora, Princess of Hohenlohe-Langenburg (1807–72). To the left of Queen Adelaide is Charlotte, Duchess of Northumberland (1786–1866), the princess's governess; to the right stand Victoria, Duchess of Kent (1786–1861), the princess's mother, with Leopold, Prince of Saxe-Coburg-Saalfeld (1790–1865), her uncle. On the far right stands the Comptroller of the Duchess of Kent's household, Sir John Conroy (1786–1854). The dog on the steps belonged to Baroness Lehzen (1784–1870), Queen Victoria's German governess.

1. *The Royal Lady's Magazine and Archives of the Court of St James*, 1831, I, p. 192.

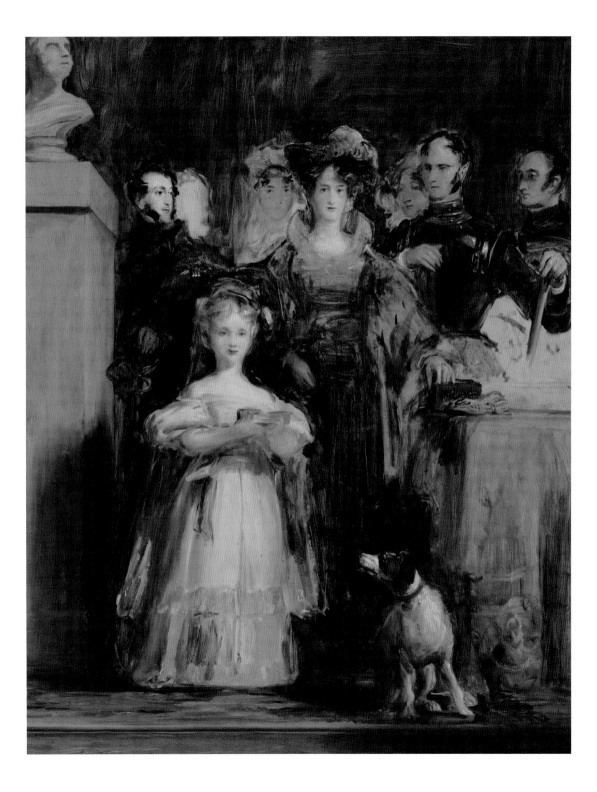

25 Sir David Wilkie
Charles, Prince of Leiningen (1804–1856), c.1831–2

Oil on canvas
53 x 43.2 cm
RCIN 402415

PROVENANCE
Presented by the artist's sister after his death to Victoria, Duchess of Kent; given by her to Queen Victoria.

REFERENCES
Edinburgh 1958, no. 72; London 1958, no. 33; Millar 1969, no. 1189.

This oil sketch relates to the figure of Charles, Prince of Leiningen in Wilkie's *Queen Adelaide with Princess Victoria and Members of her Family* (no. 24). Apart from that of Princess Victoria, the head of the Prince is the most finished in the oil portrait; in this sketch only the face is complete, with the cravat barely suggested and no further details of the costume worked up. The remarkable liveliness of the sketch is reminiscent of the work of Sir Thomas Lawrence, who alone of Wilkie's contemporaries could surpass this in vivacity.

Charles, Prince of Leiningen, half-brother to Queen Victoria, was the only son of the Duchess of Kent by her first marriage to Emich Charles, 2nd Prince of Leiningen. Two years after the Prince of Leiningen was painted by Wilkie he visited London again, prompting the young Princess Victoria to write to her half-sister Feodora, Princess of Hohenlohe-Langenburg: 'Charles is with us now. I think he looks very well. He goes out in the evenings a good deal, though not so much as the year before last, and gets up very late.'[1]

1. Princess Victoria to Feodora, Princess of Hohenlohe-Langenburg, 31 May 1833, RA VIC/ADDU/171/41.

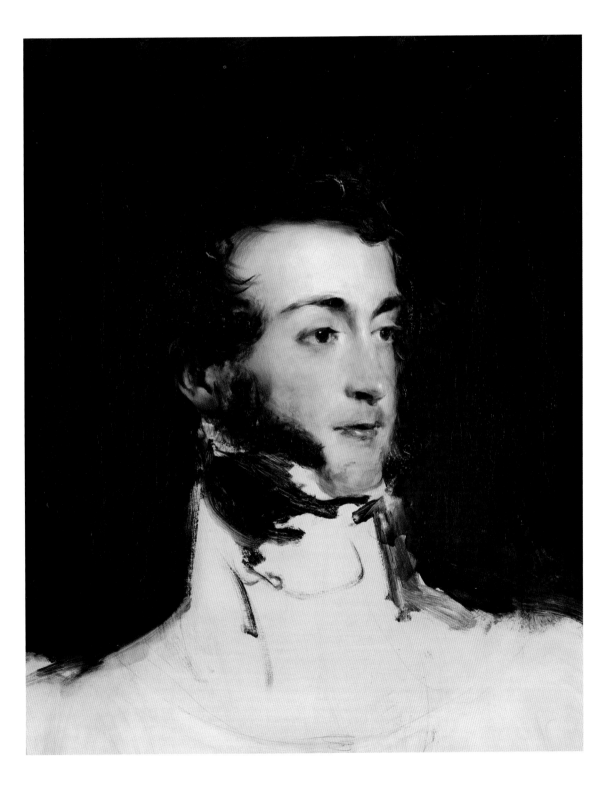

26 Sir David Wilkie
Queen Victoria (1819–1901), 1837

Oil on canvas
57.8 x 51.1 cm
RCIN 401442

PROVENANCE
Purchased by HM The Queen in 1990.

This is a study for the head of Queen Victoria for the full-length figure of the Queen in Wilkie's *The First Council of Queen Victoria* 1838 (fig. 34). The first meeting of Queen Victoria's Privy Council took place on 20 June 1837, only hours after the accession of the 18-year-old Queen. The painting of the event was begun by Wilkie at the Queen's instigation in October the same year and was completed by August 1838. Although the Queen recorded at least five sittings in her journal, this oil sketch may have been painted at the first of these,

which took place at the Royal Pavilion, Brighton, on 17 October 1837, making it the earliest painting of Victoria as reigning queen.

Initially the project progressed well and Queen Victoria seemed satisfied with the likeness. 'All here think the subject good, and she likes it herself', Wilkie wrote to his sister on 28 October 1837.[1] Before long, however, the Queen began to express dissatisfaction with the likenesses in the painting and, over time, she came to find it 'one of the worst pictures I have ever seen, both as to painting & likenesses'.[2] No basis for this reaction can be observed in this sensitive sketch. The bare canvas suggests the white dress in which Wilkie chose to portray the Queen, altering her black mourning attire to suggest her innocence and purity in a gathering of more seasoned, male statesmen.

1. Cunningham 1843, III, p. 227.
2. Journal, 12 November 1847.

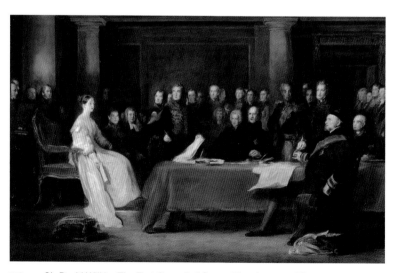

FIG. 34. Sir David Wilkie, *The First Council of Queen Victoria*, 1838. Oil on canvas.
RCIN 404710

27 Alexander Nasmyth (1758–1840)
View of the High Street Edinburgh and the Lawn Market, 1824

Oil on canvas
108 x 148 cm
RCIN 403133

PROVENANCE
Presented to HM The Queen and The Duke of Edinburgh by
the City of Edinburgh in 1949.

REFERENCES
Millar 1977, p. 218; Cooksey 1991, pp. 33, 34–8, 85, no. 018;
Morrison 2003, pp. 66–7, pl. 3.9.

Alexander Nasmyth was the son of an Edinburgh master
builder who contributed to the construction of the
city's Georgian New Town. He trained at the Trustees'
Academy and was apprenticed to a local coach painter
before going to London to work in the studio of Allan
Ramsay. Here he was employed to paint replicas of the
state portraits of George III and Queen Charlotte. Once
established back in Edinburgh, Nasmyth specialised in

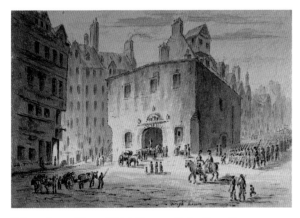

FIG. 35. James Skene, *Weigh House or Butter Tron*, 1817.
Watercolour. City of Edinburgh Council (Capital Collections no. 629)

portraits and landscapes; he also worked in architecture,
landscape and garden design, civil engineering and
theatrical scene painting.

This fascinating scene is set in the medieval Old
Town of Edinburgh and depicts the Lawnmarket, near
the top of the Royal Mile and below Edinburgh Castle,
with West Bow to the right, St Giles Cathedral ahead
and a view down towards the Palace of Holyroodhouse
and the Firth of Forth in the distance. In the foreground
can be seen the demolition of the fourteenth-century
Weigh-House, or Butter Tron, a building used to weigh
butter and cheese to be sold in the Lawnmarket (fig. 35).
This is being accomplished with crowbars, ropes, planks
and ladders. The building was removed in 1822 to make
way for the procession of George IV to the Castle,
during his visit to Scotland in August of the same year.
Nasmyth has widened the narrow Lawnmarket to allow
inclusion of as much as possible: the painting is full of
the daily activities and occupations that take place in
a busy street, including merchants and tradesmen at
work, women selling bread and cabbages from barrows,
water being drawn from a well, soldiers (who would
have lived in barracks at the Castle) walking around, the
City Guard patrolling on horseback and Mr Bell the
wigmaker leaning out of his window.

A companion picture, *The Port of Leith* (CAC,
1978/227), shows the commercial seaport of the city.
The two may have been painted to mark the visit of
George IV and to record the city for posterity; they were
exhibited at the Royal Academy in London in 1824.
Nasmyth went on to paint two more spectacular views
of the city, *Princes Street with the Commencement of the
Building of the Royal Institution* (SNG, 2542) and *View of
Edinburgh from the Calton Hill* (Clydesdale Bank), both
exhibited in 1826.

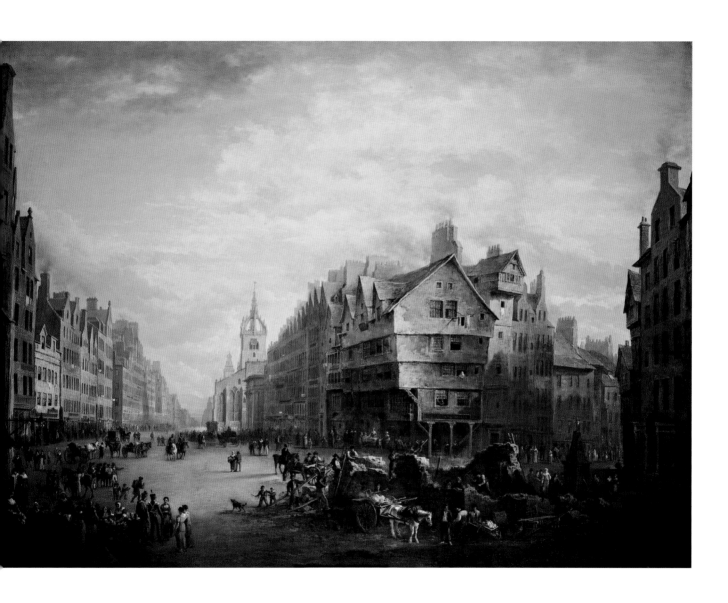

FIG. 36. Louis Haghe, *David Roberts* from *The Holy Land, Syria, Idumea, Arabia, Egypt and Nubia*, v. I, 1847. Lithograph. RCIN 1075154

FIG. 37. James Giles, *Self-portrait, c.*1830. Oil on board. Aberdeen Art Gallery and Museum ABDAG002430

Scottish Artists in the Victorian Era

'From scenes like these Old Scotia's grandeur springs,
That makes her loved at home, revered abroad.'
—Robert Burns, *The Cotter's Saturday Night,* 1786

By 1850 it was accepted that there existed a 'Scottish School' of art, although it was less clear what the defining characteristics of that particular school might be. [1] Sir David Wilkie's personal success, and his unashamed promotion of the interests of young Scottish painters, had raised the profile of the Scottish community of artists in London. Meanwhile, the native school was supported almost exclusively in Edinburgh by the Royal Scottish Academy, granted its royal charter by Queen Victoria in 1838, and the Royal Association for the Promotion of the Fine Arts in Scotland. Those searching for generic qualities to encompass the full range of Scottish art produced in the mid-nineteenth century were destined to be unsuccessful. However, it became clear that much of the art emanating from Scotland in the second and third quarters of the nineteenth century was inseparable from the landscape, folklore or literature of the nation. For some artists, even this deep well of Scottish artistic themes proved exhaustible, and their Celtic imagination was driven to seek inspiration abroad, putting Scottish artists at the forefront of Orientalism and giving them a leading role in introducing Spanish imagery to the British public. [2]

Sir William Allan, like his near-contemporary Wilkie, found inspiration both at home and abroad. He enjoyed a long spell at court in St Petersburg during his period working in Russia (1805–14) and gained the patronage of Tsar Nicholas I, who subsequently visited his studio in Edinburgh in 1819. The Tsarina and the Tsar's daughters were later painted by another Scottish artist resident at St Petersburg, Christina Robertson (1796–1854), and these portraits were hung at Osborne House by Queen Victoria and Prince Albert. [3] Like Wilkie, William Allan travelled to Italy to recover from ill-health in 1829; he later visited Spain and Morocco. Unlike Wilkie, however, he did not radically transform his style or subject matter as a result of his foreign adventures but continued to look to Scottish sources, predominantly literary ones, as his main themes (no. 28). By contrast, the art of John Phillip was revolutionised by his experience of studying the culture and communities of Spain. Unlike Wilkie, in the vanguard of Spanish travel, who returned to London to find his Spanish paintings a reputation-breaker, for Phillip Spain was a reputation-maker: indeed, his Spanish work earned him the title 'Phillip of Spain' (nos 41–44). David Roberts (fig. 36), who also visited Spain, subsequently sought inspiration in the architectural landscape of the Middle East and was the first artist to familiarise British audiences with scenes from the Holy Land, Palestine, Egypt and Syria (nos 36, 37).

For many Scottish artists the landscape of Scotland itself was sufficient to underpin a long professional career. One such was Alexander Nasmyth, who spent two years in Italy in his youth but whose paintings of Scottish landscapes are driven by a uniquely native vision that

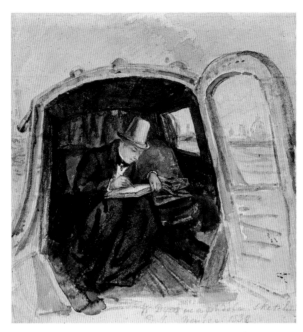

FIG. 38. David Scott, *William Dyce*, 1832. Watercolour. Scottish National Portrait Gallery PG 208

laid the foundations for Scottish landscape art (no. 27). Indeed, his vision of the landscape may have been influenced by his friend, the poet Robert Burns (1759–96).[4] Both Nasymth and James Giles (fig. 37) worked as landscape gardeners as well as landscape painters. Although Giles visited Paris, Italy and Switzerland, it is for his Highland landscapes, populated by stags, that this Aberdeen artist is best known (nos 45–48). Joseph Farquharson (1846–1935) later drew inspiration from the savagery of the Scottish winter landscape for his art (no. 55), while his unrelated namesake David Farquharson focused instead on the tranquil passing of the seasons and the rural rhythms of Scottish life (no. 56).

Robert Burns contributed a rich seam of literary source-material to artists of the early nineteenth century, with his narrative poem, *The Cotter's Saturday Night,* proving the most popular of all poetic subjects. But no writer contributed more to burgeoning notions of Scottish identity than Sir Walter Scott (no. 28). His retelling of episodes from Scottish history in his novels was mirrored by a renewal of interest in Scottish history and folklore in art. William Allan was persuaded by Scott himself to turn to historical painting, and others were quick to follow. The historical subjects of John Pettie (1839–93), while not exclusively Scottish, were driven by the same search for the romantic that informed Scott's historical novels (no. 61).

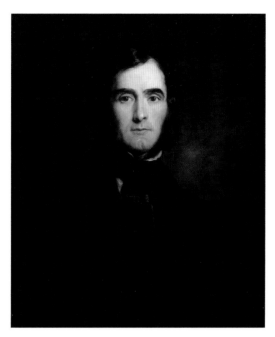

FIG. 39. Sir Francis Grant, *Self-portrait*, 1845. Oil on canvas.
National Portrait Gallery, London NPG 1286

Both William Dyce (fig. 38; nos 32–34) and Sir Joseph Noël Paton (no. 35) were associated with the Pre-Raphaelite Brotherhood, Dyce as an early supporter of William Holman Hunt (1827–1910) and Paton as a friend of John Everett Millais (1829–96). Although no Scottish artists fully embraced Pre-Raphaelitism, their impact on this pivotal movement was significant. Both Dyce and Paton were popular with Queen Victoria and Prince Albert, despite royal failure to endorse Pre-Raphaelitism itself.

Portraiture was an acknowledged speciality of the Scottish school of art. For Sir Francis Grant (fig. 39), a gentleman and a sportsman, it was sporting art rather than a training in portrait painting that proved an entrée into society portraiture and ultimately led to several royal commissions (nos 29–31). Landseer, together with the German artist Franz Xaver Winterhalter (1805–73), monopolised court portraiture from the 1840s onwards, but on Landseer's death it was the Scottish animal painter Gourlay Steell who succeeded as Animal Painter to the Queen in Scotland (no. 54).

1. *Art Journal*, 1850, cited in Irwin 1975, p. 37.
2. Irwin 1974, p. 353.
3. *Alexandra, Empress of Russia (1798–1860)*, RCIN 408911 and *The Grand Duchess Maria, afterwards Princess of Leuchtenberg (1819–76), and Grand Duchess Olga, afterwards Queen of Wurttemberg (1822–92)* RCIN 408912; see Edinburgh 1996.
4. Irwin 1975, p. 141.

28 Sir William Allan (1782–1850)
The Orphan, 1834

Oil on panel
85.7 x 72.4 cm
Signed and dated: *William Allan pinxt 1834*
RCIN 401189

PROVENANCE
Exhibited at the Royal Academy in 1834 and probably acquired from there by William IV or Queen Adelaide.

REFERENCES
Millar 1969, no. 653; Irwin 1975, p. 212; Edinburgh 2001, p. 94.

This painting is a personal lament by William Allan for the loss of his friend and supporter Sir Walter Scott, cast in the style of a scene of everyday life or genre painting. The 'orphan' is Scott's late daughter Anne (1803–33) and the scene is the dining room of Scott's home, Abbotsford. Allan knew the house well as he had been invited by Scott's son-in-law and biographer, J.G. Lockhart (1794–1854), to record the interiors shortly before the writer's death in 1832 (SNG, D 2700, 2704–9). The room is filled with works of art that suggest the range of his interests, but it is his massive carved oak chair that evokes most powerfully the absent monumental figure of Scott.

It was in part thanks to Scott that Allan became established as one of the most successful artists of his generation. There were two strains to Allan's output: exotic subjects inspired by his travels abroad to Russia (1805–14), Italy and the Ottoman Empire (1829) and to Spain and Morocco (1834); and subjects drawn from Scottish history. Allan's first exotic subjects, based on his Russian tour, did not find a ready market in Edinburgh. It was Scott, along with David Wilkie in 1817, who encouraged him to draw instead on episodes from Scottish history, rich in romance and drama, in an effort to revive a form of historical painting that had become moribund in Scotland since the death of his unrelated namesake David Allan. Scott also appointed William Allan as the first illustrator of the Waverley novels in 1820.[1] By sharing Scott's vision, Allan helped ensure that Scottish art and literature ran in parallel in the mid-nineteenth century, and his rise to success followed that of his mentor. He was appointed Master of the Trustees' Academy in Edinburgh in 1826, Associate and Member of the Royal Academy in 1825 and 1834 respectively, and President of the Royal Scottish Academy in 1838. In 1841 he succeeded Wilkie as Queen's Limner in Scotland and he was knighted the following year.

1. Hill 2013, pp. 99–100.

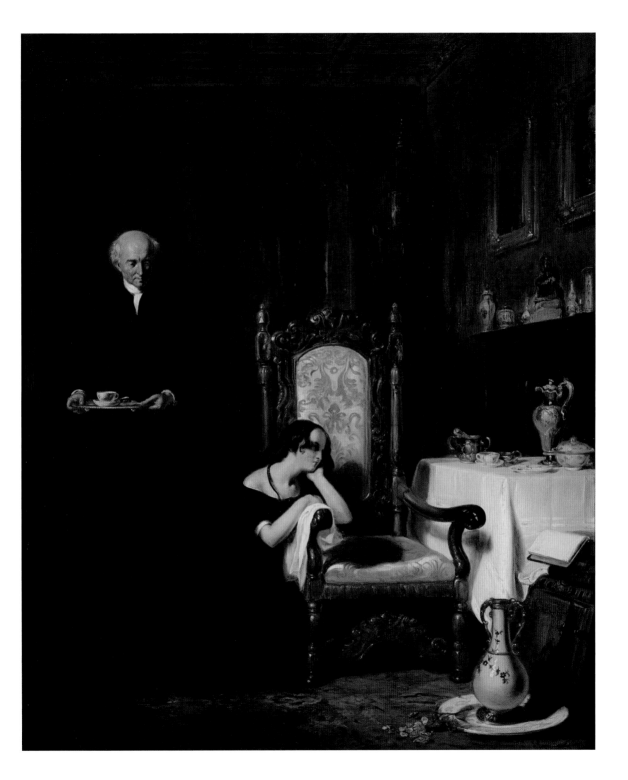

29 Sir Francis Grant (1803–1878)
Queen Victoria Riding Out, 1839–40

Oil on canvas
99.1 x 137.5 cm
RCIN 400749

PROVENANCE
Commissioned by Queen Victoria.

REFERENCES
Millar 1992, I, no. 270; Edinburgh 2003, no. 26; Edinburgh and London 2009, no. 31.

Queen Victoria and her entourage are seen here 'riding out' in Windsor Great Park, a practice that she greatly enjoyed as a young woman. Beside her is the Prime Minister, Viscount Melbourne; on the left, the Lord Chamberlain, the Marquess of Conyngham (1797–1876), raises his hat to her. Riding through a Gothic archway are, on the left, the Hon. George Byng (1806–86), later Earl of Strafford, Comptroller of the Household; Henry Paget (1797–1869), Earl of Uxbridge, Lord in Waiting; and Sir George Quentin (1760–1851), the Crown Equerry.

Lord Melbourne appears here as a protective father-figure, riding close to the Queen's side. He exerted a strong influence over Queen Victoria until her marriage to Prince Albert in 1840, and it is likely to have been at his suggestion that Francis Grant was commissioned to paint this group portrait. Grant was still at the outset of his career in 1839; he had been exhibiting at the Royal Academy since 1834 and painting profession-

ally for just over ten years. A gentleman and a passionate sportsman, he had made his name as a painter of hunting scenes. He had painted Melbourne only recently in *The Shooting Party at Ranton Abbey* (1839; Shugborough, NT inv. 85687), his most prestigious commission to date.

The qualities that had distinguished Grant's early hunting scenes are also evident here: he excelled at arranging riders in graceful groups that relate naturally to one another and was able to capture successful likenesses of both horse and rider. Likeness was always of supreme importance to Queen Victoria in her assessment of any portrait. She commented on Grant's achievement here: 'Grant has got him [Melbourne] so like it is such a happiness for me to have that dear kind friend's face, his expression, his air, his white hat and his cravat, waistcoat and coat, all just as he wears it. He has got Conyngham in also very like and Uxbridge, George Byng and Quentin ludicrously like'.[1]

Although the Queen's horse here is Comus, Grant's inspiration was the majestic mount ridden by Charles I in Sir Anthony van Dyck's *Charles I on Horseback* (NG, 1172). However, it was Reynolds and Gainsborough who became his dominant artistic influences as he moved away from equestrian and sporting paintings in favour of society portraiture during the 1840s and 1850s.

1. Journal, 24 July 1839.

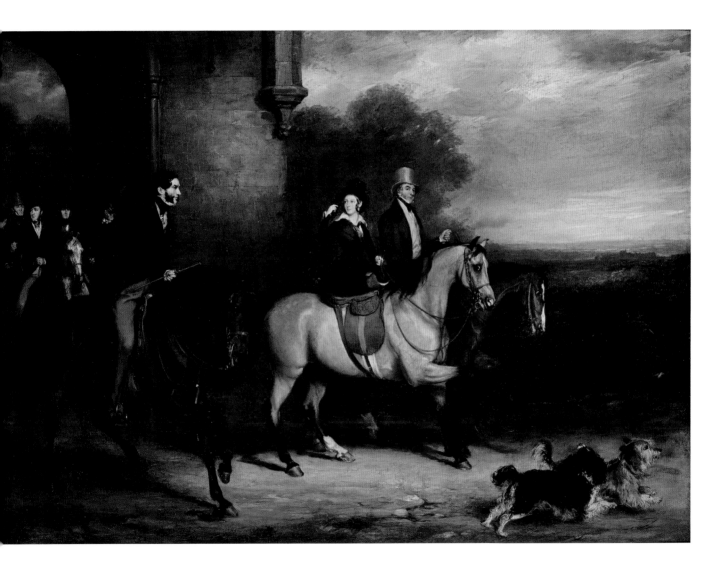

30 Sir Francis Grant
Queen Victoria on Horseback, 1845

Oil on canvas
34.3 x 29.8 cm
RCIN 400589

PROVENANCE
Given to Queen Victoria by Lady Grant after the artist's death.

REFERENCES
Millar 1992, I, no. 272; Edinburgh 2003, p. 30.

Grant's success with *Queen Victoria Riding Out* (no. 29) encouraged the Queen to commission two further portraits from him in 1842: *Queen Victoria with Victoria, Princess Royal and Albert Edward, Prince of Wales* (fig. 12) and another, small-scale double portrait of the children alone (RCIN 405044). When Grant was next called upon to paint official portraits of the Queen, the command came not from the Palace but from the United Services Club (1843) and from Christ's Hospital (1845). In the interim, the German artist Franz Xaver Winterhalter had started to pay annual visits to the English court and was never to relinquish his dominance as Queen Victoria's favourite court portraitist.

The commission for Christ's Hospital was for a large-scale equestrian portrait of Queen Victoria to commemorate her visit to the school. The sittings, which took place in October and November 1845, initially progressed well. However, in mid-October Grant was forced to rework the composition entirely, as it was too similar to an equestrian portrait of the Queen on which Landseer had been working intermittently since 1838 (RCIN 409252). This sketch shows the new design conceived by Grant, which derives from Van Dyck's equestrian portrait of *Albert de Ligne, Prince of Arenberg and Barbançon* (1600–74) (The Earls of Leicester and the Trustees of the Holkham Estate, Norfolk). The Queen's rearing horse is Hammon, an Arab given to her by the King of Prussia in 1844. In the background, a review of the cavalry is taking place in the Home Park at Windsor, in the presence of the Duke of Wellington.

Although Queen Victoria noted on 3 November that Grant 'is making a good picture of me and really has talent', she later became indifferent to his home-grown skills, complaining to Lord John Russell: '[Grant] boasts of never having been in Italy or studied the Old Masters. He has decidedly much talent, but it is the talent of an amateur.'[1]

1. Queen Victoria to Lord John Russell, 19 February 1866, RA VIC/MAIN/C/15/30.

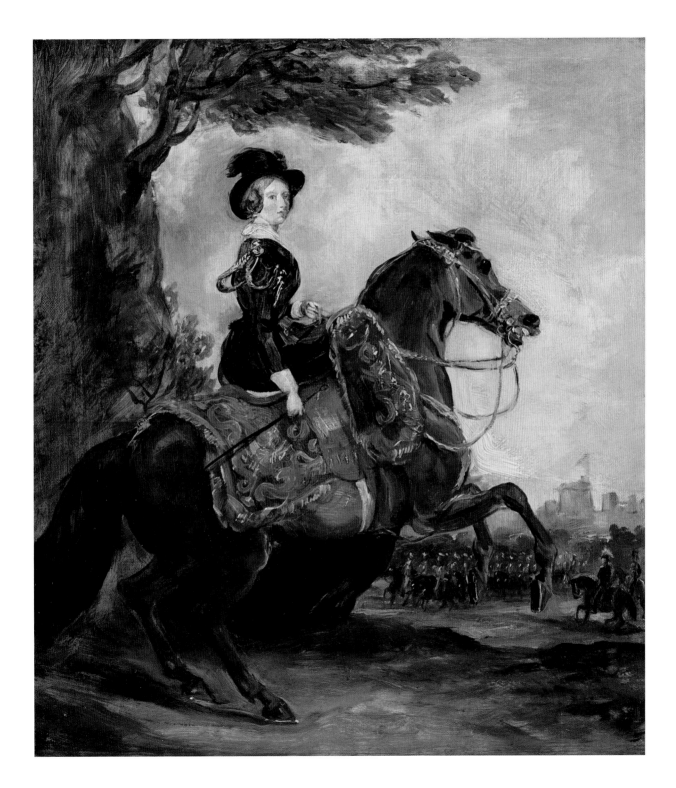

31 Sir Francis Grant
Prince Albert (1819–1861), 1845

Oil on canvas
45.1 x 35.6 cm
RCIN 400584

PROVENANCE
Presented to Queen Victoria by Lady Grant after the artist's death.

REFERENCE
Millar 1992, I, no. 273.

Prince Albert accompanied Queen Victoria to a review of the Regiment of Royal Horse Guards and the 2nd Battalion of Coldstream Guards at Windsor on 11 June 1845; he is shown here as he appeared on that occasion, in Field Marshal's uniform, with his charger. The sketch is for the full-length portrait of the Prince painted by Francis Grant for Christ's Hospital as a pendant to the equestrian portrait of Queen Victoria. Both portraits were exhibited at the Royal Academy in 1846.

Grant produced some of his most successful portraits in the mid-1840s and rose steadily to become the most fashionable portrait painter since Sir Thomas Lawrence. Eugène Delacroix (1798–1863), who saw four of Grant's pictures when they were exhibited at the Exposition Universelle in Paris in 1855, regarded him as a representative of the 'special charm of the English school'.[1] However, Grant took care to maintain his Scottish connections, returning home to paint every autumn. As the first Scottish President of the Royal Academy (1866), he worked hard to establish exhibitions of Old Master and early British paintings similar to those already mounted by the Royal Scottish Academy in Edinburgh. In 1859 he wrote: 'I think the Royal Academy of Scotland may read a lesson to other brethren in this, for we are far behind you in spirit and enterprise.' He may have been mindful of the importance to his own training and development of the copying of Old Master paintings in his youth in Edinburgh.[2]

1. *Journal d'Eugène Delacroix*, Paris 1932, II, pp. 338–9 quoted in Edinburgh 2003, p. 65.
2. *Annual Reports of the Royal Scottish Academy*, 1856–67, p. 45A, quoted in Edinburgh 2003, p. 76.

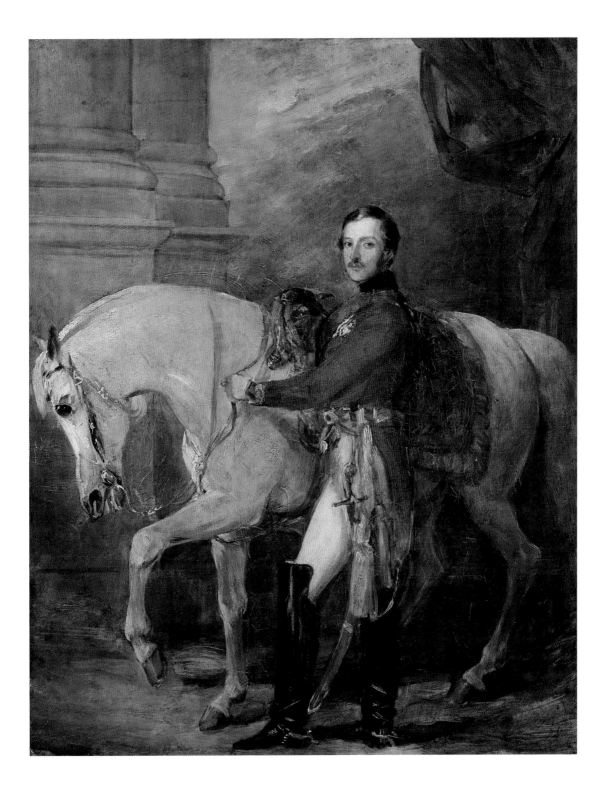

32 William Dyce (1806–1864)
The Madonna and Child, 1845

Oil on canvas
80.2 x 58.7 cm
Signed and dated: *WD* [in monogram] *1845*
RCIN 403745

PROVENANCE
Purchased by Prince Albert, 1845.

REFERENCES
Pointon 1979, pp. 87–8; London 1991a, no. 90; Millar 1992, I,
no. 227; London 1998, no. 35; Staley 2001, pp. 225–37;
London 2001, pl. 24; London 2010, no. 54.

William Dyce was born in Aberdeen but, following his
appointment as Superintendent of the Government
School of Design in 1838, spent the majority of his career
in London. He also made frequent trips to the Continent
for study, at times meeting with other Scottish artists,
such as in Venice in 1832 when the Edinburgh-born
artist David Scott (1806–49) drew a portrait of Dyce in a
gondola (fig. 38). Dyce played a leading role in cultural
debates in the 1840s and 1850s in which Prince Albert
was also heavily involved, such as those regarding the
management of the National Gallery and the decoration
of the newly rebuilt Houses of Parliament. Prince Albert's
undoubted favouring of Dyce manifested itself through
patronage: in addition to purchasing this painting, he gave
Dyce a number of royal commissions, including a share
in the decoration of the Garden Pavilion at Buckingham
Palace (now destroyed; fig. 13).[1]

The *Madonna and Child* was purchased by Prince
Albert in 1845 and exhibited at the Royal Academy the
following year. The Prince and Dyce shared a taste for
early Italian (and Northern European) art and culture.
Having studied extensively in Italy, Dyce's engagement
with early Italian art was profound: he painted devotional
subjects in a recognisably Quattrocento style, studied
and revived the technique of *buon* (true) fresco and, as
Professor of Fine Arts at King's College London, taught
an 'ethical' art history that favoured Italian art of the
fourteenth and fifteenth centuries.[2] His affinities with the
controversial young Pre-Raphaelite Brotherhood were
manifest when Prince Albert lent this painting to the
1855 Exposition Universelle in Paris, where it was hung
with works by the movement's founders, John Everett
Millais and William Holman Hunt.[3] Both on this
occasion and at its earlier showing at the Royal Academy,
Dyce's painting elicited a wide variety of responses.
These ranged from those who admired it, such as Queen
Victoria, who made her own copy of the upper half of
the composition in pastel in 1851 (fig. 40), to others who
found its archaising style 'a lifeless, soulless, rigid
reproduction of an obsolete mannerism'.[4]

Conservation of the painting in the 1990s revealed
that Dyce made a number of changes to the composition
as he worked on it. Most notably, the figure of the
Madonna was originally painted bareheaded, as she is
in what is generally accepted to be an earlier, perhaps
preparatory, variant of this work (Nottingham Castle
Museum and Art Gallery, NCM 1910–53). It is possible
that the models for this painting were Dyce's favourite
sister, Isabella (d. 1852), and one of her sons, who lived
in Scotland until 1844.[5]

1. See Gruner 1845, p. 8 and pl. 10.
2. Errington 1992, pp. 491–7.
3. *Exposition Universelle de 1855: explications des ouvrages de peinture, sculpture, gravure, lithographie et architecture des artistes vivants étrangers et français* (Paris, 1855) pp. 85–121.
4. *Spectator*, 16 May 1846, p. 18.
5. Isabella Dyce married Dyce's friend the Edinburgh lawyer Robert Dundas Cay (d. 1888) in 1835 and moved with her husband to Hong Kong in 1844, on his appointment as Registrar to the Supreme Court of the colony.

FIG. 40. Queen Victoria, after William Dyce,
Madonna and Child, 1851. Pastel. RCIN 980142

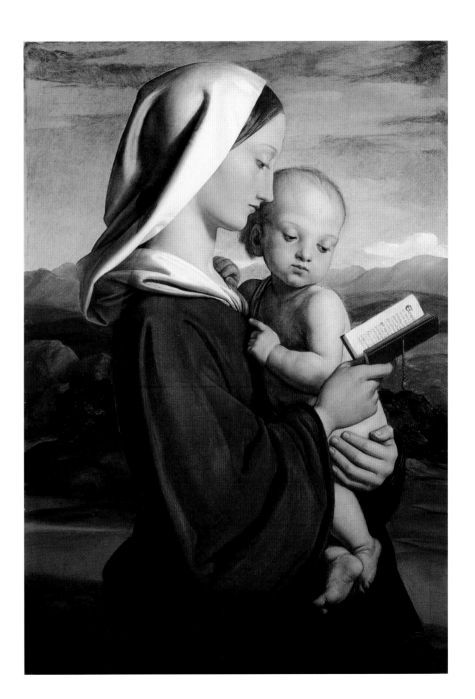

33 William Dyce
St Joseph, 1847

Oil on canvas
78.9 x 54.8 cm
Signed and dated: *W. Dyce. 1847*
RCIN 403746

PROVENANCE
Commissioned by Prince Albert.

REFERENCES
Pointon 1979, pp. 87–8; London 1991a, no. 91; Millar 1992,
no. 228; London 1998, no. 35; Staley 2001, pp. 225–37.

This painting was preferred by Prince Albert to its earlier companion piece, the *Madonna and Child* of 1845 (no. 32); the Prince thought the head of Joseph 'beautiful'.[1] It is confidently painted, with the canvas itself used as a mid-tone for Joseph's beard, and the highly finished figure with its heavy drapery rendered prominent against the more fluidly painted landscape background.

While the overall tonality of the *St Joseph* is darker than that of the *Madonna and Child*, their similarly generalised backgrounds are examples of what has been termed Dyce's earlier landscape style. In his later biblical paintings of the 1850s and early 1860s the landscapes take on more importance in relation to the overall composition and, significantly, are much more recognisable. While contemporary artists such as William Holman Hunt were presenting scrupulously researched depictions of biblical figures in their historical settings, Dyce was perplexing critics by introducing British, often distinctly Scottish, landscapes as a device to emphasise the immanence of Christ.[2] In this picture there are hints of the lowland Scottish scenery that later appears in his *Good Shepherd* of 1859 (Manchester Art Gallery, M10615).[3]

Dyce returned to and travelled widely in Scotland throughout his life, drawing increasingly on the country's landscape as a source of inspiration for his paintings.

1. Letter from Charles Anson to William Dyce, 13 March 1847; Dyce Papers, AAGM, (typescript of *The Life, Correspondence, and Writings of William Dyce, R.A., 1806–64: Painter, Musician, and Scholar by his son, Stirling Dyce*).
2. In response to Dyce's *Man of Sorrows* (SNG 2410), exhibited at the Royal Academy in 1860, which depicted Christ as a small figure within a localised Scottish Highlands landscape, the critic F. G. Stephens asked 'But why—with all this literalness—not be completely loyal, and paint Christ himself in the land where he really lived?' *The Athenaeum*, May 12 1860, p. 653. Dyce also visited Wales.
3. See Pointon 1979, p. 88 and 161–63.

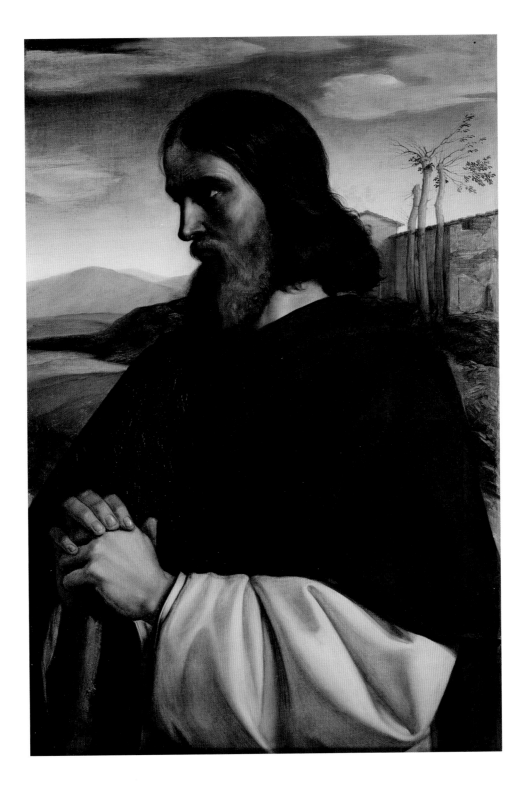

34 William Dyce
Princess Victoria (1840–1901) and *Princess Alice* (1843–1878), 1848

Stylus and coloured chalks on grey prepared ground
Whole sheets 57.8 x 44.8 cm and 56.3 x 46.3 cm respectively;
sight size 46.2 x 38.4, oval
RCIN 917908.a–b

PROVENANCE
Purchased by Queen Victoria from Colnaghi, 18 May 1865.

REFERENCE
Millar 1995, II, nos 5569–70.

These portraits of the eldest daughters of Queen Victoria and Prince Albert have long been attributed to George Housman Thomas (1824–68), following an annotation in the inventory of pictures at Windsor Castle begun in the 1860s.[1] However, on cataloguing them in the early 1990s, Delia Millar noted that they are 'stylistically unlike other known work by Thomas'.

In January 1848 Queen Victoria made a number of references in her Journal to Princess Victoria and Princes Albert Edward (later King Edward VII) and Alfred having sittings with 'Mr. Dyce' at Windsor Castle. On 3 February she noted that 'Dyce has sent the portraits of the Children, framed, & they really are beautiful, even though not very individual likenesses.'[2] It would seem that the Queen decided not to keep (or perhaps purchase) the works, as lots 55–8 in the posthumous sale of Dyce's studio in 1865 comprised portraits of 'HRH The Prince of Wales, when a child, HRH The Princess Royal, HRH The Princess Alice and HRH The Prince Alfred', all described as 'in chalks, in gilt frame, with cardboard mounts'.[3]

A few days later, on 18 May 1865, the Queen bought 'two drawings by William Dyce RA Portraits of HRH the Princess Royal and HRH the Princess Alice' from Colnaghi, whose name appears next to lots 56 and 57 in an annotated copy of the studio sale catalogue.[4] Why the Queen apparently rejected the four works in 1848 only to acquire two of them almost twenty years later is puzzling. Dyce's portrait of Prince Albert Edward, identical in size and technique to the present two works, was acquired by the National Gallery of Victoria, Melbourne, in 1877 (P167.31-1);[5] the whereabouts of the portrait of Prince Alfred is currently unknown.

The portraits of the royal children were executed during a period in Dyce's career when he is known to have been experimenting with materials and techniques of Italian Renaissance art. Notably, Dyce was an early protagonist in the revival of metalpoint drawing in nineteenth-century Britain, and the ground applied to the two Royal Collection portraits is very much an attempt to recreate the type of metalpoint ground used by artists such as Raphael and Leonardo.[6]

1. Millar 1992, I, p. lxxii.
2. Journal, 3 February 1848. The other dates on which the Queen noted her children sitting to Dyce were 6, 7, 8, 18, 20 and 24 January.
3. *Catalogue of the Whole of the Remaining Works in Oil, Drawings in Watercolour and Pencil, and Studies, of that distinguished artist William Dyce, R.A.*, Christie's, London, 5 May 1865. There is no mention in Queen Victoria's Journal of Princess Alice sitting to Dyce but the four drawings were clearly intended to be a set.
4. National Art Library, London. Lots 55 and 58 were purchased by 'Money' and 'White' respectively. The receipt for Queen Victoria's payment to Colnaghi is in the Royal Archives, RA PPTO/PP/QV/PP2/94/9024.
5. Presented by Duncan Elphinstone Cooper, an amateur artist and landholder who spent over a decade in Australia.
6. There are metalpoint drawings by Dyce in the V&A, the BM and SNG. Two are dated: one 1845 and the other 1849.

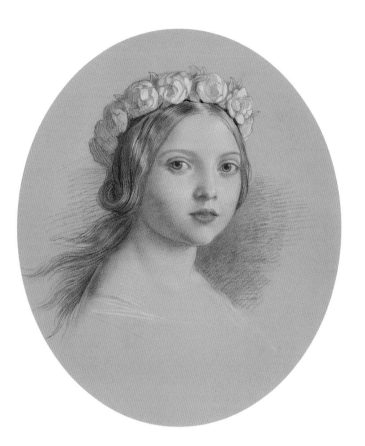

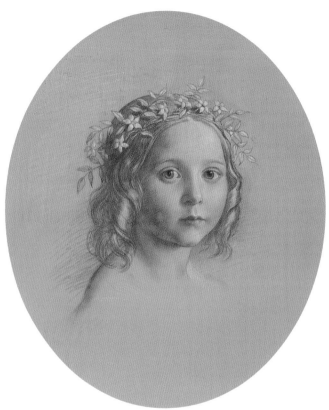

35 Sir Joseph Noël Paton (1821–1901)
'Home': The Return from the Crimea, 1859

Oil on panel
71 x 57.5 cm
Signed and dated: *NP* [in monogram] *1859*.
RCIN 406954

PROVENANCE
Commissioned by Queen Victoria in 1856 and given to the Prince Consort for Christmas 1859.

REFERENCES
Irwin 1975, p. 293; London 1991a, no. 75; Millar 1992, I, no. 541; London 2010, no. 68.

An injured veteran of the Crimean War is slumped by the fireside, moments after his return home to the embrace of his wife and the tears of his mother. The soldier is a corporal in the Scots Fusilier Guards, which suffered heavy losses during the Crimean campaign between March 1854 and February 1856. This guardsman has lost his left arm and sustained a head injury. The message of the painting—that Christianity will provide solace to this grievously injured soldier and his family—is indicated by the open Bible on the table and by the gleaming light of dawn breaking over the church spire in the background. The Christian overtones are further suggested by the composition, which echoes the traditional form of a Lamentation with the Virgin Mary and Mary Magdalene supporting the body of the crucified Christ.

Paton enjoyed a long-standing friendship with John Everett Millais and, although he never fully espoused the Pre-Raphaelite Brotherhood's aims, some of Paton's works demonstrate an affinity with their style. *'Home': The Return from the Crimea* reveals Pre-Raphaelite influence in the minute rendering of every detail in this interior. A fishing rod, which will never be used again by this limbless soldier, is suspended from the rafters; a box of folded letters lies on the table beneath the clock, which has marked the slow passage of time since the soldier's departure; and a Russian infantry helmet, a trophy of war, lies on the floor.

Paton first exhibited a larger painting on this subject at the Royal Academy in 1856 (Chrysler Museum of Art, Norfolk, 2006.5.1), where its combination of sentiment, patriotism and piety achieved great acclaim. Lady Eastlake commented that 'few came away from it with dry eyes. It is a superb thing'; and Queen Victoria was so struck with it that she commissioned the artist to paint this reduced replica.[1] He later received further royal commissions for two mourning scenes after the Prince Consort's death and for a triptych for Osborne House, completed between 1876 and 1885.[2]

Born in Dunfermline and settling in Edinburgh, Joseph Noël Paton rarely left Scotland, although he trained briefly at the Royal Academy Schools in London in 1843. He achieved early success in the competition to provide designs for the decoration of the new Houses of Parliament, submitting a design in 1847 (*The Reconciliation of Oberon and Titania*) that anticipated the fairy subjects for which he later became best known. He was appointed Her Majesty's Limner in Scotland and also knighted in 1867.

1. Eastlake 1895, II, p. 84.
2. Millar 1992, I, pp. lviii–lix.

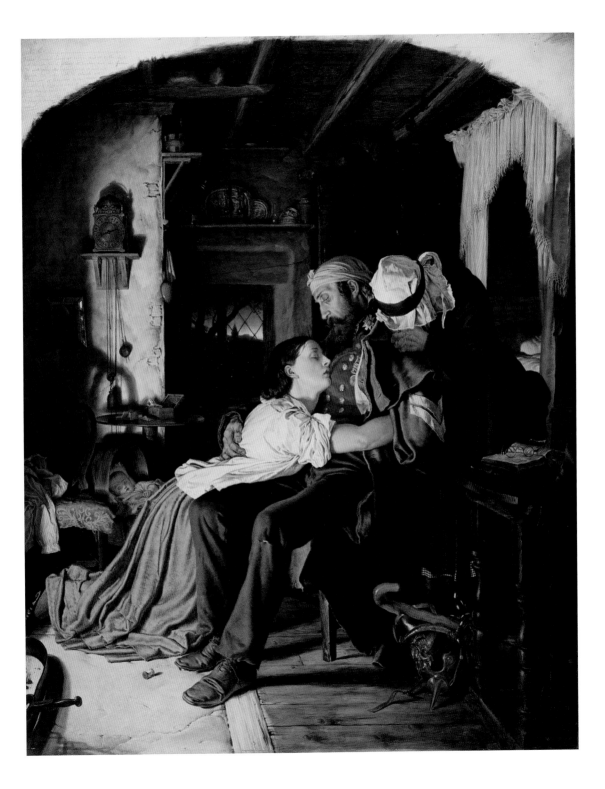

36 David Roberts (1796–1864)
A View in Cairo, 1840

Oil on canvas
23.5 x 35.4 cm
Signed and dated: *David Roberts. 1840*
RCIN 403602

PROVENANCE
Purchased by Queen Victoria for 100 guineas at the Royal
Academy in 1840.

REFERENCES
Guiterman 1990, p. 44, fig. 2; London 1991a, no. 72; Millar
1992, I, no. 584; London 2010, no. 51.

David Roberts was born into poverty in Stockbridge,
near Edinburgh, but became the leading topographical
artist of the mid-nineteenth century. He trained initially
as a house painter and decorator before moving to
London in 1822 to work as a theatrical scene painter
at Covent Garden and Drury Lane. He first exhibited at
the Royal Society of British Artists in 1824, becoming
its President in 1830, and also at the Royal Academy
between 1826 and 1864. He maintained his links with
Edinburgh, exhibiting in 1822 at the Institution for the
Encouragement of the Fine Arts in Scotland, and at
the Royal Scottish Academy between 1829 and 1865.
Roberts's primary inspiration was drawn from the
journeys he undertook to Spain (1832–3) and the Middle
East (1838–9). As only the second British artist to
explore Spain, and the first to travel to the Middle East,
he provided the British public with views of Spain and
the Orient that were almost entirely new to them.

In 1838, when David Roberts visited Egypt, Syria
and the Holy Land, this area was still undiscovered by
the artistic community despite being the focus of contem-
porary scholarly interest. The scenes he observed

inspired 55 oil paintings of this region, painted by
Roberts over the following years.

This view of Cairo shows the district of Bab
Zuweyleh (also known as Metawalea), at the heart of
which lies one of the three medieval gates leading into
the city. Above it tower the fifteenth-century minarets of
the mosque of Sultan Mu'ayyad Shaykh. Roberts
relished painting the mosques of Cairo, observing that
'some of the mosques are of the most extraordinary
description, of which there are not less than 400. To be
the first artist that has made drawings of these Mosques
is worth the trouble of a little inconvenience'.[1] This

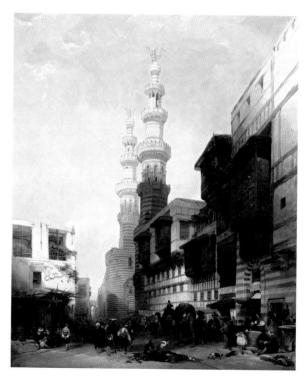

FIG. 41. David Roberts, *The Gate of Metawalea, Cairo*, 1843. Oil on
panel. Victoria and Albert Museum, London FA.176[0]

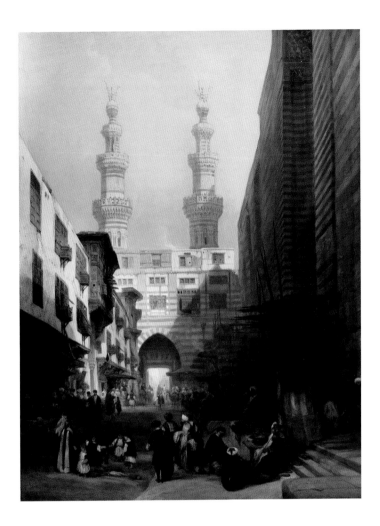

painting was one of the first to be seen in London after Roberts's return and was purchased by Queen Victoria soon after it was exhibited at the Royal Academy in 1840.

Another view of the *Gate of Metawalea, Cairo* was purchased from Roberts by the collector John Sheepshanks (1787–1863) in 1843 (fig. 41). In both cases, deep contrasts in light and shade and the addition of colourful foreground figures demonstrate Roberts's ability to transcend the merely topographical in the interests of dramatic effect. William Thackeray (1811–63) predicted

that there was 'a fortune to be made for painters in Cairo, and materials for a whole Academy of them'.[2] This proved to be correct in Roberts's case: his Middle Eastern works fetched high prices and met with great acclaim, ensuring his election to membership of the Royal Academy in 1841.

1. Guiterman 1978, p. 10.
2. W. Thackeray, *Notes on a Journey from Cornhill to Grand Cairo*, ed. M.A. Titmarsh, 2nd edn, London 1846, p. 205, quoted in London 1986, p. 205.

37 After David Roberts
Louis Haghe (1806–1885), lithographer
The Holy Land, Syria, Idumea, Arabia, Egypt and Nubia; from drawings made on the spot by David Roberts, v. III

London: F.G. Moon, 1847
Printed on paper, colour lithographed illustrations, burgundy goat binding, bookplate and bookstamp of Queen Victoria
63.5 x 42.0 x 4.0 cm
RCIN 1075156
Open at the Treasury at Petra, v. III, opposite p. 6

PROVENANCE
Acquired during the reign of Queen Victoria.

David Roberts was the first professional artist to visit the Middle East without a patron or a connection with a military expedition. He sailed to Alexandria in Egypt in 1838 and travelled up the Nile, through Cairo and Luxor to Abu Simbel, and on to the Holy Land, arriving in Jerusalem at Easter in 1839, before travelling north through Lebanon and departing from Beirut. He filled three sketchbooks and made 272 watercolours of temples, ruins, people and landscapes. It was these that provided the basis for the 247 lithographs by Louis Haghe, published in three volumes entitled *The Holy Land, Syria, Idumea, Arabia, Egypt and Nubia* between 1842 and 1849, and an additional three volumes, *Egypt and Nubia*, published in 1846. Haghe, the leading lithographer of the time, specialised in hand-tinted lithographs; the range of colours and tonality used in these volumes give a sense of the delicacy and sponta-neous quality of Roberts's original drawings. The

volumes also included detailed descriptions of the sites by the Irish writer and historian Revd George Croly (1780–1860). The publication, which was sold by subscription and was an immediate success, ensured that Roberts's views were seen by a wide audience and became the most popular images of the Middle East of his time. They were dedicated to Queen Victoria, who had acquired his *A View in Cairo* (no. 36) in 1840. The volumes were known by the artist and photographer Francis Bedford (1815–94), who was commissioned by Queen Victoria in 1862 to accompany the Prince of Wales, the future King Edward VII, on a tour around the Middle East and create a photographic record of the journey.[1]

1 See Edinburgh and London 2013 for a detailed discussion of Bedford's photographs of the Middle East.

FIG. 42. After David Roberts, *Abu Simbel* from *Egypt and Nubia;* v. I, 1846. Lithograph. RCIN 1075157

38 David Roberts
The Fountain on the Prado, Madrid, 1841

Oil on panel
25.2 x 36.2 cm
Signed and dated: *David Roberts 1841*
RCIN 405005

PROVENANCE
Commissioned by Queen Victoria and given by her to
Prince Albert for Christmas in 1841.

REFERENCES
Ballantine 1866, p. 144; Guiterman 1990, p. 44; Millar 1992,
I, no. 586.

When David Wilkie visited Spain in 1827–8 it was the
customs and appearance of the Spanish people that
particularly enthralled him. David Roberts, who arrived
in Spain in early December 1832, was attracted above all
by the Moorish architecture: the highlight of his journey
was his visit to the Alhambra in Granada. Earlier, in
Madrid, he had produced numerous city sketches,
including a watercolour of the fountain at the Prado,
in the Retiro Park, with the Observatory in the
background.[1] On his return to London, many of his
Spanish sketches were reproduced as engravings in the
Landscape Annual (1835–8) and as lithographs in
Picturesque Sketches in Spain (1837). The watercolour of
the fountain at the Prado relates closely to the frontis-
piece vignette for the *Landscape Annual* of 1837 (fig. 43)
and may also have served as the basis for Roberts's oil
painting of the same subject commissioned by Queen
Victoria and completed in 1841, eight years after his
return from Spain. He was paid £52 10s for the painting,
which hung in the Queen's Dressing Room at Osborne
House, and £26 5s for two drawings, including one of
the same subject (now untraced).[2]

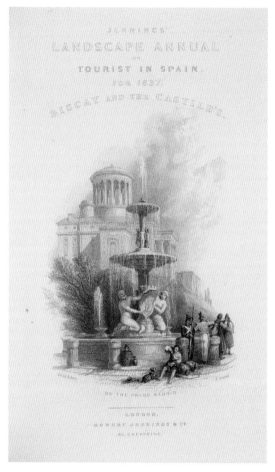

FIG. 43. Thomas Roscoe, *Jennings Landscape Annual for
1837; the tourist in Spain: Biscay and the Castilles*
(frontispiece), 1838. RCIN 1191069

1. Christie's, London, 19 November 1992 (lot 135). The sale of Roberts's
Spanish sketches at Christie's on 28 April 1860 included a view of the fountain
on the Prado with the Observatory behind (lot 155). His sale at Christie's on
13 May 1865 included a sketch of the fountain on the Prado (lot 231).
2. Millar 1995, II, p. 734.

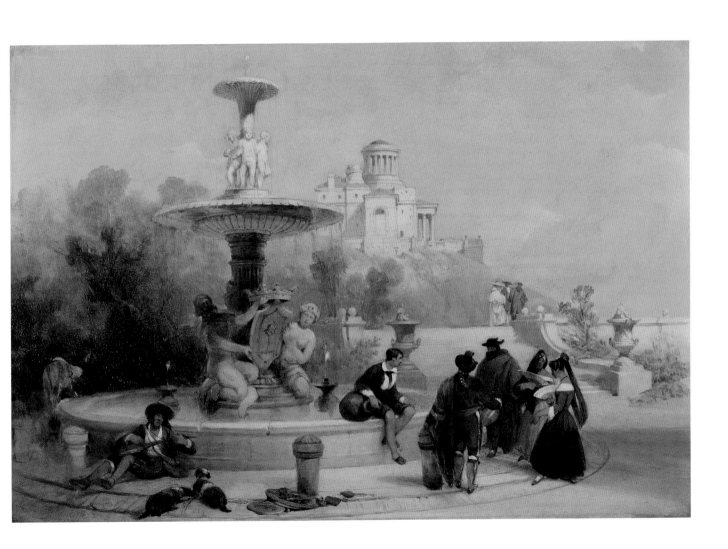

39 David Roberts
A View of Toledo and the River Tagus, 1841

Oil on panel
23.5 x 35.4 cm
Signed and dated: *David Roberts 1841*
RCIN 405042

PROVENANCE
Commissioned by Queen Victoria and given to Prince Albert on her birthday, 24 May 1841.

REFERENCES
Ballantine 1866, p. 144; Paisley, Dundee and Edinburgh, 1981–2, no. 4; Sim 1984, pp. 63–4; Guiterman 1990, p. 44, fig. 3; Millar 1992, no. 585.

Like no. 38, this view was inspired by David Roberts's seminal tour of Spain in 1832–3 but painted for Queen Victoria in 1841, many years after he had returned home. The composition was not, however, painted from direct observation: he had been unable to visit Toledo during his journey, as an outbreak of cholera prevented him from completing his planned itinerary. When Queen Victoria commissioned a view of the Alcantara Bridge across the River Tagus in the city, Roberts worked up an oil painting using a watercolour based on sketches provided by his fellow-traveller Edmund Head (1805–68).[1] Roberts's oil painting is also indebted to J.M.W. Turner's watercolour of *Florence from S. Miniato* (fig. 45). In both compositions the bridge is positioned in shadow in the middle distance, set against glowing sunlit water, with small groups of figures in the low foreground. Turner had been an early supporter of Roberts, and he and Roberts became close friends in the 1830s.

Roberts's painting met with 'perfect approbation' from Queen Victoria and Prince Albert.[2] When, ten years later, the royal couple wished to commemorate the opening of the Great Exhibition, they turned to Roberts again for two views of the Crystal Palace. The second and larger painting, depicting *The Inauguration of the Great Exhibition, 1 May 1851* (fig. 16), was commissioned

FIG. 44. Thomas Roscoe, *Jennings Landscape Annual for 1837; the tourist in Spain: Biscay and the Castilles, A View of Toledo and the River Tagus*, 1838. RCIN 1191069

FIG. 45. J.M.W. Turner, *Florence from S. Miniato*, c.1828. Watercolour. British Museum 1958,0712.426

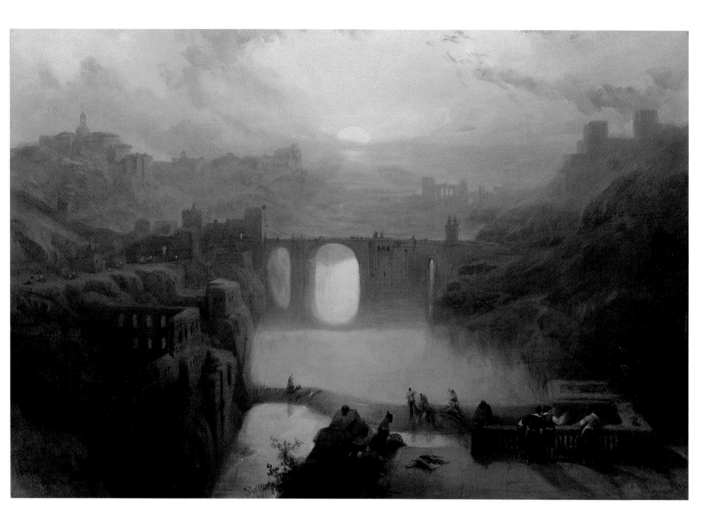

from a reluctant Roberts while he was travelling in Venice in 1851: 'I am in for it & must do my best', he wrote to his daughter.[3] The subject proved intractable and difficult. Despite the admonition of his friend, the painter Robert Scott Lauder (1803–69), to 'paint no more Crystal Palaces or hospitals, things of either kind are unworthy of your powers . . .', and Roberts's own preference for Italian and Belgian subjects throughout the 1850s,

Roberts returned to contemporary topographical scenes of London towards the end of his life with a series of paintings of the city seen from the River Thames.[4]

1. For the watercolour, see London, 1986, no. 19. *The Bridge of Toledo* appeared as an engraving after David Roberts in the *Landscape Annual* (1837) devoted to scenes of 'Biscay and the Castilles' (fig. 44).

2. Ballantine 1866, p. 144.

3. Guiterman 1990, p. 47.

4. Sim 1984, p. 270.

40 David Roberts
Ruins of the Abbey of Holyrood, 1823

Pencil and watercolour
35.1 x 23.3 cm
Signed, dated and inscribed: *David Roberts. 182[3]*
HOLYROOD; verso inscribed in a later hand: *Abbey Holyrood*
Sept 5/53 D. Roberts
RCIN 919572

PROVENANCE
Probably acquired by Queen Victoria.

REFERENCE
Millar 1995, II, no. 4603.

Roberts worked as a theatrical scene painter before he established himself as a landscape artist and painted the curtain at the Theatre Royal for the performance of *Rob Roy* presented to George IV during his visit to Edinburgh in 1822. He was also responsible for the panorama of Scottish scenery that decorated the supper room in the Assembly Rooms in Edinburgh on the occasion of the ball at which the King was present.

This watercolour of Holyrood Abbey was probably painted the following year. It shows the west front of the Abbey, where it joins the north side of the Palace of Holyroodhouse. The Abbey was founded in 1128 by David I of Scotland (r. 1124–53) but not completed until the thirteenth century. It suffered much damage over the years, particularly in 1544 during the Rough Wooing raid and in 1688, when it was ransacked, until in 1768 the roof collapsed. During the nineteenth century the picturesque remains added to the romantic setting of Holyroodhouse, and the scenic ruins of the Abbey attracted and inspired artists and writers. On a visit in 1829 the composer Felix Mendelssohn (1809–47) was moved by the melancholy grandeur of the Abbey to write his Scottish symphony.

This watercolour was probably added to one of Queen Victoria's Souvenir Albums in the 1850s. The verso is inscribed with the date on which the Queen spent a night at Holyroodhouse.

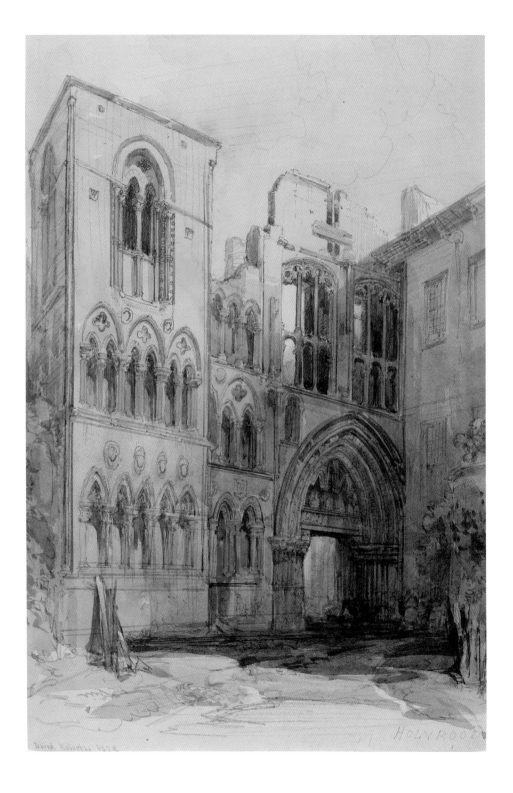

David Roberts 1828 HOLYROOD

41 John Phillip (1817–1867)
A Spanish Gipsy Mother, 1852

Oil on canvas
66 x 56.1 cm
Signed and dated: *John Phillip - / 1852*
RCIN 404588

PROVENANCE
Purchased by Queen Victoria and given to Prince Albert for Christmas in 1852.

REFERENCES
Aberdeen 1967, no. 26; Irwin 1974, p. 356; Irwin 1975, pp. 328–9; Millar 1992, I, no. 554; Aberdeen 2005, p. 33.

John Phillip, the son of an Aberdeen shoemaker, trained at the Royal Academy Schools in 1837. Like David Wilkie, his early work was dominated by tightly focused narrative scenes of Scottish rural life but was transformed by three visits that he paid to Spain, the first in 1851-2. Unlike Wilkie's, however, Phillip's Spanish

subjects painted on his return were received with universal acclaim, and the artist became popularly known as 'Phillip of Spain'.[1] In the autumn of 1852, Sir Edwin Landseer showed Queen Victoria a selection of Phillip's Spanish sketches. 'We were much pleased', the Queen wrote, 'with some very clever & talented sketches & studies, of Spanish gipsies at Seville & Ronda, & of some Sevillanas, – by an artist of the name of Philip.'[2] She immediately commissioned Phillip to paint two royal portraits (her favourite portrait painter, Franz Xaver Winterhalter, having returned to Paris in July).[3] She also bought this tender celebration of motherhood and gave it to Prince Albert for Christmas 1852, when she was expecting their eighth child, Prince Leopold. *A Spanish Gipsy Mother* was the first of four Spanish paintings by Phillip that she and Prince Albert were to acquire, mirroring the group of four Spanish pictures by Wilkie purchased by George IV (nos 16, 18-20).

Infused with the spirit of Murillo, this painting recalls Wilkie's painting of the same subject (fig. 46). John Phillip may have seen Wilkie's painting when he visited London in 1834 to view the Royal Academy exhibition where it was on display, or he may have been familiar with the engraving by Abraham Raimbach (1776-1843) published in 1836.

1. Mrs J.E. Penton, *Leaves from a Life*, London,1908, pp. 105-6, quoted in Aberdeen 2005, p. 34.
2. Journal, 31 October 1852.
3. Princess Feodora of Hohenlohe-Langenburg (1839-1872), RCIN 406943, and Princess Charlotte of Belgium (1840-1927), RCIN 406939

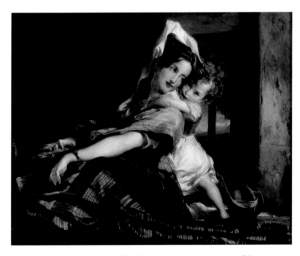

FIG. 46. Sir David Wilkie, *The Spanish Mother* 1833–4. Oil on canvas. Private Collection

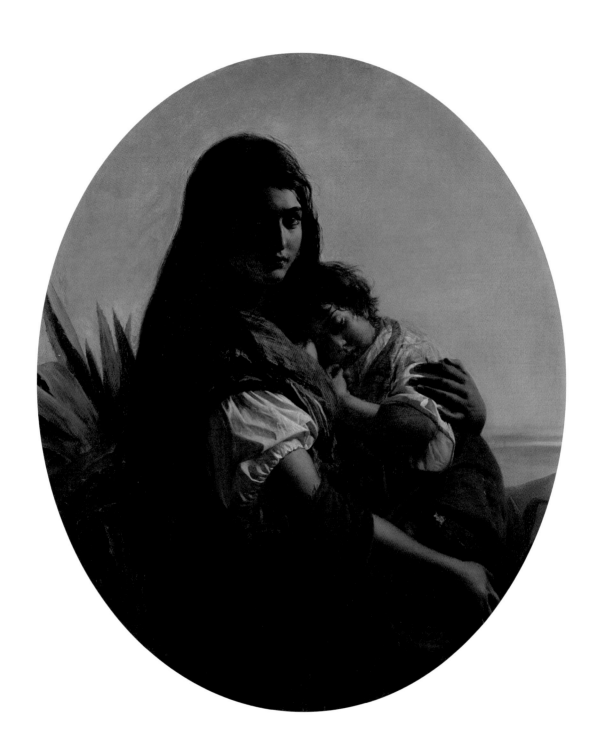

42 John Phillip
'El Paseo', 1854

Oil on panel
53.4 x 42.6 cm
Signed and dated: *JP* [in monogram] *1854*
RCIN 404597

PROVENANCE
Purchased by Queen Victoria and given to Prince Albert
for Christmas in 1854.

REFERENCE
Millar 1992, I, no. 556.

'The Promenade' which gives the painting its name
(*'El Paseo'*) is suggested not only by the two Spanish
girls, artfully posed in the sunlight in the foreground,
but by the couple (possibly their parents) strolling in the
distance beyond them on the right. Paintings like this,
which captured the exotic flavour and colour of Spain,
had become the mainstay of Phillip's work after his
return from Madrid and Seville in 1852. They catered to
the public appetite for glimpses of a country that had
been inaccessible to foreigners during the Spanish War
of Independence (1808–14) and had been romanticised
in the popular imagination by literature such as Lord

Byron's *Don Juan* (1819) and Prosper Mérimée's
Carmen (1845).

Phillip's Spanish subjects were very well received
when they were first exhibited at the Royal Academy
in 1853, one critic describing how their 'colour and
masterly execution astonished everyone'.[1] John Ruskin
(1819–1900) alone voiced concern when he viewed
'El Paseo' at the Royal Academy in 1855, stating that
'Mr Phillip's work … has become vulgar'.[2] Ruskin's
objection stemmed perhaps from the coquettish glance
and gesture of the girl on the left, who raises her fan
to protect herself from the glare of the sun. The
'wayward, half melancholy mystery of Spanish beauty'
that Ruskin longed to see instead was to be explored
further by Phillip during successive visits to Spain in
1856–7 and 1860–61.

Queen Victoria bought *'El Paseo'* for 120 guineas
and gave it to Prince Albert for Christmas in 1854. It was
placed in the Prince's Dressing Room at Windsor Castle.

1. Anonymous annotation in manuscript inserted in 40th Annual Report of the
RSA, 1867, quoted in Aberdeen 2005, pp. 34, 87.
2. Ruskin 1856, p. 7.

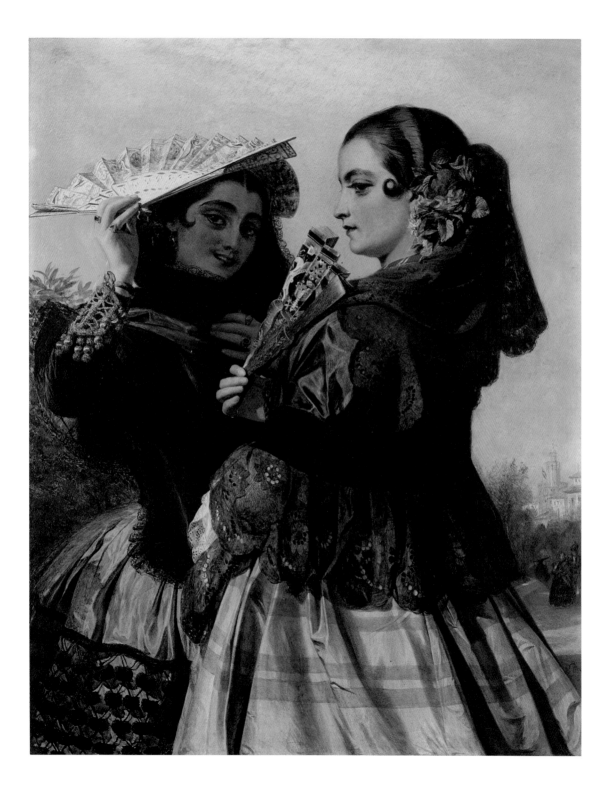

43 John Phillip
The Letter Writer of Seville, 1854

Oil on canvas
78.4 x 99.1 cm
Signed and dated: *JP* [in monogram] *1854*
RCIN 401188

PROVENANCE
Purchased by Prince Albert for £367 10s and given to Queen Victoria for Christmas 1854.

REFERENCES
Aberdeen 1967, no. 27; Irwin 1975, p. 323; Millar 1992, I, no. 555; Aberdeen 2005, p. 34; London 2010, p. 131.

The scribe (*escribáno*) or letter writer of the title sits with his back to the viewer, the better to display his embroidered jacket and the flowing cape flung carelessly across the back of his chair. This is the *capa* or *manta*, which was an essential part of male Spanish national costume that protected the wearer from scorching heat by day and piercing cold by night. The letter writer's name and occupation are indicated by the sign hanging on the wall above him. He leans towards a young woman on the left, who dictates a letter as she shields her face with her fan. Is the recipient of the letter the young matador depicted in a bullfighting scene on the fan? To the right, an illiterate young mother with her children waits patiently for the letter writer to read the letter that she is holding.

Richard Ford's *Handbook for Travellers in Spain* (1845) served as a guide to the customs and sights that Phillip encountered during his visit to Andalucia in 1851–2. Costume, architectural detail (the Moorish tower and arched windows in the background and the wayside shrine to the Virgin), accessories (such as the amphora) and character types (including the Catholic priest) all contribute to Phillip's accurate re-creation of the local setting.[1] The atmosphere is further enhanced by the glowing colours and brilliant sunlight that bathes the scene. When it was exhibited at the Royal Academy in 1854, *The Letter Writer of Seville* was singled out for praise on account of its 'atmosphere, local character and brilliant colouring'.[2]

This was third of four Spanish paintings acquired by the royal family between 1852 and 1858. It was bought by Prince Albert for £367, given to Queen Victoria for Christmas in 1853 and placed in the Duchess of Kent's Sitting Room at Osborne House. Even after Phillip's death in 1867, Queen Victoria made strenuous efforts to acquire any of the artist's work that came to the market, particularly his Spanish paintings.

1. Phillip also gave a prominent role to a large terracotta amphora in *La Loteria Nacional: Reading the Numbers* (AAGM, 004149).
2. *New Monthly Magazine* 1854, p. 48.

FIG. 47. After David Roberts, *The Letter-Writer* from *The Holy Land, Syria, Idumea, Arabia, Egypt and Nubia;* 1847, v. II. Lithograph. RCIN 1075159

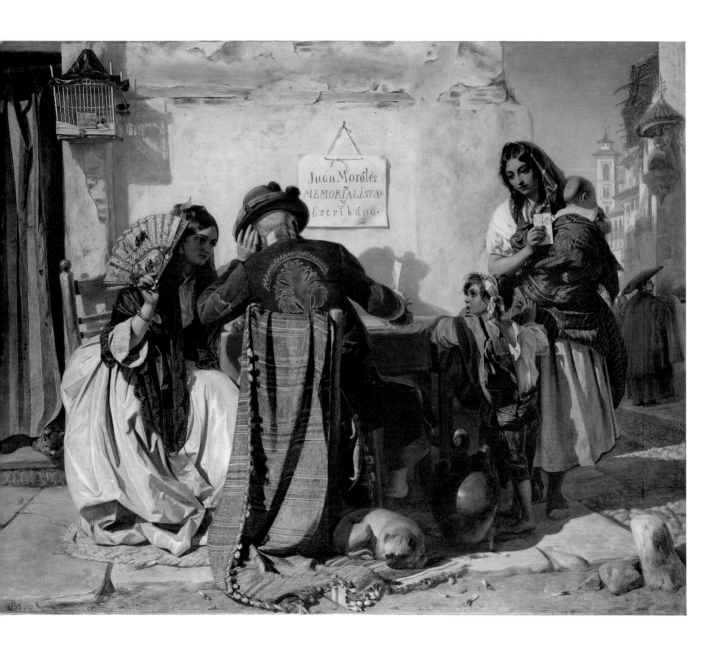

44 John Phillip
The Dying Contrabandista, 1858

Oil on canvas
132.1 x 203.2 cm
Signed and dated: *JP* [in monogram] *1858*
RCIN 404562

PROVENANCE
Purchased by Queen Victoria for 650 guineas and given to
Prince Albert for Christmas, 1858.

REFERENCES
Aberdeen 1967, no. 35; Irwin 1975, pp. 322–3; Millar 1992, I,
no. 557; Aberdeen 2005, p. 44.

Queen Victoria was enchanted with *The Dying Contra-
bandista*, which she first saw at the Royal Academy in
1858: 'Such splendid paintings (Spanish subjects) by
Philip,' she wrote, '5 or 6 in number, one, very large
one, the Contrabandista, in which figures a dying man,
with a distracted wife leaning over him, is magnificent'.[1]
The Queen bought the painting soon after the exhibition
and gave it to Prince Albert for Christmas the same year.

The subject of the wounded guerrilla had been
tackled by Wilkie (no. 20) in his series of heroic
paintings inspired by the Spanish resistance fighters of
the Spanish War of Independence. Phillip returns to this
theme in his depiction of the noble death of a smuggler
in the arms of his beloved. She holds a mirror up to his
lips in a gesture explained by lines from *King Lear*
published in the Royal Academy catalogue: 'If that [his]

breath should mist or stain the stone, why then [he]
lives'.[2] The setting is a *venta* or inn, from which two of
their companions keep watch.

The Dying Contrabandista was a product of
Phillip's second visit to Spain (1856–7), but it was not
until after his third and final visit (1860–1) that his style
moved away from the narrative tightness displayed here
towards the simpler, grander form of composition that
characterised his later work. He did not work exclusively
on Spanish subjects and continued to accept portrait
commissions throughout his career. In August 1857 he
had been commissioned to paint a large-scale ceremo-
nial painting to commemorate the marriage of Victoria,
Princess Royal. This included over forty portraits and
took almost three years to complete (fig. 17).

The 1860s were years of untrammelled professional
success for Phillip, but his workload and the stresses
of his family life put a strain on his health. Soon after a
visit to Italy in 1866 he succumbed to a stroke and died,
aged 49, in 1867. Queen Victoria wrote to Victoria,
Crown Princess of Prussia, soon afterwards: 'Were you
not grieved to hear of the death of our greatest painter
– Phillip? His pictures were so beautiful. Darling Papa
had such an admiration for him. He was only 2 years
older than me …'.[3]

1. Journal, 29 April 1858.
2. *King Lear*, act V, scene III.
3. Queen Victoria to Victoria, Crown Princess of Prussia, 13 March 1867,
RA VIC/Add U/32

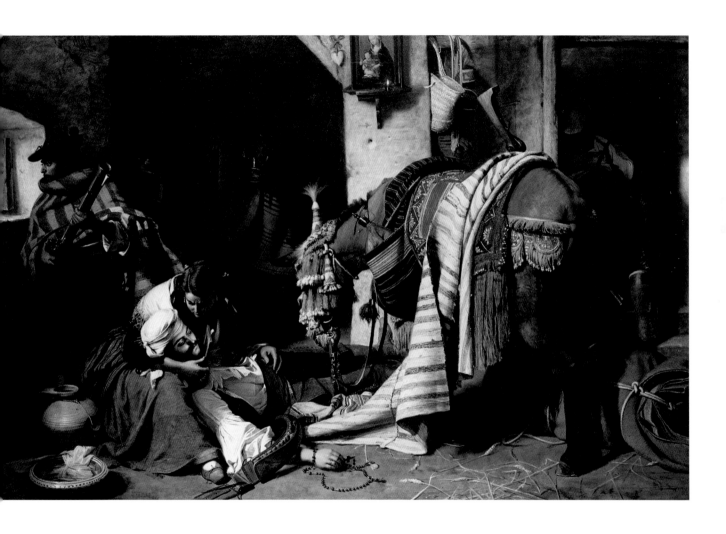

45 James Giles (1801–1870)
A View of Balmoral, 1848

Oil on panel
Signed and dated: *J. Giles / 1848*
56.0 x 81.6 cm
RCIN 405007

PROVENANCE
Given by Queen Victoria to Prince Albert for Christmas in 1848.

REFERENCE
Millar 1992, no. 254.

James Giles was born in Aberdeen and began his career as a drawing master and painter of snuff-box lids. After spending two years travelling on the Continent, particularly in Italy, he returned home to Aberdeen and worked for several Scottish landowners as a painter of views and a designer of gardens. This painting and no. 46, both views of the Balmoral estate, were Giles's first royal commissions; Queen Victoria gave both pictures to Prince Albert for Christmas in 1848.

The view is of the old castle of Balmoral from the east, with the River Dee to the north. Prince Albert acquired the lease of the Balmoral estate in 1848, following the death of the previous leaseholder, Sir Robert Gordon. The Prince and Queen Victoria had not seen the property but they were shown Giles's depictions of the castle during negotiations in 1847; Queen Victoria described it as 'a pretty little Castle in the old Scotch style ... In front are a nice lawn & garden, with a high wooded hill behind, & at the back ... the hills rise all around.'[1] The Prince purchased the estate outright in 1851 and shortly afterwards work began on a new castle in the 'baronial' style. Giles also produced drawings of the intended final appearance of the new castle for the royal couple (fig. 19) and in 1855 he was asked to record the interiors of the old castle before its demolition.

1. Journal, 8 September 1848.

46 James Giles
A View of Lochnagar, 1848

Oil on panel
Signed and dated: *J. Giles / 1848*
55.6 x 81.3 cm
RCIN 405006

PROVENANCE
Given by Queen Victoria to Prince Albert for Christmas in 1848.

REFERENCE
Millar 1992, no. 255.

Giles's view shows the mountain of Lochnagar, on the Balmoral estate, with deer in the foreground and the Gelder Burn in the distance. Like no. 45, this was commissioned by Queen Victoria after her first visit to Balmoral and given to Prince Albert for Christmas in 1848.

The Queen and the Prince had made an expedition up Lochnagar in September of the same year, where they had experienced bad weather: 'The scenery became finer & finally we ascended … but as we got on to Lochnagar it became cold & misty … as we reached the top, the mist drifted and hid everything … Alas! Nothing whatever could we see & it was cold, wet & cheerless.'[1] Only the day before, the Queen had sketched 'beautiful Lochnagar & the surrounding hills'.

Giles's painting catches the grandeur of the landscape, the deer amongst the autumnal foliage in the foreground against the silvery light on the heather-clad hills. As he recorded in his diary, 'the Queen and the Prince were very much pleased with my two paintings … Her Majesty liked them so much as to be induced to copy one of them.'[2] Giles was paid £100 for the two paintings. Queen Victoria's copy was done in watercolour (RCIN 450489).

1. Journal, 16 September 1848.
2. James Giles diary, 3 January 1849.

47 James Giles
The boundary between Balmoral and Invercauld, below the Keeper's House,
1848

Pencil and watercolour with touches of bodycolour
30.3 x 45.0 cm
Signed twice: *J. Giles 1848*; verso inscribed with title,
the artist's name and date: *Sep. 18th 1848*
RCIN 919616

PROVENANCE
Commissioned by Queen Victoria.

REFERENCES
Millar 1985, p. 43; Millar 1995, I, no. 2101.

This watercolour is probably a record of an expedition made in September 1848 by Queen Victoria to the Ballochbuie Forest on the boundary of the Balmoral and Invercauld estates.[1] Giles had painted a number of views of Invercauld for the Farquharson family in the 1840s and in 1848 he was commissioned by the Queen to paint a series of landscapes around Balmoral. The elaborately finished nature of this watercolour contrasts with the earlier and more freely painted works by Giles for the Farquharsons and for Sir Robert Gordon when he was the leaseholder of Balmoral (RCINS 919606–13). The foreground has been heavily worked, perhaps with a sponge, to create a variety of texture in the depictions of grass and trees. Although this work was completed in his studio, Giles preferred painting out of doors, commenting '… every artist knows with what rapidity and certainty he can sketch from nature but how difficult and tedious it is to repeat such a sketch – impossible.'[2]

The Ballochbuie Forest, one of the last remaining Caledonian pine forests, was owned by the Farquharsons of Invercauld. Queen Victoria purchased the forest in 1878 when the Farquharsons were planning to cut it down.

1. The date on the verso probably refers to the date of the expedition rather than the date on which the work was executed
2. James Giles diary, 3 February 1849

See also detail on page 33

48 James Giles
The Dubh Loch, 1849

Pencil and watercolour with touches of bodycolour
30.0 x 45.2 cm
Signed and dated: *J. Giles 1849*; verso inscribed with title
and date: *17 September 1849*
RCIN 919622

PROVENANCE
Probably commissioned by Queen Victoria.

REFERENCES
Millar 1995, I, no. 2107; Aberdeen 2001, no. 69.

This view of the Dubh (Dhu) Loch from the eastern end
shows the remote expanse of water within an amphi-
theatre of rock, with Cairn Taggart in the distance.
Queen Victoria recorded a visit to the Dubh Loch in
September 1849: 'We walked to a little hollow, immedi-
ately above the Dhu Loch & seated ourselves to have
some very welcome luncheon. The Loch is only a mile
in length & very wild, the hills rising perpendicularly
from it.'[1] According to his diary, Giles received instruc-
tions from the Queen shortly afterwards to make
drawings of the Dubh Loch and other views around
Glen Muick and Lochnagar.[2] On 1 October he travelled
through sleet and snow to the Dubh Loch to make a
sketch and verify one he had drawn on an earlier
occasion, but it was not until November that he began
work on the finished watercolour.

Giles's sketchbook (no. 49) shows studies of stags
for this watercolour, inscribed 'for the Queen's drawing'.

1. Journal, 17 September 1849.
2. James Giles diary, 28 September 1849.

49 James Giles
Sketchbook, 1848–56

Quarterbound sketchbook with black leather spine, marbled binding, 115 folios, open at fol. 31
Pen and ink
41.4 x 26.8 x 1.7 cm
RCIN 932572

PROVENANCE
Purchased by HM The Queen in 1993.

REFERENCE
Millar 1995, I, p. 29.

This sketchbook contains working studies in ink by James Giles, dated between 17 February 1848 and the end of September 1856. Many of the sketches are of deer and some relate directly to Giles's work for Queen Victoria: those on fol. 106 were used for the painting *A View of Lochnagar* (no. 46). Giles's accompanying notes often give an indication when they relate to his royal work: fol. 16, for example, is inscribed 'drawings for the Queen'. Studies of stags (fol. 34) stated to be 'for the Queen's drawing' were used in the watercolour *The Dubh Loch* (no. 48). Some of Giles's inscriptions comment on the weather – 'Commencement of a snowstorm/very cold indeed' – and his health: on one occasion he noted that his eyes were 'very, very weak' (fol. 34, dated November 1849).

Also in the sketchbook are drawings of cows, dogs and birds as well as ships, coastlines, houses and figures.

James Giles, *Sketchbook*, 1848–56. Pen and ink. Fol. 34

50 William Leighton Leitch (1804–1883)
Dalkeith Palace seen from the River Esk, c.1844

Pencil and watercolour with touches of bodycolour
25.0 x 36.7 cm
RCIN 919668

PROVENANCE
Presented to Queen Victoria in 1888 by the
Duchess of Buccleuch.

REFERENCE
Millar 1995, II, no. 3374.

William Leighton Leitch was born in Glasgow and initially trained as a decorator and scene painter with David Roberts (nos 36–40). Following a visit to Italy, he established a reputation as a drawing master and had a number of distinguished pupils, including the Duchess of Buccleuch and the Duchess of Sutherland. He was brought to the notice of Queen Victoria by one of her ladies-in-waiting, Lady Canning. Leitch reported: 'I had a note from Lady Canning, saying it was the Queen's desire that I should go down to Windsor to give her Majesty a series of lessons in water-colour painting.'[1] Queen Victoria had her first lesson with Leitch in 1846 and he continued to give lessons to the Queen and her children until 1865, when ill-health forced him to cease teaching. On his retirement he was given a pension by the Queen.

This watercolour is one of a series commissioned by the 5th Duke of Buccleuch to illustrate Queen Victoria and Prince Albert's first visit to Scotland in September 1842. The royal tour was largely organised by the Duke, who was Lord Lieutenant of Midlothian and Gold Stick of Scotland, and the Duchess, who was the Queen's Mistress of the Robes. The royal couple stayed with the Duke and Duchess at Dalkeith Palace for a number of nights during their tour. The house can be seen here in the distance, beneath the Montague Bridge (designed by Robert Adam in 1792) over the River Esk. Queen Victoria described Dalkeith as 'a large house built of reddish stone … and the Park is fine & large'.[2] She walked in the extensive grounds, 'down by the stream (the river Esk), under a fine bridge, up a steep bank along the river'.[3]

1. MacGeorge 1884, p. 58.
2. Journal, 1 September 1842.
3. Journal, 2 September 1842.

51

William Leighton Leitch
Fingal's Cave, Isle of Staffa, c.1847

Pencil, watercolour and bodycolour
13.7 x 23.3 cm
RCIN 919679

PROVENANCE
Commissioned by Queen Victoria.

REFERENCE
Millar 1995, II, no. 3397.

Queen Victoria and Prince Albert visited Fingal's Cave on the Isle of Staffa, one of the Inner Hebrides, on a tour of the west coast of Scotland in 1847. The Queen wrote of the moment they arrived at the mouth of the sea cave, formed entirely of hexagonal jointed basalt columns:

We came towards the corner, the wonderful Basaltic formation, which is most extraordinary, begins & we turned the corner to go into the renowned Fingal's Cave, the effect is splendid, like a great entrance to a hall, all vaulted but it looked rather awesome as we entered.[1]

The Queen was familiar with Felix Mendelssohn's overture *The Hebrides*, which he was inspired to write after a visit to Fingal's Cave in 1829.

Leitch may have accompanied the royal party on the tour of Scotland but it is more likely that he followed the route at a later date, when he made this drawing and recorded other places visited by the Queen, such as Arrochar, Oban and Inverary.

1. Journal, 19 August 1847.

52 William Leighton Leitch
Moonlight lesson: three stage drawing demonstration, c.1846–65

Pencil and wash
Each 8.0 x 14.0 cm
RCIN 919718–20

PROVENANCE
Painted for Queen Victoria.

REFERENCE
Millar 1995, II, nos 3521–3.

This series of three small drawings constitutes a lesson in painting for Queen Victoria; a detailed note by the artist explains the three stages of creating such a watercolour. The first sketch, of a ruined abbey in moonlight, with houses and figures in the left foreground, consists of three tones of colour wash. Leitch suggests: 'After the outline is done – wash the Whole over with yellow ochre – let the wash dry then – go over the region of the Castle with yellow ochre and a little cobalt & light red added.' The second sketch has shadows added: 'The tree next the moon – with French blue burnt umber & the slightest tinge of purple lake.' The third shows further colour added and the tones strengthened: 'The finish^d study is done with the same colours as the progressive studies merely going over the lights with the yellow ochres & the light reds – the distances with cobalt & the foreground with markings of Brown pink purple lake & indigo –.'

53 **Waller Hugh Paton (1828–1895)**
Edinburgh with a distant view of the
Palace of Holyroodhouse, 1862

Watercolour and bodycolour with gum arabic and burnishing
15.5 x 37.6 cm
Signed in monogram and dated: *WHP 1862*
RCIN 919573

PROVENANCE
Commissioned by Queen Victoria.

REFERENCE
Millar 1995, II, no. 4263.

Waller Hugh Paton was the son of a damask designer from Dunfermline and the younger brother of the artist Sir Joseph Noël Paton (no. 35). He followed his father into the textile business before becoming a landscape painter. He was elected to the Royal Scottish Academy in 1865, where he exhibited regularly until 1891. With his brother he probably attended the lectures given by the art critic John Ruskin on the principles of Pre-Raphaelitism in Edinburgh in 1853; he was influenced by the Pre-Raphaelite style for much of his career.

Paton chiefly painted landscapes, mostly of Scotland. This atmospheric view shows Edinburgh at sunset, looking west over St Margaret's Loch and Holyrood Park, with St Anthony's Chapel to the left, towards the east front of the Palace of Holyroodhouse and Holyrood Abbey, with Calton Hill, the National Monument and the Nelson Monument in the distance. The use of touches of bodycolour enabled Paton to build up a highly detailed finish in the foreground. The strong violet hue of the sky suffuses the entire scene, the 'favourite purple tints' often used by the artist in sunset scenes.[1]

Queen Victoria commissioned this view of Holyroodhouse as 'she used to see it on approaching it from the Station'.[2] The watercolour was originally mounted in one of Queen Victoria's nine Souvenir Albums, which were compiled by the Queen and Prince Albert during their marriage and comprised a chronological visual record of their lives together. The albums were dismantled in the early twentieth century and re-bound in new volumes, rearranged thematically and with additions, but a written record of the original contents and organisation still exists.

1. *Art Journal* 1874, p. 153; see Millar 1995, II, p. 681.
2. RA PPTA/PP/QV/PP2/014/11026.

54 Gourlay Steell (1819–1894)
Highland Cattle in the Pass of Leny, 1876

Oil on canvas
79.0 x 122.3 cm
Signed and dated: *Gourlay Steell. RSA 1876*
RCIN 403647

PROVENANCE
Commissioned by Queen Victoria in 1874.

REFERENCE
Millar 1992, I, no. 659.

A herdsman watches a herd of Highland cattle as they are driven through the Pass of Leny, north of Callander in the central Highlands. Queen Victoria was familiar with this remote location, having crossed the pass several times during a stay at Invertrossachs, near Callander, in 1869. She had encountered in the pass

FIG. 48. Gourlay Steell, *A Study of Highland Cattle*, 1873. Oil on canvas. RCIN 404116

'endless droves of wild looking, very small, shaggy West Highland cattle, with their drovers & dogs – most wild and picturesque – going to *Falkirk* Tryst'.[1] Steell had produced a sketch of Highland cattle in Callander in October 1873 and was commanded by Queen Victoria to produce a '*finished* picture of cattle the same size as the sketch of Highland calves' the following year.[2] The two calves in Steell's initial oil sketch (fig. 48) appear in the foreground of *Highland Cattle in the Pass of Leny*.

Queen Victoria's patronage of Gourlay Steell commenced on his appointment as Her Majesty's Animal Painter for Scotland following Landseer's death in 1873. He produced a number of paintings for the Queen of her favourite dogs and horses, reflecting the role that he fulfilled for the Scottish aristocracy as a specialist in canine and equestrian portraits.[3] Steell had specialised as an animal painter since the start of his career, after training at the Trustees' Academy in Edinburgh under Sir William Allan. He was an accomplished draughtsman as well as an oil painter. In the early part of his career he worked as a book illustrator; he later produced large-scale pastel and charcoal animal studies, such as *Young Noble and Bess* (1884) depicting two sheepdogs in a Highland setting (RCIN 452480). Steell exhibited at the Royal Scottish Academy between 1832 and 1894; he was elected an Associate in 1846 and an Academician in 1859. In 1882 he was appointed Curator of the National Gallery of Scotland.

1. Journal, 9 September 1869.
2. RA VIC/ADDT/130–1.
3. See Millar 1992, I, pp. 238–9.

55 Joseph Farquharson (1846–1935)
Flock of Sheep Approaching through a Blizzard, 1881

Oil on paper
14.3 x 22.5 cm
Signed: *J.F.*
RCIN 914252

PROVENANCE
Possibly acquired by Queen Victoria or Queen Alexandra.

REFERENCE
Millar 1995, I, no. 1837.

Joseph Farquharson made his name with wild snowscapes depicting the bleak beauty of the Highlands around his ancestral home in Aberdeenshire. The artist was the son of the laird of Finzean, an estate near Balmoral. He trained as an artist at the Trustees' Academy, Edinburgh, and then with the Scottish landscape painter Peter Graham (1836–1921). He also spent several winters from 1880 onwards in the studio of the Parisian society portraitist Charles Émile Auguste Duran (1837–1917), where he became acquainted with John Singer Sargent (1856–1925). It is likely that he also accompanied fellow students on visits to the Forest of Fontainebleau, where members of the Barbizon School had practiced *plein-air* painting, directly from nature.

Fortified by these experiences, Farquharson returned to Finzean and developed his own *plein-air* landscape style, choosing as his most frequent subject the resilience of animals, particularly sheep, in the face of hostile nature. He exhibited snowscapes annually at the Royal Academy in London until 1925, earning the nickname 'Frozen Mutton Farquharson'. Having found a successful idiom, Farquharson exploited its commercial appeal, with repeated large-print editions of his works produced by firms such as Frost and Reed. Academic recognition followed commercial success with his appointment as an Associate of the Royal Academy in 1900 and an Academician in 1915.

Queen Victoria may have acquired this work after seeing Farquharson's illustration 'Over Snowfields Waste and Pathless' in Dr R.A. Profeit's book, *Under Lochnagar* (1894). However, family tradition maintains that Queen Alexandra admired Farquharson's paintings and would visit the artist in his studio when she was staying at Balmoral, so it is also possible that she was responsible for acquiring this small oil sketch. This may be a study for a finished oil painting, although few preparatory works by the artist survive; most of his painting was done *in situ,* using an all-weather painting hut on wheels equipped with a stove that allowed him to endure the bleak weather conditions that he depicted.[1] Several painting huts were stationed at different locations around Finzean, allowing Farquharson to select the light and atmospheric conditions he required. He also made use of model sheep produced for him by William Wilson, a carver and gilder of Monymusk, Aberdeen, which could be arranged as he wanted.[2]

1. Evidence for the artist's working methods is incomplete owing to a fire at Finzean in the 1950s, which destroyed the artist's studio and much of the house.
2. Aberdeen, London and Edinburgh 1985, p. 10.

56 David Farquharson (1839–1907)
View of Strathmore with Harvesters, 1881

Oil on canvas
25.7 x 41.0 cm
Signed and dated: *D. Farquharson / 1881*
RCIN 409023

PROVENANCE
Purchased by Queen Elizabeth The Queen Mother in 1956.

FIG. 49. Sir James Guthrie, *A Hind's Daughter*, 1883. Oil on canvas.
Scottish National Gallery NG 2142

David Farquharson, from Blairgowrie in Perthshire, turned to landscape painting as a profession late in life, after beginning his career as a painter-decorator. By 1868 he had begun to exhibit paintings of rural life at the Royal Scottish Academy, initially recording scenes from his native Perthshire but eventually painting scenes from across the Highlands as well as Ireland. He moved in 1872 to Edinburgh and a decade later to London, settling finally in Sennen Cove in Cornwall in 1895. Farquharson was elected an Associate of the Royal Academy in 1905, two years before his death, which occurred during one of his regular visits to Scotland.

In this view of Strathmore, Perthshire, harvesters with their hay wagons are at work in a bright, open landscape. Farquharson's real interest here lies in the play of light on the haystacks and in capturing the atmospheric conditions that prevail across the deep valley. He shared this preoccupation with contemporaries of the Hague School, such as Anton Mauve (1838–88), whose works were well known in Scotland at this period and influenced other Scottish artists of his generation. Unlike artists such as Arthur Melville (1858–1904) and W. Darling McKay (1844–1923), however, Farquharson was not concerned with the detail of rural life and labour. Furthermore, his pastoral landscapes evoke a gentle, elegiac mood that is at variance with the more direct interpretation of the landscape scene demonstrated by Glasgow painters such as James Guthrie during the same decade (fig. 49).

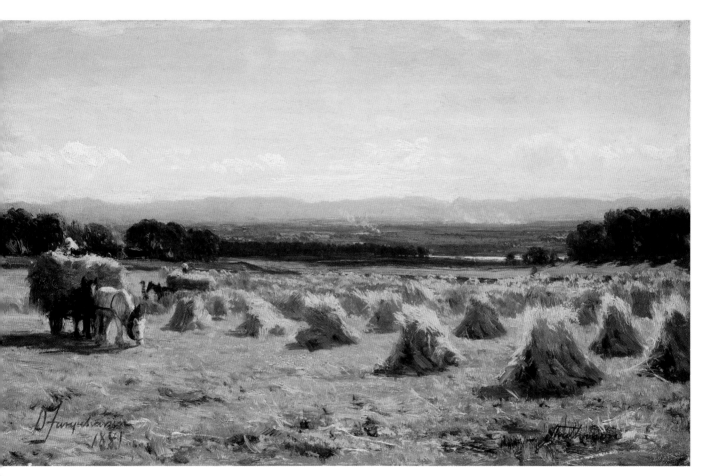

See also detail on pages 2–3

Kenneth MacLeay (1802–1878)

57 *Donald Stewart* (1827–1909) *and Charles Duncan* (1826–1904), *c.*1865–6

Pencil and watercolour
54.0 x 42.8 cm
RCIN 920714

PROVENANCE
Commissioned by Queen Victoria.

REFERENCES
Millar 1986, pp. 18, 24, pl. 5; Millar 1995, II, no. 3745.

58 *William Ross* (1823–1891), 1866

Pencil and watercolour
52.7 x 41.0 cm
Signed and dated: *K. McLeay RSA. 1866*
RCIN 920712

PROVENANCE
Commissioned by Queen Victoria.

REFERENCES
Millar 1985, p. 16, pl. II; Millar 1986, pp. 17, 23, pl. 5; Millar 1995, II, no. 3743; London and Edinburgh 2003–4, no. 83, p. 171.

Kenneth MacLeay was born in Oban and trained at the Trustees' Academy in Edinburgh before becoming a successful miniature painter. Working in watercolour, he later expanded his range to include larger portraits, partly in reaction to the impact of photography on miniature painting. These were highly successful, and in 1865 Queen Victoria commissioned him to paint a series of large watercolour portraits of her favourite retainers. The project took MacLeay several years and was expanded to include Scottish clansmen. It was published in 1870 in two volumes of chromolithographs entitled *The Highlanders of Scotland*.

Donald Stewart wears a kilt of Balmoral tartan and holds a gun and bonnet, while Charles Duncan is in a kilt and plaid of Royal Stewart tartan. Donald Stewart worked for Prince Albert from 1848 as Under-Forester and assistant to the Head Keeper, John Grant. He became Head Keeper on Grant's death in 1875 and retired in 1901. Charles Duncan was a ghillie from 1849, Keeper at Balmoral and Forester to the Prince of Wales at Birkhall from 1868. MacLeay was paid 30 guineas for this watercolour on 14 March 1866.[1]

William Ross, the Queen's Piper, is depicted in full Highland dress of Royal Stewart tartan, playing the pipes on the East Terrace at Windsor Castle. Ross, from Knockbain in Ross-shire, was appointed Queen's Piper in 1854 after serving in the 42nd Royal Highlanders. He set up a bagpipe business in London, which supplied pipes to all the Scottish regiments. An expert on pipe music, he often adjudicated at Highland Gatherings in Scotland and abroad, and published a *Collection of Pipe Music* containing four hundred tunes collected from Scottish and Irish pipers.

The detailed depiction of tartan by MacLeay in this series of watercolours was unmatched in any other nineteenth-century publication. Although the publication of *The Highlanders of Scotland* coincided with a time of major distress and mass emigration from the Highlands, no reference was made to these problems.[2]

1. RA PPTO/PP/QV/PP2/100/10128.
2. Smailes 1992, p. 15.

59 William Simpson (1823–1899)
The Ballroom, Balmoral Castle, 1882

Pencil, watercolour and bodycolour
Signed, dated and inscribed: *Wm. Simpson./1882/The Ball
Room Balmoral Castle*
35.0 x 56.6 cm
RCIN 919532

PROVENANCE
Probably painted for Queen Victoria or given to her by the
Prince of Wales, later King Edward VII.

REFERENCES
Millar 1995, II, no. 5037; London 2001, pl. 34.

William Simpson was a self-taught artist from Glasgow,
who was apprenticed to a lithographer and attended
the Glasgow School of Design in the evenings, before
moving to London. In 1854 he was invited to work as a
war artist in the Crimea. His watercolours were sent
back home from the Front to be made into a series of
lithographs, which Simpson dedicated to Queen
Victoria. He continued to travel extensively and from
1866 was Special Artist to the *Illustrated London News.*

In this role he covered the visit of the Prince and
Princess of Wales to Egypt in 1868–9 and the tour of the
Prince of Wales to India in 1875–6.

Simpson made sketches in the Balmoral area in 1881
and it is likely that these were studies for a series of
watercolours of the Castle and the surrounding country-
side, which were completed the following year. This
colourful watercolour shows guests dancing a lively reel
in the Ballroom on the occasion of either a Ghillies' or
Neighbours' Ball, with Queen Victoria and her party in
the alcove on the left. Simpson's depiction shows the
decoration of the Ballroom by Thomas Grieve of 1858.
It was described as 'a rare sight to see – being a splendid
specimen of artistic decoration; the Highland element,
in the shape of antlered stags' heads, dirks, swords and
sporrans, forming a striking object of interest'.[1] Simpson
recorded in his autobiography that he was asked by
Queen Victoria to make drawings for her album 'not
of the great events, marriages and the like – but the
lesser ceremonies'.[2]

1. *Aberdeen Herald*, 24 September 1859; quoted in Millar 1995, II, p. 592.
2. Eyre-Todd 1903, p. 86.

60 George M. Greig (c.1820–1867)
*The Palace of Holyroodhouse:
the Prince Consort's Sitting Room
and Dressing Room*, 1863

Pencil, watercolour and bodycolour
29.6 x 39.8 cm
RCIN 919571

PROVENANCE
Commissioned by Queen Victoria.

REFERENCES
Gow 1987, p. 128; Millar 1995, I, no. 2226.

George M. Greig, a watercolour artist based in Edinburgh who specialised in depicting historic buildings, seems to have been introduced to Queen Victoria by her mother, the Duchess of Kent. Greig 'was honoured with a commission from Her Majesty to execute three drawings of the interior of Holyrood'.[1]

Queen Victoria first stayed at the Palace of Holyroodhouse in 1850 and stayed a night or two each year on the journey to or from Balmoral. The former royal apartments on the first floor of the Palace had been restored and redecorated for her use by the Edinburgh decorator David Ramsay Hay (1798–1866), who repainted the spectacular plasterwork ceilings in rich colours.[2] This watercolour depicts the Prince Consort's sitting room and dressing room, and shows a shower cubicle in the corner and his slippers laid on the floor; the room was the King's Bedchamber in the seventeenth-century Palace. Greig also painted views of Queen Victoria's bedroom and her Evening Drawing Room (RCIN 919569 and 919567); the Queen was so pleased with these that she commissioned a further watercolour of her Morning Drawing Room (RCIN 919568). He was paid 40 guineas for each.[3] The Queen went on to commission from Greig a series of interiors of Alltnaguibhsaich on the Balmoral estate of which only one survives in the Royal Collection (RCIN 919501).

1. Art Journal, 1863, p. 176
2. Gow 1987, p. 128.
3. RA PPTO/PP/QV/PP2/72/5272.

61 John Pettie (1839–1893)
Bonnie Prince Charlie Entering the Ballroom at Holyroodhouse, 1891–2

Oil on canvas
158.8 x 114.3 cm
Signed: *J. Pettie*
RCIN 401247

PROVENANCE
Sold from the sale of the artist's studio, 1894; R. Wharton; Charles Stewart of Achara (1840–1916), by whom presented to King George V in 1916.

REFERENCE
Edinburgh 1983, no. 107.

This late work by the East Lothian artist John Pettie was exhibited at the Royal Academy in 1892, only a year before his death. Prince Charles Edward Stuart (1720–88) emerges from the shadows into the brilliant light of the Ballroom at the Palace of Holyroodhouse, his elegant figure bedecked in Stuart tartan, the floor in front of him strewn with silk favours. He is flanked by Donald Cameron of Lochiel (*c.*1700-1748) on the left and Alexander Forbes, 4th Lord Pitsligo (1678-1762), on the right. Both were loyal chiefs who joined the Prince's uprising in 1745 but lived out their lives in exile and in hiding after the defeat of the Prince's forces at the Battle of Culloden.

Like many of Pettie's historical themes, the painting depicts an incident that has a basis in fact but is embellished for pictorial effect. Prince Charles Edward Stuart led the campaign to regain the throne of Great Britain in the name of his father, Prince James Francis Stuart, son of James VII and II. The Prince seized Edinburgh in September 1745 and shortly after won a victory over the English forces at the Battle of Prestonpans. He held court at the Palace of Holyroodhouse before leaving in late October, heading for London. The ball at Holyroodhouse was, however, a literary creation, described by Sir Walter Scott in his novel *Waverley*, and Pettie seems to depict the moment when the Prince pauses on the threshold of the ballroom, 'dazzled at the liveliness and elegance of the scene now exhibited in the long-deserted halls of the Scottish palace'.[1] Pettie did not make use of an engraved likeness of the Prince but instead asked his son-in-law, Hamish McCunn (1868–1916), a composer, to model for the figure of Bonnie Prince Charlie.

Pettie's vivid narrative style was influenced by the early work of David Wilkie. However, his enthusiasm for costume pieces set in the seventeenth and eighteenth centuries may have been inculcated early on in his training, when he saw *La Rixe* (RCIN 404872) by Jean-Louis Ernest Meissonier (1815–91), which was lent to the Royal Scottish Academy by Prince Albert while Pettie was still a student in Edinburgh. He worked as a book illustrator early in his career, before moving to London in 1862. His works were exhibited at the Royal Scottish Academy from 1858 and at the Royal Academy from 1860 until 1892. He became an Associate of the Royal Academy in 1866 and an Academician in 1874.

1. Scott 1825, II, p. 215.

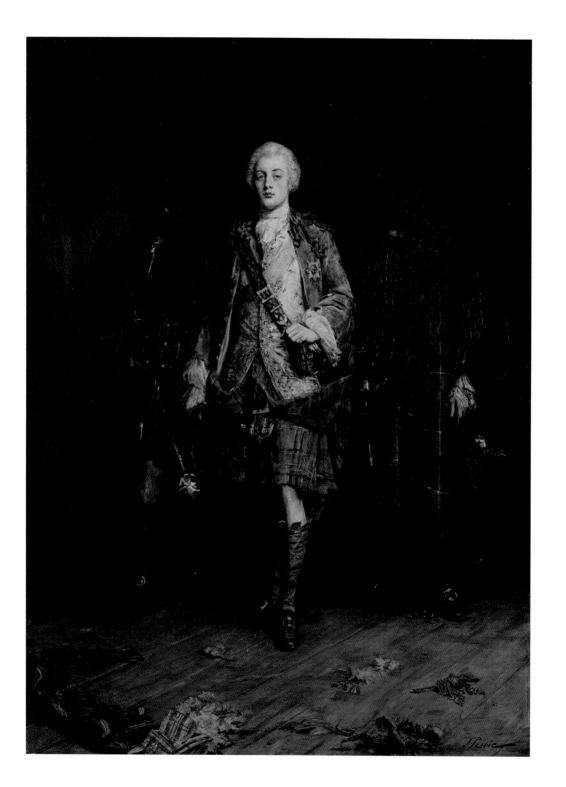

62 Sir James Guthrie (1859–1930)
In the Orchard, c.1888

Pencil, watercolour and bodycolour
14.7 x 12.6 cm
Signed: *J. Guthrie*
RCIN 922832

PROVENANCE
Glasgow Art Club Album, 1888.

REFERENCE
Millar 1995, I, no. 2255.

This watercolour was included in one of two albums of works by members of the Glasgow Art Club, founded in 1867 for painters in the city to exhibit their works together. The Club's standing in Glasgow was confirmed when, on the occasion of the opening of the Glasgow International Exhibition on 8 May 1888, the Prince and Princess of Wales (later King Edward VII and Queen Alexandra), were presented with two albums of watercolours by its members.[1] The albums included watercolours by Guthrie, E.A. Walton (no. 63) and Robert Macaulay Stevenson (no. 64), all members of the Glasgow Boys, the group of Scottish artists known for their naturalistic painting and realist subject matter.

James Guthrie, from Greenock, trained as a lawyer before he changed career to become a painter. After brief periods in London and Paris, he settled in Scotland and

FIG. 50. *Glasgow Art Club Album*, 1888, title page. RCIN 970478

committed himself to painting out of doors, directly from nature. In the company of other artists, he spent several summers painting in Cockburnspath in Berwickshire and Kirkcudbright on the south-west coast of Scotland. This small watercolour of girls collecting apples shows the bold colour and loose brushwork which characterise Guthrie's work of the 1880s. He had previously painted a large-scale oil of this subject, with the same title, but a different composition (SNG 2866).

1. The watercolours were mounted in a single album at a later date.

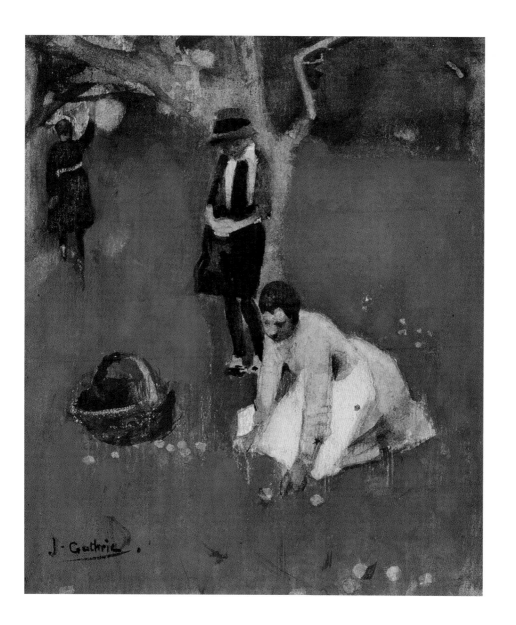

63 Edward Arthur Walton (1860–1922)
On the Way to the Tennis Court, c.1888

Pencil and watercolour
13.9 x 22.3 cm
Signed: *E.A. Walton*
RCIN 922826

PROVENANCE
Glasgow Art Club Album, 1888.

REFERENCE
Millar 1995, II, no. 5674.

E.A. Walton was one of the Glasgow Boys, the group of artists inspired by developments in landscape painting in France. Born in Renfrewshire, he trained in Düsseldorf and at the Glasgow School of Art. Like the other artists in the group, he sought to explore the natural effects of light in the open air.

Walton spent several summers with his close friend James Guthrie and others in Cockburnspath, in Berwickshire, and at his studio at Cambuskenneth, near Stirling. A leading member of the Glasgow Boys was the Irish-born painter Sir John Lavery (1856–1941), whose large painting *The Tennis Party* of 1885 (AAGM, ABDAG 002350) may have influenced Walton's small watercolour. Walton also painted murals for the main building of the Glasgow International Exhibition in 1888. His brother was the architect and furniture designer George Henry Walton (1867–1933).

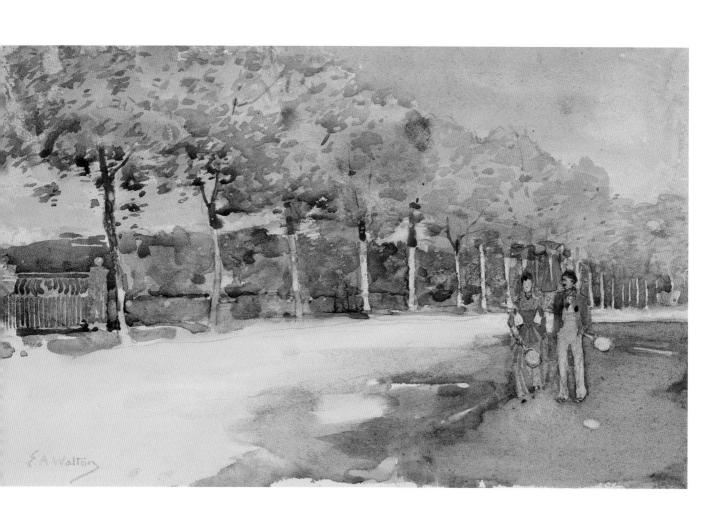

64 Robert Macaulay Stevenson (1860–1922)
Romance, 1888

Watercolour and bodycolour
20.7 x 17.5 cm
Signed, dated and inscribed: *R Macaulay Stevenson 1888*
and *Romance*
RCIN 922835

PROVENANCE
Glasgow Art Club Album, 1888.

REFERENCE
Millar 1995, II, no. 5163.

Stevenson, the son of a wealthy engineer, studied at the Glasgow School of Art and became associated with the Glasgow Boys. He spent some time in France and was influenced by the work of the Barbizon School, the group of French artists who worked in the Forest of Fontainebleau from 1830 to around 1870, and in particular the paintings of Jean-Baptiste-Camille Corot. Like Corot, he employed muted colours for his misty, moonlight scenes in oil or watercolour, which earned him the nickname 'The Moonlighter'.

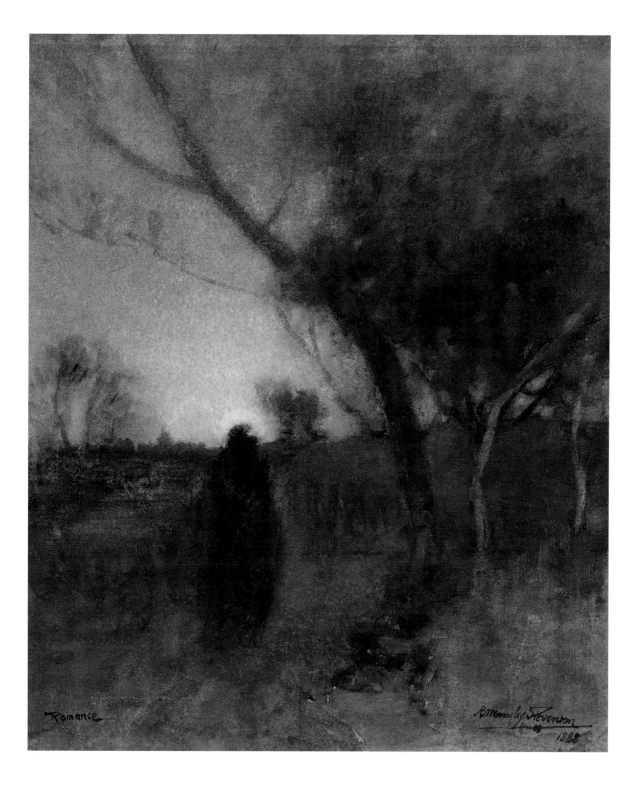

Romance R Manley Stevenson
 1888

65 Sir William Quiller Orchardson (1832–1910)
Prince Edward of York, 1897

Oil on linen
20.3 x 16.2 cm
Signed, dated and inscribed: *HRH / Prince Edward of York / 1897* and *WQO*
RCIN 914293

PROVENANCE
Probably acquired by King Edward VII or King George V.

REFERENCES
Edinburgh 1972, no. 67; Millar 1995, II, no. 4199.

Sir William Quiller Orchardson was born in Edinburgh and studied at the Trustees' Academy, where he was a pupil of Robert Scott Lauder (1803–69). On his move to London in 1865 he shared a house with fellow artist and Scot John Pettie (no. 61). Orchardson specialised in narrative paintings and portraiture.

This small study of Prince Edward of York (later King Edward VIII), Queen Victoria's great-grandson, is one of a group of portrait sketches of members of the royal family (RCIN 913963–6) for a large painting, *Four Generations: Queen Victoria and her Descendants,* commissioned in 1897 by the Royal Agricultural Society (GAC 0/632; fig. 51). The finished painting depicts Queen Victoria with her son, the Prince of Wales (later King Edward VII), her grandson, the Duke of York (later King George V) and her great-grandson, Prince Edward of York. Orchardson's daughter remembered how her father conceived the scene: 'My father … invented the little scene (which very likely actually occurred) of the small great-grandson presenting a bouquet to his great-grandmother, with the two princes of the intervening generations looking on with fatherly and grandfatherly pride.'[1]

Orchardson negotiated a sitting with the Queen at Windsor and selected as the setting 'the long corridor, outside her dining room, where she often sat, in a special chair with a rod to raise and lower it at will'. The Prince of Wales and the Duke of York each visited Orchardson's London studio in Marylebone and his home at 13 Portland Place.[2] Prince Edward is shown here, as in the finished picture, wearing a sailor suit and holding a bunch of flowers, although in an oil study for the picture, probably executed slightly earlier in the year, he wears a frock and has curls (NPG 4536).

1. Gray 1930, p. 284.
2. Gray 1930, p. 286.

FIG. 51. Sir William Quiller Orchardson, *Four Generations: Queen Victoria and her Descendants,* 1899. Oil on canvas. Government Art Collection 0/632

H.R.H.
Princ Edward of York.
1897.

W.G.O.

Miniatures

66 Andrew Robertson (1777–1845)
Princess Elizabeth (1770–1840), 1807

Watercolour on ivory laid on card
10.9 x 8.1 cm
RCIN 420228

PROVENANCE
Commissioned by Augustus, Duke of Sussex, in 1807.

REFERENCE
Walker 1999, no. 899.

Andrew Robertson, the son of an Aberdeen architect, trained in Edinburgh under Alexander Nasmyth and Sir Henry Raeburn before entering the Royal Academy Schools in 1801. He aimed to challenge the very premise of miniature painting, bringing the art form closer to that of oil painting in scale and technique and rai sing the status of the miniature painter in the process. He used large, rectangular ivory plaques that were unlike the smaller oval surfaces favoured in the late eighteenth century, and employed gum mixed with varnish in the latter stages of painting to produce a highly finished, glossy surface that emulated oil paint. His work was an instant success. Robertson was appointed Miniature Painter to Augustus, Duke of Sussex (1773–1843), younger brother of the Prince Regent, for whom he painted a series of miniatures of the royal princesses in 1807.

Princess Elizabeth, third daughter of George III and Queen Charlotte, sat for Robertson at Windsor Castle in February and March that year. The artist described her as 'a hearty girl, dignified, sensible and accomplished, more style about her than the rest'.[1] The princess was a talented artist herself, and a number of her etchings and silhouettes were published during her lifetime. In 1818, at the age of 48, she married Frederick, Hereditary Prince of Hesse-Homburg, later Frederick VI, Landgrave of Hesse Homburg (1769–1829).

1. Robertson 1897, p. 140.

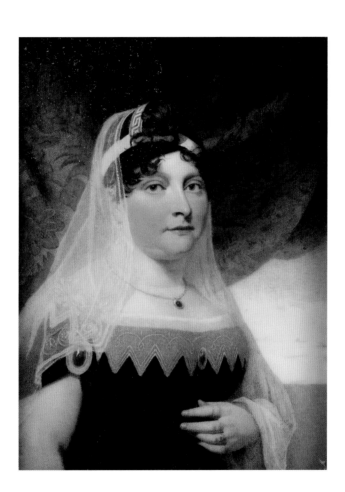

67 Andrew Robertson
Princess Sophia (1777–1848), 1807

Watercolour on ivory laid on card
11.0 x 8.4 cm
RCIN 420227

PROVENANCE
Commissioned by Augustus, Duke of Sussex, in 1807.

REFERENCE
Walker 1999, no. 900.

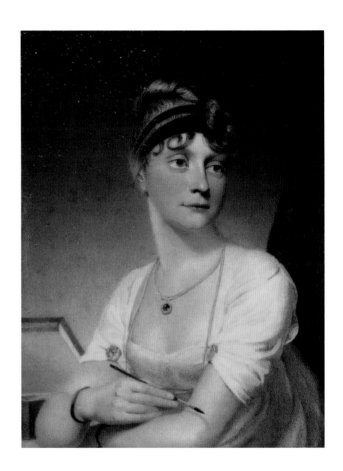

Another in the series of portrait miniatures of the royal princesses, painted at Windsor Castle in 1807, this one depicts Princess Sophia, fifth daughter of George III. Robertson recorded his impressions of Princess Sophia as 'sensible, mild, reflective and good', reflecting her character in this miniature: she appears to concentrate on the subject she herself is painting, with brush in hand and colour-box behind her.[1] In the same year Robertson painted George, Prince of Wales, later George IV; he subsequently depicted Sir Walter Scott, Robert Southey, Sir Thomas Lawrence and Sir Francis Chantrey in miniature.

The impact of Robertson's 'new large style' was long-lasting and his pupils, such as Sir William Ross, ensured that his new approach to miniature painting was sustained in Britain.[2] Andrew Robertson's brothers, Archibald (1765–1835) and Alexander (1772–1841), practiced as miniature painters in New York from the early 1790s onwards, ensuring that the techniques they had learned in Edinburgh and London spread to the newly independent United States of America.

1. Robertson 1897, p. 142.
2. Robertson 1897, p. 76.

68 Sir William Ross (1794–1860)
Queen Victoria (1819–1901), 1838

Watercolour on ivory laid on card
4.6 x 3.9 cm
Signed and dated on the reverse: *Painted by /*
W.C. Ross / 1838
RCIN 420959

PROVENANCE
Commissioned by Queen Victoria in 1837.

REFERENCES
Reynolds 1988, p. 166, pl. 111; Remington 2010, II, no. 702.

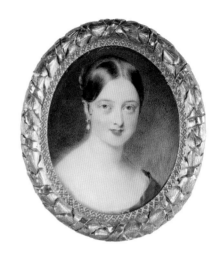

Queen Victoria collected portrait miniatures as a child. This was the first to be painted of her as a reigning queen and soon after it was finished she appointed William Ross Miniature Painter to the Queen, warmly praising him as 'the best miniature painter there is'.[1] Ross became an Associate of the Royal Academy in 1838 and an Academician in 1842, and in the same year he became the first miniature painter since the seventeenth century to be knighted.

Ross had been trained by Andrew Robertson (nos 66, 67), who may have been a family member. Ross's miniatures were admired for their naturalism, a peculiarly Scottish characteristic that can be traced back through Robertson to Sir Henry Raeburn and Allan Ramsay. This quality is particularly evident here, where the only indication of Queen Victoria's regal status is the slender section of Garter ribbon at her shoulder. According to Ross's obituary in *The Times*: 'far from partaking of "The Grand Style", the composition of his figures and groups and the feeling of his heads became eminently pure and natural and had that something more than simplicity which the artist would agree to call naiveté'.[2]

1. Queen Victoria to Charles, Prince of Leingingen, 13 December 1837, RA VIC/QVLB 53/3.
2. *The Times*, Wednesday 1 February 1860, p. 5.

Sir William Ross

69 *Victoria, Princess Royal* (1840–1901), 1845

Watercolour on ivory laid on card
6.0 x 5.7 cm
Inscribed on the reverse: *Painted by / W.C. Ross R.[A] /
Miniature [Painter to The Queen]*
RCIN 420340

70 *Albert Edward, Prince of Wales*
(1841–1910), 1846

Watercolour on ivory laid on card
6.6 x 5.7 cm
RCIN 420337

71 *Princess Alice* (1843–1878), 1847

Watercolour on ivory laid on card
6.1 x 5.7 cm
RCIN 420338

72 *Prince Alfred* (1844–1900), 1848

Watercolour on ivory laid on card
6.2 x 5.7 cm
Signed and dated on the reverse: *Sir W.C. Ross R.A. Miniature
Painter to The Queen 1848*
RCIN 420339

PROVENANCE
Commissioned by Prince Albert and given to Queen Victoria.

REFERENCE
Remington 2010, II, nos 711, 714–16.

This group of four from a series of nine portrait miniatures depicts children of Queen Victoria and Prince Albert, each painted at around the age of four or five. Eight of them were painted by Sir William Ross between 1845 and 1857; the ninth, depicting Princess Beatrice, was painted by Annie Dixon (1817–1901) after Ross's death.[1] Prince Albert's accounts suggest that they were commissioned by the Prince and given by him to Queen Victoria.

Ross excelled at painting children and was regularly commissioned to produce miniatures of Queen Victoria's immediate and extended family. Many were inset into items of jewellery and worn as treasured keepsakes. Through Queen Victoria's active patronage, Ross was invited to paint the royal families of Belgium (1840), France (1841) and Portugal (1852), and by the end of his career he enjoyed an international reputation and an unprecedented level of success for a miniature painter.[2]

1. The remainder of Ross's set shows Princess Helena (RCIN 420341), Princess Louise (RCIN 420336), Prince Arthur (RCIN 420342) and Prince Leopold (RCIN 420343). Annie Dixon's miniature of Princess Beatrice is RCIN 422018.
2. Remington 2013, pp. 83–90.

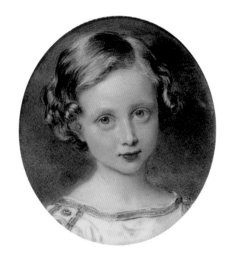

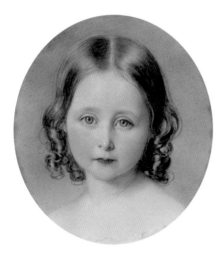

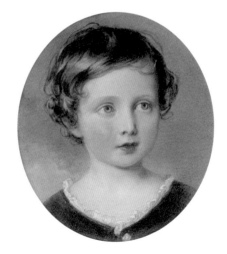

Sir William Ross:
Victoria, Princess Royal (1840–1901)
Princess Alice (1843–1878)

Albert Edward, Prince of Wales (1841–1910)
Prince Alfred (1844–1900)

73 Robert Thorburn (1818–1885)
Prince Albert (1819–61), 1852

Watercolour on ivory laid on leather adhered to board
28.8 x 20.4 cm
RCIN 404111

PROVENANCE
Commissioned by Prince Albert and given to Queen Victoria
for her birthday in 1852.

REFERENCE
Remington 2010, II, no. 880.

Robert Thorburn, a young artist from Dumfries, trained
at the Trustees' Academy in Edinburgh under Sir
William Allan. His early success attracted the attention
of Walter Francis Montagu Douglas Scott (1806–84),
5th Duke of Buccleuch, who became an early and
long-standing patron of the artist. His support enabled
Thorburn to further his training at the Royal Academy
Schools in London, and possibly also to travel abroad,
for Queen Victoria noted in 1844 that he had spent two
winters in Italy.[1] Thorburn then settled in London and
became a leading miniature painter, second only in
reputation to Sir William Ross.

Prince Albert sports Highland dress with Royal
Stewart tartan and the ribbon of the Order of the Thistle
as he stands in a craggy Highland landscape. This
portrait of the Prince masquerading as a Highland
chieftain was an appropriate gift for Queen Victoria the
year after they had purchased the Balmoral estate in
Aberdeenshire. By 1852, when he made this watercolour,
Robert Thorburn had already enjoyed significant royal
patronage. He had completed *chefs-d'oeuvre* depicting
Queen Victoria (1845) and Prince Albert (1844), showing
his mastery of the portrait miniature art form (RCIN
421665–6). However, relations between the artist and his
royal patrons were never harmonious. A complete fracture
occurred a year after this miniature was painted, after
which Thorburn refused to undertake any further royal
commissions. He turned to oil painting after 1860, perhaps
because of failing eyesight, but his large-scale oil paintings
of religious subjects were not well received. Thorburn's
departure from the field of miniature painting is widely
considered to be an important factor in the decline of
the art form at the end of the nineteenth century.

1. Journal, 23 February 1844.

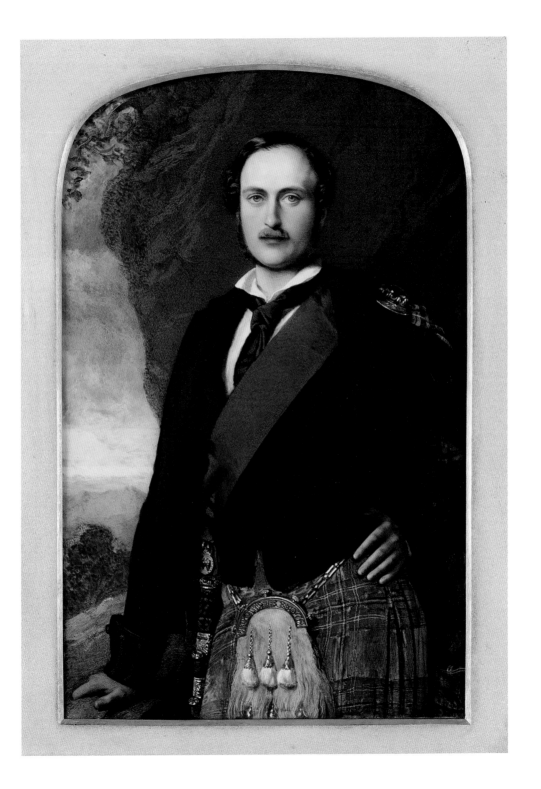

74 Robert Thorburn
Charlotte Anne, Duchess of Buccleuch
(1811–1895) and her daughter, Lady
Victoria Scott (1844–1938), 1847

Watercolour on ivory laid on card
21.0 x 17.0 cm
RCIN 420401

PROVENANCE
Given to Queen Victoria by the Duchess of Buccleuch in
May 1847.

REFERENCES
Long 1929, p. 437; Remington 2010, II, no. 887.

This miniature was given to Queen Victoria by the Duchess of Buccleuch, one of the sitters, after she had left office as Victoria's Mistress of the Robes in 1846. The Raphaelesque tones and arresting low viewpoint vindicate Queen Victoria's first impressions of Thorburn as 'a young Scotchman, of great talent, who … has painted some splendid miniatures, with such depth of colouring & such power, as I have never before seen in a miniature'.[1] Thorburn's success as a miniature painter was due partly to the richness of his colouring and partly to the exceptional size of his miniatures. This was achieved by using a new technique to cut larger slices of ivory from the circumference of the tusk than had been possible hitherto.

1. Journal, 23 February 1844.

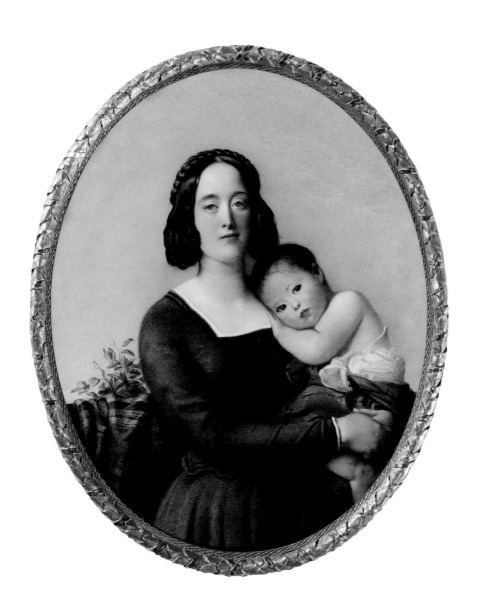

75 Kenneth MacLeay (1802–1878)
Prince Alfred (1844–1900), 1864

Watercolour on ivory laid on card
8.5 x 6.8 cm
RCIN 420330
Signed, dated and inscribed on reverse: *His / Royal Highness / The Prince Alfred. / painted by / Kenneth Macleay / R.S.A. / Edinburgh / July 1864.*

PROVENANCE
Commissioned by Queen Victoria in 1864.

REFERENCE
Remington 2010, I, no. 607.

Royal patronage reversed a period of decline in Kenneth MacLeay's career. He flourished as a miniature painter from the 1820s until 1859 but then suffered a reversal of fortune owing to the popularity of the rival art form of photography. MacLeay's miniatures came to the attention of the royal family through Prince Alfred, who saw them on display at a special exhibition of Scottish art in honour of the Social Science Congress at the Royal Scottish Academy in 1863. Paton, the Queen's Limner for Scotland, endorsed MacLeay's work, and the following year Queen Victoria commissioned him to paint watercolour portraits of Prince Alfred and her two youngest sons, Prince Arthur and Prince Leopold (RCIN 914291).[1]

Prince Alfred sat in Highland dress for his watercolour, which was painted at Dalkeith Palace in June 1864. The following month, back in Edinburgh, MacLeay copied the watercolour for this miniature, altering the neckerchief from white to black at Queen Victoria's command. The miniature has the freshness and vivacity that was common to MacLeay's watercolours; soon after its completion he was rewarded with his most important commission, the *Highlanders of Scotland* series (nos 57–58).

1. Prince Alfred, current location unknown

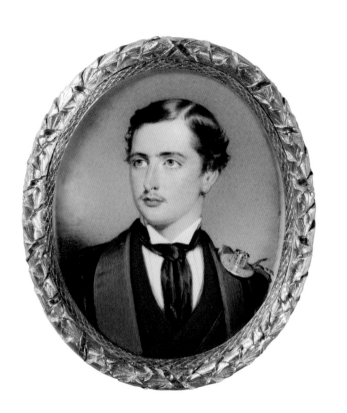

Works of Art

Young, Trotter and Hamilton

76 Pair of pier tables, 1796

Mahogany, sycamore, ebony and boxwood
94.3 x 132.5 x 63.0 cm
RCIN 27597

PROVENANCE
Supplied to the Palace of Holyroodhouse in 1796.

REFERENCES
Swain 1985, p. 510, p. 2; Swain 1992, p. 104, fig. 7.

77 Writing table, 1796

Mahogany and boxwood
80.5 x 99.5 x 65.2 cm
RCIN 27847

PROVENANCE
Supplied to the Palace of Holyroodhouse in 1796.

REFERENCES
Swain 1985, p. 510, pl. 1; Swain 1992, p. 101, fig. 1.

This pair of pier tables and writing table form part of a group of furniture made by the Edinburgh firm of Young, Trotter and Hamilton and supplied to the Palace of Holyroodhouse in 1796 for the residence of Charles-Philippe, comte d'Artois (1757–1836), the future Charles X of France and the youngest brother of Louis XVI (fig. 52). The comte had been in exile since the start of the French Revolution in 1789; he had incurred large debts on the Continent and was offered refuge at Holyroodhouse, where he was able to take advantage of the sanctuary it offered to debtors.[1]

Young, Trotter and Hamilton were commissioned to renovate the interiors of the neglected State Apartments at the Palace for use by the comte and his court. The firm had set up a carpet manufactory in the 1760s and James Hamilton, a cabinetmaker, was taken on as a partner in 1775. By 1796 it was undoubtedly the largest furnishing firm in Edinburgh, with an extensive warehouse on the corner of Princes Street. At its head

FIG. 52. Sir Thomas Lawrence, *Charles X, King of France*, 1825 (detail). Oil on canvas. RCIN 405138

was 24-year-old William Trotter, whose father and grandfather had founded the firm; he became sole proprietor in 1805.[2] The renovations at Holyroodhouse took around four months: as well as supplying new furniture, Young, Trotter and Hamilton cleaned and re-hung tapestries, repaired and papered walls, laid carpets and made curtains for windows and bed-hangings. The total bill for the work was £2,613 13s 9d and the first instalment of £750 was paid by His Majesty's Court of Exchequer for Scotland.

A collection of new mahogany furniture, plain but elegant and decorated with delicate stringing, was provided for the comte d'Artois at the Palace. The writing desk, described on the orginal bill as 'neatly finished with Rising Top covered with fine green cloth on brass socket castors five drawers with good brass locks and handles', cost £5 14s 6d and was for use in the comte's private sitting room.[3] The pair of tables was

for his *levée* room (now the Morning Drawing Room), where they were fitted to stand under a pair of mirrors. The elegant style of furniture was similar to that supplied by Young, Trotter and Hamilton to the residents of Edinburgh's stylish New Town.

The comte d'Artois was joined at Holyroodhouse by members of his family and his servants; he remained there until 1803. He eventually succeeded to the French throne in 1824 and, following his abdication in 1830, returned to take up residence in the Palace. The Trotter furniture was reused: an inventory compiled on his arrival shows the pair of pier tables in the Drawing Room (also known as the *levée room*) and describes them as 'not in good order'.[4] One of these can be seen in an illustration of the room in 1831 (fig. 53).

The Holyroodhouse commission cemented the reputation of Young, Trotter and Hamilton as the makers of the most fashionable furniture in Edinburgh. Trotters (as the firm was known after 1805) were also called in to the Palace in 1822 to supply furniture and upholstery for the visit of George IV and to fit out the Great Drawing Room in Charles II's old Guard Chamber for George IV's *levée*. The firm also renovated areas of the Palace for Queen Victoria's visit in 1850.

FIG. 53. Augustin Edouart, *The French Royal Family in the Salon du roi (Morning Drawing Room) at Holyroodhouse*, 1831. Silhouette. Whereabouts unknown

1. The precincts of Holyrood Abbey (which included the Palace) had been a place of sanctuary for debtors since the sixteenth century.
2. Bamford 1983, pp. 115–22.
3. Edinburgh University Library, Laing MS II 448/29.
4. SRO E885/13/4; see Clarke 2009, p. 211.

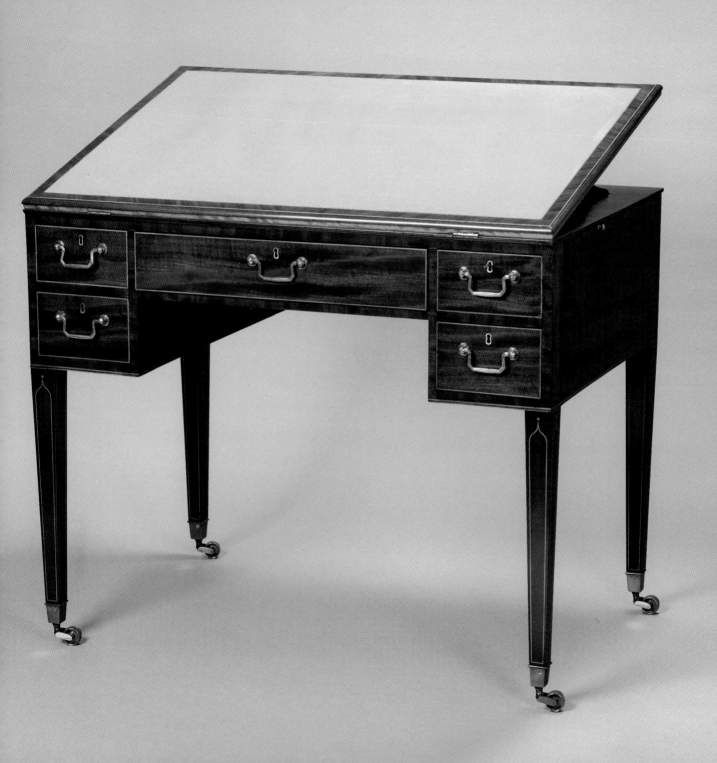

78 John Underwood (active 1818–22) 'Tam O'Shanter' Chair, 1822

Oak and brass
112.0 x 60.0 x 56.0 cm
RCIN 27942

PROVENANCE
Presented to George IV in 1822.

REFERENCE
Roberts 2001, p. 248, fig. 350.

This gothic-style armchair carved with thistles celebrates the work of the Scottish poet Robert Burns. It was made by John Underwood of Ayr from a portion of the roof of the old Kirk of Alloway, Ayrshire; Burns was born in Alloway in 1759, in a cottage close to the old Kirk. By the time that Burns was at the height of his fame, the Kirk had become a ruin and the timbers of the roof were used to make a number of Burns-related memorabilia and souvenirs.[1]

The back of the chair is inlaid with four brass panels engraved with Burns's celebrated poem *Tam O'Shanter*, written in 1790. The Kirk is the setting for much of the poem, in which Tam, on returning drunk from market in Ayr, sees witches and warlocks dancing and the devil playing the bagpipes in the Kirk. They give chase and pull off the tail of Tam's horse, Meg. The reverse of the back of the chair is painted with Tam riding his horse.

This chair was presented to George IV in 1822, the year of his visit to Scotland, and was received at Carlton House shortly after his return. Another similar chair was presented to the 13th Earl of Eglinton and Winton in 1818 by David Auld.[2]

1. For example, snuff box, no. 3.4542 and necklace, no. 3.4531, Robert Burns Birthplace Museum, Alloway.
2. Sotheby's, New York, 1 February 1992 (lot 271).

79 John Smith (active 1770–1816)
Pedestal clock, 1800–1808

Gilded oak, glass, gilt brass, brass and paint
143.5 x 60.4 x 50.0 cm
Inscribed: *JOHN SMITH PITTENWEEM NORTH BRITAIN 1804*
RCIN 2918

PROVENANCE
Presented to the Duke of York (later George VI) and Lady Elizabeth Bowes-Lyon on the occasion of their marriage on 26 April 1923, by the citizens of Glasgow.

REFERENCES
Smith 1921, pp. 363–4; Jagger 1983, pp. 189–92; Hudson 1985, pp. 440–78.

This magnificent large-scale automaton and musical clock with three painted dials was made by John Smith, who came from the small fishing village of Pittenweem, in the East Neuk of Fife. By the late eighteenth century there was a strong tradition of clockmaking in Scotland, particularly in the larger towns and cities such as Edinburgh, Dundee and Aberdeen, but there were few clockmakers working in Fife. Little is known of Smith's life; in 1775 he stated in an advertisement that 'he was bred in the trade and had never been out of the country'.[1] Despite the fact that Pittenweem was tucked away in a remote corner of Fife, Smith established a successful business specialising in the manufacture of clocks with highly complicated mechanisms and distinctive dials. The tradition of clockmaking in this area of Scotland continued after his death.

The main dial, on the front of the clock, shows the time and has subsidiary dials for the month, date and day of the week, with a control for music, chiming and silence. In addition, there is a seconds ring, a lunar phases display and, in the arch, a tidal dial. The musical

dial, on the left side, shows 16 tune titles arranged in two concentric rings, set against a background of landscape scenes. The outer ring has eight marches to accompany the processions on the automata dial, such as 'God Save the King' and 'The Duke of York's March'; the inner ring has eight tunes, including 'Yellow Hair'd Laddie' and 'East Neuk of Fife', played on the hour. The automaton dial, on the left-hand side, shows two processions of figures, the upper one of 15 members of the royal family, the lower one a similar number of members of the household, who march every three hours across the exterior of a mansion, possibly intended to be a palace. The painting of the landscapes and other scenes has been attributed to the Edinburgh artist Alexander Nasmyth, who began his career apprenticed to a coach painter (no. 27).[2]

In 1808 John Smith is recorded as having exhibited this clock in London, together with another automaton and musical clock (NMS, H.NL 88). While he was there he had the pedestal clock valued at £900, but failed to find a purchaser for either clock. He returned to Edinburgh and in 1809 put the clocks up for sale by lottery, together with a number of other pieces. Despite making tickets available for six months, Smith only realised £500 for all the items, less than half of the expected sum. The purchaser was not recorded but in the early twentieth century the clock was acquired by William B. Smith, of Glasgow, an antiquarian and keen collector of clocks. It was exhibited in the Glasgow Exhibition of 1911 and purchased by the citizens of Glasgow in 1922. The following year it was presented to the Duke of York and Lady Elizabeth Bowes-Lyon on the occasion of their marriage.

1. Hudson 1985, p. 440.
2. Smith 1921, p. 354.).

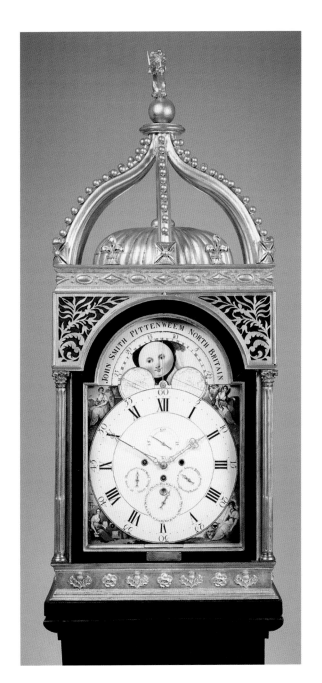

80 Thomas Campbell (1790–1858)
George, Duke of Gordon (1770–1836), 1836

Marble
71.5 x 49.5 x 27.0 cm
Signed and dated: *1836*
RCIN 31316

PROVENANCE
First recorded in the Royal Collection in 1872.

FIG. 54. Thomas Campbell, *Pope Pius VII*, 1826. Marble. RCIN 35406

The sculptor Thomas Campbell was initially apprenticed to a marble cutter in Edinburgh, the city where he was born, before his work caught the attention of Gilbert Innes (1751–1832) of Stow, Depute Governor of the Bank of Scotland, who became his patron. Innes's support enabled Campbell to study at the Royal Academy Schools in London and then move to Rome in 1818, where he remained until 1830.

Campbell set up a studio in Rome, where he produced portrait busts for many eminent visitors and became the 'doyen of Scottish expatriate sculptors'.[1] Here he became associated with the neoclassical sculptors Antonio Canova (1757–1822) and Bertel Thorvaldsen (1770–1844), and in 1826 George IV commissioned him to make copies of Thorvaldsen's busts of Pope Pius VII (1742–1823; fig. 54) and Cardinal Ercole Consalvi (1757–1824) (RCIN 35407).[2] These were delivered to Windsor Castle in 1829, shortly before Campbell's return to London. He continued to produce portrait busts but also undertook a number of commissions for monuments, including a bronze of the 4th Earl of Hopetoun (1765–1823) for St Andrew's Square, Edinburgh, and a statue of the Duke of Wellington (1769–1852) for the 5th Duke of Buccleuch at Dalkeith House.

George Gordon, 5th Duke of Gordon, was a soldier, politician, Keeper of the Great Seal of Scotland and, from 1827 to 1836, Governor of Edinburgh Castle. Between 1830 and 1839 Campbell executed a bronze of Frederick, Duke of York (1763–1827) for the Castle Esplanade.[3] Campbell's last Scottish commission was a granite statue of Gordon for Castlegate, Aberdeen (1839–44).

1. Edinburgh 1991, p. 66.
2. Thorvaldsen's original bust of Consalvi had been commissioned in 1824 by the Duchess of Devonshire for the Pantheon in Rome.
3. Younger brother of George IV.

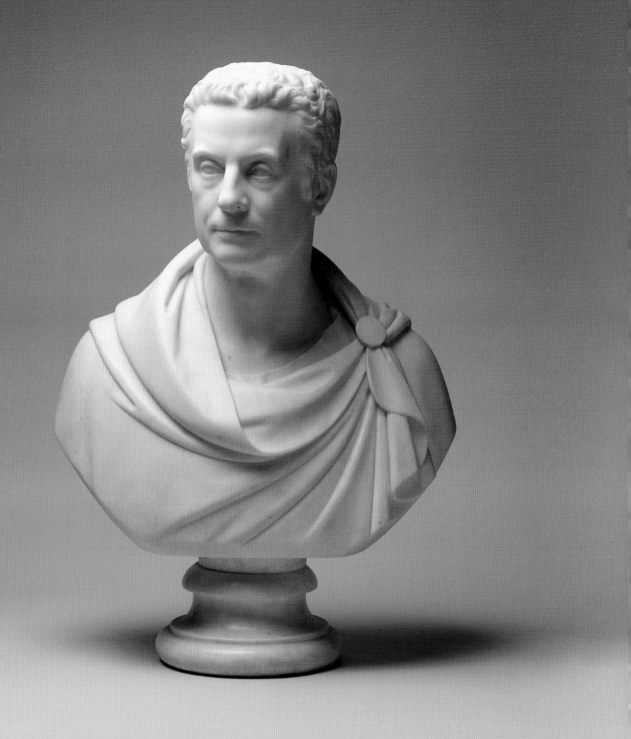

81 Lawrence Macdonald (1799–1878)
Adolphus, Duke of Cambridge (1774–1850), 1846

Marble
71.0 x 46.0 x 23.4 cm
Signed and dated: *1846*
RCIN 31611

PROVENANCE
Presented to Queen Victoria by Adolphus,
Duke of Cambridge.

Lawrence Macdonald was born at Findo Gask, Perth-shire, and began his working life as a mason's apprentice. He entered the Trustees' Academy, Edinburgh, in 1822 but left for Rome a few months later, supported financially by his patrons, the Oliphants of Gask. He set up as a sculptor of portrait busts and, with other artists, helped to found the British Academy of Arts in Rome. Unlike his compatriot Thomas Campbell (no. 80), he returned to Scotland in 1826 and established a studio in Edinburgh. In 1829 he was elected a member of the Scottish Academy (later the Royal Scottish Academy). Between 1829 and 1831 he exhibited regularly in Edinburgh, where he was hailed as 'our Canova'.[1] Although most of his income came from portrait bust commissions, Macdonald's main interest was in idealised neoclassical statuary and Scotland lacked the facilities for the necessary large-scale marble cutting. Macdonald returned to Rome in 1832, where he remained for the rest of his life.

Adolphus, Duke of Cambridge (1774–1850) was the tenth child and seventh son of George III and Queen Charlotte. He was the Viceroy of Hanover from 1816 until 1837, when he returned to Britain. He presented this sculpture to his niece Queen Victoria after its completion in 1846. The Queen later commissioned from Macdonald a full-length marble of *Hyacinthus*, which she gave to Prince Albert for Christmas in 1852 and which was originally placed in Osborne House (fig. 55). This was a version of the sculpture he had made in 1842 for his patron, the Liverpool merchant John Gladstone (1764–1851), father of the British Prime Minister.

1. See Edinburgh 1991, p. 67, for further details of Macdonald's life and career.

FIG. 55. Lawrence Macdonald, *Hyacinthus*, 1852. Marble. RCIN 69001

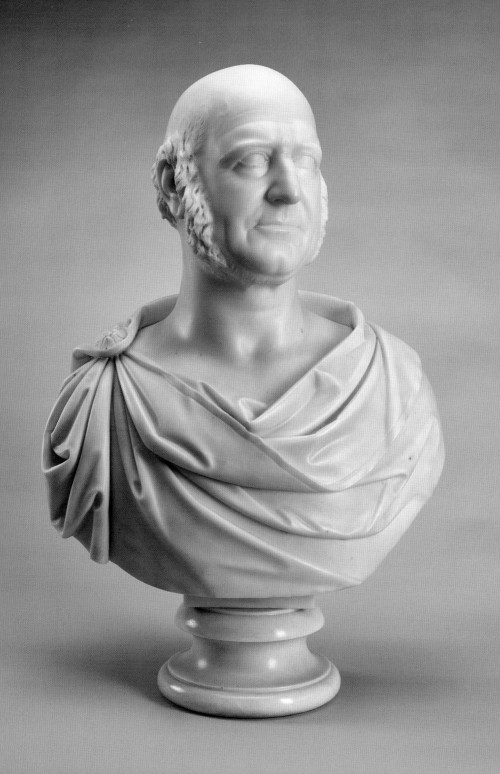

Bibliography

Anderson 2014–15
Kate Anderson, 'The Scottish Connection: John Michael Wright and the Development of Portrait Painting in Scotland, 1660–1700', *Journal of the Scottish Society for Art History*, 19, 2014–15, pp. 7–14

Aspinall 1962–70
Arthur Aspinall (ed.), *The Later Correspondence of George III*, 5 vols, Cambridge 1962–70

Ballantine 1866
James Ballantine, *The Life of David Roberts R.A.*, Edinburgh 1866

Bamford 1983
Francis Bamford, *A Dictionary of Edinburgh Furniture Makers*, London 1983

Berlioz 1969
Memoirs of Hector Berlioz from 1803 to 1865, rev. tr. E. Newman, New York, 1969, 2nd ed. 1977

Burnet 1848
John Burnet, *Practical essays on various branches of the fine arts. To which is added, a critical inquiry into the principles and practice of the late Sir David Wilkie*, London 1848

Campbell 1989
Una Campbell, *Robes of the Realm: 300 Years of Ceremonial Dress*, London 1989

Clarke 2009
Deborah Clarke, 'Charles X's residence at the Palace of Holyroodhouse 1830–32: An inventory of furniture', *Furniture History*, XLV, 2009, pp. 193–294

Cooksey 1991
J.C.B. Cooksey, *Alexander Nasmyth 1785–1840: A Man of the Scottish Renaissance*, Edinburgh 1991

Croly 1891
George Croly, *The Personal History of George IV*, 2nd edn London 1891

Cunningham 1829–33
Allan Cunningham, *The Lives of the Most Eminent British Painters*, 6 vols, London 1829–33

Cunningham 1843
Allan Cunningham, *The Life of Sir David Wilkie*, 3 vols, London 1843

Eastlake 1895
Journals and Correspondence of Lady Eastlake, ed. C.E. Smith, 2 vols, London 1895

Emerson 1973
Roger Emerson, 'The social composition of enlightened Scotland: The Select Society of Edinburgh, 1754–65', *Studies on Voltaire in the Eighteenth Century*, CXIV, 1973, pp. 291–329

Errington 1988
Lindsay Errington, *David Wilkie 1785–1841*, Edinburgh 1988

Errington 1992
Lindsay Errington, 'Ascetics and Sensualists: William Dyce's views on Christian art', *The Burlington Magazine*, CXXXIV, 1073, August 1992, pp. 491–7

Eyre-Todd 1903
George Eyre-Todd (ed.), *The Autobiography of William Simpson, R.I.*, London 1903

Fleming 1962
John Fleming, *Robert Adam and his Circle in Edinburgh and Rome*, London 1962

Fulford 1971
Roger Fulford (ed.), *Your Dear Letter: Private Correspondence of Queen Victoria and the Crown Princess of Prussia 1865–1871*, London 1971

Gordon 1976
Esmé Gordon, *The Royal Scottish Academy of Painting, Sculpture and Architecture 1826–1976*, Edinburgh 1976

Gow 1987
Ian Gow, 'Queen Victoria at Holyrood', *Country Life*, 6 August 1987, pp. 126–9

Gray 1930
Hilda Orchardson Gray, *The Life of Sir William Quiller Orchardson*, London 1930

Gruner 1845
Ludwig Gruner, *The Decorations of the Garden Pavilion in the Grounds of Buckingham Palace*, London 1845

Guiterman 1978
Helen Guiterman, *David Roberts R.A. 1796–1864*, London 1978

Guiterman 1990
Helen Guiterman, 'Roberts on Royalty', *Turner Studies,* x, 1, 1990, pp. 44–50

Hill 2013
Richard J. Hill, *Picturing Scotland through the Waverley Novels: Walter Scott and the Origins of the Victorian Illustrated Novel*, Aldershot 2013

Hudson 1985
Felix Hudson, 'John Smith, Pittenweem, 1770–1814', *Antiquarian Horology*, xv, 5 September 1985, pp. 440–78

Irwin 1974
Francina Irwin, 'The Scots Discover Spain', *Apollo*, xcix, May 1974, pp. 353–8

Irwin 1975
David and Francina Irwin, *Scottish Painters at Home and Abroad, 1700–1900*, London 1975

Jagger 1983
Cedric Jagger, *Royal Clocks: British Monarchy and its Timekeepers, 1300–1900*, London 1983

Journal
Queen Victoria, *Journal*, Royal Archives, http://www.queenvictoriasjournals.org/home.do

Layard 1906
G.S. Layard (ed.), *Sir Thomas Lawrence's Letter-Bag*, London 1906

Lockhart 1837
J.G. Lockhart, *The Life of Sir Walter Scott*, 7 vols, Edinburgh and London 1837

Long 1929
Basil Long, *British Miniaturists*, London 1929

MacGeorge 1884
A. MacGeorge, *W.L. Leitch, Landscape Painter. A Memoir*, London 1884

Macmillan 2000
Duncan Macmillan, *Scottish Art 1460–2000*, Edinburgh and London (1990), rev. edn 2000

Macmillan 2001
Duncan Macmillan, '"A Journey through England and Scotland": Wilkie and other influences on French art of the 1820s', *British Art Journal*, II, 3, 2001, pp. 28–35

Millar 1952
Oliver Millar, 'The Brunswick Art Treasures at the Victoria and Albert Museum: The Pictures', *Burlington Magazine*, xciv, 1952, p. 268

Millar 1969
Oliver Millar, *The Later Georgian Pictures in the Collection of Her Majesty The Queen*, London 1969

Millar 1977
Oliver Millar, *The Queen's Pictures*, London 1977

Millar 1985
Delia Millar, *Queen Victoria's Life in the Scottish Highlands Depicted by Her Watercolour Artists*, London 1985

Millar 1986
Delia Millar, *The Highlanders of Scotland. The Complete Watercolours Commissioned by Queen Victoria from Kenneth MacLeay of her Scottish Retainers and Clansmen*, London 1986

Millar 1992
Oliver Millar, *The Victorian Pictures in the Collection of Her Majesty The Queen*, 2 vols, Cambridge 1992

Millar 1995
Delia Millar, *The Victorian Watercolours and Drawings in the Collection of Her Majesty The Queen*, 2 vols, London 1995

Morrison 2003
John Morrison, *Painting the Nation*, Edinburgh 2003

Nasmyth 1885
James Nasmyth, *An Autobiography*, ed. S. Smiles, London and Edinburgh 1885

Norman 1996–7
A.V.B. Norman, 'George IV and Highland Dress', *Review of Scottish Culture*, x, 1996–7, pp. 5–15

Oppé 1950
Adolf Oppé, *English Drawings: Stuart and Georgian Periods in the Collection of His Majesty The King at Windsor Castle*, London 1950

Pointon 1979
Marcia Pointon, *William Dyce 1806–1864: A Critical Biography*, Oxford 1979

Pointon 1984
Marcia Pointon, ' "*From Blind-Man's-Buff to Le colin maillard*": Wilkie and his French audience', *Oxford Art Journal,* VII, 1984, pp. 15–25

Prebble 2000
John Prebble, *The King's Jaunt*, Edinburgh (1988), 2nd edn 2000

Pyne 1819
William H. Pyne, *The History of the Royal Residences*, 3 vols, London 1819

Remington 2010
Vanessa Remington, *Victorian Miniatures in the Collection of Her Majesty The Queen,* 2 vols, London 2010

Remington 2013
Vanessa Remington, 'Sir William Ross (1794–1860): International court miniaturist?', in *La Miniature en Europe: Des Portraits de propagande aux œuvres éléphantesques*, ed. N. Lemoine-Bouchard, Paris 2013, pp. 83–90

Retford 2006
Kate Retford, *The Art of Domestic Life: Family Portraiture in Eighteenth-Century England*, New Haven and London 2006

Reynolds 1988
Graham Reynolds, *English Portrait Miniatures*, rev. edn, Cambridge 1988

Roberts 2001
Hugh Roberts, *For the King's Pleasure: The Furnishing and Decoration of George IV's Apartments at Windsor Castle*, London 2001

Robertson 1897
Emily Robertson, Letters and Papers of Andrew Robertson, London 1895, new edn. 1897

Ruskin 1856
John Ruskin, ' "Notes on the Royal Academy 1856", in *The Works of John Ruskin*, eds E.T. Cook and A. Wedderburn, XIV, London 1904, pp. 1–39

Russell 1987
Francis Russell, *Portraits of Sir Walter Scott: A Study of Romantic Portraiture*, London 1987

[Scott] 1822
[Walter Scott], *Hints Addressed to the Inhabitants of Edinburgh, and others, in Prospect of His Majesty's visit. By an Old Citizen*, Edinburgh 1822

Scott 1825
Sir Walter Scott, *Waverley or 'Tis Sixty Years Since*, 3 vols, Paris 1825

Sickert 2003
Walter Sickert, *The Complete Writings on Art*, ed. A. Robins, Oxford 2003

Sim 1984
Katharine Sim, *David Roberts R.A. 1796–1864, A Biography*, London 1984

Simon 1987
Robin Simon, *The Portrait in Britain and America*, London 1987

Simon 1994
Jacob Simon, 'Allan Ramsay and picture frames', *Burlington Magazine*, CXXXVI, 1096, July 1994, pp. 444–55

Smailes 1992
Helen Smailes, *Kenneth MacLeay 1802–1878*, Edinburgh 1992

Smart 1992
Alistair Smart, *Allan Ramsay: Painter, Essayist and Man of the Enlightenment*, New Haven and London 1992

Smart and Ingamells 1999
Alistair Smart and John Ingamells (eds), *Allan Ramsay: A Complete Catalogue of his Paintings*, New Haven and London 1999

Smith 1921
John Smith, *Old Scottish Clockmakers*, Edinburgh, 2nd edn 1921

Staley 2001
Allen Staley, *The Pre-Raphaelite Landscape*, New Haven and London 2001

Swain 1985
Margaret Swain, 'Understated elegance: Trotter furniture at Holyroodhouse', *Country Life*, 22 August 1985, pp. 510–511

Swain 1992
Margaret Swain, 'Furniture for the Comte d'Artois at Holyroodhouse, 1976', *Furniture History*, 28, 1992, pp. 98–105

Tite 2001
Catherine Tite, 'Constructing the succession: ritual and the production of history at Kensington Palace', *Chicago Art Journal*, XI, 2001, pp. 1–14

Tromans 2007
Nicholas Tromans, *David Wilkie: The People's Painter*, Edinburgh 2007

Walker 1992
Richard Walker, *The Eighteenth and Early Nineteenth Century Miniatures in the Collection of Her Majesty The Queen*, Cambridge, 1992

Walpole 1937
Horace Walpole, *Anecdotes of Painting in England*, eds F.W. Hilles and P.B. Daghlian, 5 vols, New Haven 1937

Walpole 1937–83
Horace Walpole's Correspondence, ed. W.S. Lewis, 48 vols, New Haven and London 1937–83

Exhibitions

Aberdeen 1967
John Phillip, Aberdeen Art Gallery 1967

Aberdeen 2001
Aspects of Landscape: A Bicentenary Celebration of James Giles RSA Aberdeen Art Gallery 2001

Aberdeen 2005
Phillip of Spain: The Life and Art of John Phillip (1817–1867) Aberdeen Art Gallery 2005

Aberdeen, London and Edinburgh 1985
Joseph Farquharson of Finzean, Aberdeen Art Gallery; Fine Art Society, London; and Fine Art Society, Edinburgh 1985

Edinburgh 1958
Paintings and Drawings by Sir David Wilkie, National Gallery of Scotland, Edinburgh 1958

Edinburgh 1961
Visit of George IV to Edinburgh 1822: An Exhibition of Paintings, Drawings and Engravings by Contemporary Artists Depicting the Ceremonies and Personalities Involved, Scottish National Portrait Gallery, Edinburgh 1961

Edinburgh 1972
Sir William Quiller Orchardson RA, Royal Scottish Academy, Edinburgh 1972

Edinburgh 1975
Work in Progress: Sir David Wilkie. Drawings into Paintings, National Gallery of Scotland, Edinburgh 1975

Edinburgh 1982
John Michael Wright: The King's Painter, Scottish National Portrait Gallery, Edinburgh 1982

Edinburgh 1983
Masterclass: R. Scott Lauder & Pupils, National Gallery of Scotland, Edinburgh 1983

Edinburgh 1985
Tribute to Wilkie, National Gallery of Scotland, Edinburgh 1985

Edinburgh 1989
Patrons and Painters: Art in Scotland 1650–1760, Scottish National Portrait Gallery, Edinburgh 1989

Edinburgh 1991
Virtue and Vision: Sculpture and Scotland 1540–1990, Royal Scottish Academy, Edinburgh 1991

Edinburgh 1992
Dutch Art in Scotland: A Reflection of Taste, National Gallery of Scotland, Edinburgh 1992

Edinburgh 1996
Christina Robertson: A Scottish Portraitist at the Russian Court, City Art Centre, Edinburgh 1996

Edinburgh 1997
Raeburn: The Art of Sir Henry Raeburn 1756–1823, Scottish National Portrait Gallery, Edinburgh 1997

Edinburgh 2001
William Allan: Artist Adventurer, City Art Centre, Edinburgh 2001

Edinburgh 2003
High Society: The Life and Art of Sir Francis Grant 1803–1878, Scottish National Portrait Gallery, Edinburgh 2003

Edinburgh 2009
The Discovery of Spain, National Galleries of Scotland, Edinburgh 2009

Edinburgh and London 1951
Ramsay, Raeburn and Wilkie, National Gallery of Scotland, Edinburgh, and Royal Academy of Arts, London 1951

Edinburgh and London 1986–7
Painting in Scotland: The Golden Age, Talbot Rice Art Centre, Edinburgh, and Tate, London 1986–7

Edinburgh and London 1992–3
Allan Ramsay 1713–1784, Scottish National Portrait Gallery, Edinburgh, and National Portrait Gallery, London 1992–3

Edinburgh and London 2009
The Conversation Piece: Scenes of Fashionable Life, The Queen's Gallery, Edinburgh, and The Queen's Gallery, London 2009

Edinburgh and London 2013–14
Cairo to Constantinople. Francis Bedford's Photographs of the Middle East, The Queen's Gallery, Edinburgh, and The Queen's Gallery, London, 2013–14

Edinburgh and Wellington 2004–5
Holbein to Hockney: Drawings from the Royal Collection, The Queen's Gallery, Edinburgh, and Museum of New Zealand, Wellington 2004–5

Glasgow 2013–14
Allan Ramsay: Portraits of the Enlightenment, The Hunterian, University of Glasgow, 2013–14

Hanover 2014
Als die Royals aus Hannover Kamen, Niedersächsisches Landesmuseum, Hanover 2014

London 1958
Sir David Wilkie, Royal Academy of Arts, London 1958

London 1981
Gerald Finley, *Turner and George IV in Edinburgh 1822*, Tate. London 1981

London 1986
David Roberts, Barbican Art Gallery, London 1986

London 1988–9
Treasures from the Royal Collection, The Queen's Gallery, London 1988–9

London 1991a
The Queen's Pictures: Royal Collectors through the Centuries, National Gallery, London 1991

London 1991b
Carlton House, The Queen's Gallery, London 1991

London 1998
The Quest for Albion, The Queen's Gallery, London 1998

London 2001
The Victorian Vision: Inventing the New Britain, Victoria and Albert Museum, London 2001

London 2002a
Royal Treasures: A Golden Jubilee Celebration, The Queen's Gallery, London 2002

London 2002b
David Wilkie: Painter of Everyday Life, Dulwich Picture Gallery, London 2002

London 2004
George III and Queen Charlotte: Patronage, Collecting and Court Taste, The Queen's Gallery, London 2004

London 2010
Victoria and Albert: Art and Love, The Queen's Gallery, London 2010

London and Edinburgh 2003–4
Below Stairs: 400 years of Servants' Portraits, National Portrait Gallery, London, and Scottish National Portrait Gallery, Edinburgh 2003–4

Nottingham and Penzance 1998–9
Rustic Simplicity: Scenes of Cottage Life in Nineteenth-Century British Art, Djanogly Art Gallery, Nottingham, and Peake House Gallery and Museum, Penzance 1998–9

Oxford 1985
Sir David Wilkie: Drawings and Sketches in the Ashmolean Museum, Ashmolean Museum, Oxford 1985

Paisley, Dundee and Edinburgh 1981–2
David Roberts: Artist and Adventurer, Paisley Museum and Art Gallery, Dundee Museum and Art Gallery and City AA Centre, Edinburgh 1981–2

Raleigh 1987
Sir David Wilkie of Scotland, North Carolina Museum of Art, Raleigh 1987

Acknowledgements

The authors are deeply grateful to the following for their assistance:

Hugh Buchanan, Alisa Bunbury, Mungo Campbell, Janet Casey, Michael Clarke, Donald Farquharson, Vivien Gaston, Dame Anne Griffiths, Duncan Macmillan, T.A.S. MacPherson, Hamish Miles, Ian O'Riordan, Helen Smailes and Charlotte Topsfield

Colleagues from the Royal Collection Trust have contributed in many ways to the production of this catalogue. We are particularly grateful to Carly Collier, who has written the catalogue entries on William Dyce. We would also like to thank: in the Pictures Department, Desmond Shawe-Taylor and Jeannie Chapel; in the Print Room, Martin Clayton; from the Royal Library, Emma Stuart; from the Royal Archives, Pam Clark; and from the Decorative Arts department, Caroline de Guitaut, Kathryn Jones, Nicola Turner Inman and Paul Cradock. Conservation, framing and display support for the exhibition has been provided by Nicola Christie, Adelaide Izat, Claire Chorley, Rosanna da Sancha, Karen Ashworth, Tabitha Teuma, Al Brewer, Katelyn Reeves, Michael Field, Sonja Leggewie, Alan Donnithorne, Kate Stone and David Westwood. Grateful thanks are due to the exhibitions team: Theresa-Mary Morton, Hannah Belcher, Stephen Weber and Roxanna Hackett as well as to the Picture Library and photography section: Shruti Patel, Daniel Partridge and Eva Zielinska-Millar. We would also like to thank Jacky Colliss Harvey, David Tibbs and Lizzy Simpson from the Publications Department, the Production Manager Debbie Wayment, the editors Johanna Stephenson and Nina Shandloff, and the designer, Miko McGinty, for the production of this catalogue.

Abbreviations

AAGM	Aberdeen Art Gallery and Museum	NRS	National Records of Scotland
BM	British Museum, London	NT	National Trust
BMAG	Blackburn Museum and Art Gallery	NTS	National Trust for Scotland
CAC	City Art Centre, Edinburgh	RA	Royal Archives
DPG	Dulwich Picture Gallery	RCIN	Royal Collection Inventory Number
GM	Glasgow Museums	RSA	Royal Scottish Academy
LLAG	Lady Lever Art Gallery, Port Sunlight	SNG	Scottish National Gallery, Edinburgh
NG	National Gallery, London	SNPG	Scottish National Portrait Gallery, Edinburgh
NLS	National Library of Scotland, Edinburgh		
NPG	National Portrait Gallery, London	V & A	Victoria and Albert Museum, London

202

Index

Scottish Artists: From Caledonia to the Continent

Written by Deborah Clarke and Vanessa Remington

To find out more about Scottish paintings
and works of art in the Royal Collection, visit
www.royalcollection.org.uk

Published 2015 by Royal Collection Trust
York House
St James's Palace
London SW1A 1BQ

Royal Collection Trust / © HM Queen Elizabeth II 2015

All rights reserved. Except as permitted under current
legislation no part of this work may be photocopied,
stored in a retrieval system, published, performed in
public, adapted, broadcast, transmitted, recorded or
reproduced in any form or by any means without the
prior permission of the copyright owner.

ISBN 978 1 909741 20 1

British Library Cataloguing in Publication Data:
A catalogue record for this book is available from the
British Library.

100170

Designed by Miko McGinty, Inc.
Typeset in Bau and Equity
Production Manager Debbie Wayment
Printed on 150gsm Gardamat
Colour reproduction by Altaimage, London
Printed and bound in Italy by Printer Trento

Pages 2–3: David Farquharson, *View of Strathmore with Harvesters*, 1881 (detail). Oil on canvas. RCIN 409023
Page 4: Alexander Nasmyth, *View of the High Street Edinburgh and the Lawn Market*, 1824 (detail). Oil on canvas. RCIN 403133
Page 6: Allan Ramsay, *Queen Charlotte with her Two Eldest Sons*, c.1764–9 (detail). Oil on canvas. RCIN 404922
Page 33: James Giles, *The boundary between Balmoral and Invercauld, below the Keeper's House*, 1848 (detail). Pencil and watercolour with touches of bodycolour. RCIN 919616
Front cover: Sir David Wilkie, *The Penny Wedding*, 1818 (detail). Oil on panel. RCIN 405536
Back cover: James Giles, *A View of Balmoral*, 1848 (detail). Oil on panel. RCIN 405007

All works reproduced are Royal Collection Trust / © HM Queen Elizabeth II 2015 unless indicated otherwise below.

Royal Collection Trust is grateful for permission to reproduce the following:

Pages 12, 46, 154 © Scottish National Gallery
Pages 54, 96 © Scottish National Portrait Gallery
Page 70 © Leicester Museum and Art Gallery / Bridgeman Images
Page 92 © City of Edinburgh Council - Edinburgh Libraries and www.capitalcollections.org.uk
Page 94 © Aberdeen Art Gallery & Museums Collections
Page 97 © National Portrait Gallery, London
Page 114 © Victoria and Albert Museum, London
Page 120 © Trustees of the British Museum
Page 170 © UK Government Art Collection.
Page 186 © Reserved